MENTORS

The Making of an Art Historian

10 May 2019

Martica,

　　I know there are parts
of this book that you thought
were better left unsaid, but
I wrote only what I thought
would paint a fair and honest
picture of each individual (in-
cluding myself!)

Best wishes,

Francis

Also by Francis M. Naumann

The William and Mary Sisler Collection (1984)

Marcel Duchamp: Artist of the Century (1989)

New York Dada 1915-1923 (1994)

Making Mischief: Dada Invades New York (1996)

Beatrice Wood: A Centennial Tribute (1997)

Maria: The Surrealist Sculpture of Maria Martins (1998)

Marcel Duchamp: The Art of Making Art
in the Age of Mechanical Reproduction (1999)

Affectionately, Marcel:
The Selected Correspondence of Marcel Duchamp (2000)

Wallace Putnam (2002)

Conversion to Modernism:
The Early Work of Man Ray (2002)

The Recurrent, Haunting Ghost:
Essays on the Art, Life and Legacy of Marcel Duchamp (2012)

The Duchamp Family of Artists (2014)

MENTORS

The Making of an Art Historian

Francis M. Naumann

Mentors
By Francis M. Naumann

Book design: Dana Martin-Strebel

Publisher's Cataloging-in-Publication Data

Names: Naumann, Francis M., author.
Title: Mentors : the making of an art historian / by
Francis M. Naumann.
Description: Los Angeles, CA: DoppelHouse Press, 2019.
Identifiers: LCCN 2018959934 | ISBN 9780999754467
Subjects: LCSH Naumann, Francis M. | Art historians--
Biography. | Art historians--United States--Biography. |
Authors--20th century--Biography. | Mentoring in the
arts. | Mentoring--Personal narratives. | Art, Modern-
-20th century--History. | Steinberg, Leo, 1920-2011. |
Rewald, John, 1912-1994. | Wood, Beatrice. | Duchamp,
Marcel, 1887-1968. | Rosenblum, Robert. | Pincus-
Witten, Robert. | Rubin, William, 1927-2006. | BISAC
BIOGRAPHY & AUTOBIOGRAPHY / Personal
Memoirs | BIOGRAPHY & AUTOBIOGRAPHY /
Artists, Architects, Photographers | BIOGRAPHY &
AUTOBIOGRAPHY / Literary Figures
Classification: LCC N7483 .N38 2019 | DDC 709/.2--dc23

 DoppelHouse Press | Los Angeles

To the memory of

Leo Steinberg (1920-2011)
John Rewald (1912-1994)
Beatrice Wood (1893-1998)

and

William S. Rubin (1927-2006)
Robert Rosenblum (1927-2006)
Robert Pincus-Witten (1935-2018)

∽ CONTENTS ∽

∽ I. ∽

BACK STORY

No one sets out to become an art historian, except, perhaps, the children of art historians who want to follow in their parents' footsteps. To a young person making a decision about what he or she wants to be in life, becoming an art historian is not, after all, considered a glamorous or lucrative profession. Indeed, in a speech President Obama delivered while in office, he made an off-the-cuff comment about art historians when he said that people in skilled professions could make considerably more money than those "with an art history degree" (a glib remark for which he later apologized). To get an idea of what the general public thinks of art historians, I can cite an incident that occurred in the mid-1980s when I attended a taping of the David Letterman show at the NBC studios at Rockefeller Center in New York. A staff member of the program asked all of us standing in line before the show to fill out a questionnaire, one that asked about who you were and what you did for a living, information that, if sufficiently interesting, they planned to use in the warm-up session of the show. When asked my profession, I wrote "art historian." To my surprise, when David Letterman himself appeared onstage to greet the audience, he asked to see the art historian in the crowd. When I stood up, he was visibly surprised, for apparently I did not conform to his expectations of what an art historian looked like. Although I was anything but cool in appearance, my guess is that he expected me to be the quintessential nerd, the sort of person who spent his life engaged in academic pursuits to the neglect

of his physical appearance. I no longer recall the exchange that took place, but if nothing else, I was alerted to the fact that my profession carried with it a preconceived notion of what its practitioners looked like. From that time onward, I was determined not to let myself look like an art historian, at least not the type that the general public expected me to be.

At the time, I had two mentors in the profession whom I consciously emulated as role models: John Rewald, the doyen of Impressionist studies and the world's foremost authority on the French Post-Impressionist painter Paul Cézanne, and Leo Steinberg, a renowned writer on art who specialized in the great artists of the Renaissance and Baroque periods—Leonardo and Michelangelo, to name just two—but also in modernists, ranging from Picasso to Jasper Johns. They were both professors at the Graduate Center of the City University of New York, where I had been pursing my Ph.D. degree in art history. Both were exceptionally accomplished men in their respective fields, but as personalities, they could not have differed more from one another: Rewald was a true bon vivant, a man who loved the better things in this world and would do whatever was necessary to achieve a more opulent and resplendent lifestyle, whereas Steinberg lived almost entirely inside his own head, a man who remained content to pursue questions he had asked himself about works of art until he got the answers he was seeking, even if that meant ignoring everyone and everything around him. Each man looked his part. Rewald battled a slight paunch, clearly the result of fine dining, but was always impeccably dressed, in the finest hand-tailored suits that money could buy. Steinberg was a thin man, who wore the same blue blazer and gray pants for years, and his shirts were inevitably frayed at the collars (until his assistant pointed this out and coerced him into dressing more respectably). Rewald lived in an elegant and sprawling apartment on Park Avenue, with a large

study that featured an antique desk surrounded by books, Impressionist drawings, and various curiosities he had picked up during his travels. Steinberg lived on the Upper West Side of Manhattan in a nondescript, white brick building next to Lincoln Center, and his apartment always reeked of cigarette smoke (a lifelong habit that he kicked only in the last year of his life). While he had a proper study, the center of his life was a flat-topped desk in his living room that was cluttered with photocopies and open books, whatever he was working on at the time, but the reproduction of a work of art was always positioned to one side of his desk on a makeshift easel, so that he could study it carefully late into the night (he was— as I was at the time—a night owl, working until sunrise and, whenever possible, sleeping late into the next day).

When I first met these individuals, I could not decide which I preferred to be more like, for although I realized that the pleasures of life were worthwhile pursuing, playing chess, which I tried to do in earnest for several years, made me realize that you could probably achieve even greater pleasures with your mind. Of course, there was no need to select one approach over the other, since I was always free to draw from both, or, preferably, experience both to their fullest. At some point, I realized that these two individuals were offering me life choices that were both part of the same thing: the first pertained to the physical elements of this world, the second to the allure of the mind, both relating to my sense of self-worth. Neither presented a choice that considered my feelings or those of others—essentially, a function of the heart—until I met the California potter Beatrice Wood, who affected my life more than any other single individual I have ever known. Unfortunately, when I tried to tell the two art historians about her, they had no interest, and whenever her name came up in conversation, they displayed little or no interest in her life or in her work. It's easy to understand why.

When I met Beatrice in 1976, I was twenty-eight years old, she was eighty-four. The two art historians were then in their fifties and sixties, and they could not imagine what I could be getting out of a friendship with an octogenarian whose artistic production they categorically dismissed. I, however, saw in her something they would never have recognized: an unfailing generosity of spirit and a profound honesty—the latter of which was a quality Beatrice knew she possessed but continuously struggled to sustain.

* * *

Before properly introducing the three people who were such great influences in my life, it is necessary to provide a little background about myself, so as to explain what it was that led me to pursue a career in the arts. I was born in Albany, New York, the state capital, on April 25, 1948. If what I have been told is true, I first saw the light of this world five minutes after my identical twin brother. Having twins was a rare occurrence in those days (due to in vitro fertilization, it no longer is), but there was yet another exceptional factor: we were born to a nineteen-year-old mother who was unprepared to have children and, as we would later learn, never really wanted any. We were cared for temporarily by our mother's sister, our biological aunt, but when she applied to adopt us, she was informed that it would not be possible, for other than under extreme circumstances, a person cannot legally adopt a sibling's child (since that could create a situation that would result in too many potential problems of custody). From what I later learned, we were shuttled back and forth between our biological aunt's home and an orphanage run by Catholic Charities in Albany until, just before our first birthday, we were adopted by Rose and Otto Naumann, a childless couple who lived in Little Falls, New York, a quaint industrial town

in the Mohawk Valley located approximately ninety miles west of Albany. I was given the name Francis, after St. Francis of Assisi, and my brother was called Otto, after our father. We had a wonderful and loving upbringing. My father was born in Germany but left years before Hitler rose to power (indeed, he had served in the United States Air Force during World War II, repairing airplanes in New Jersey). My mother was born in Italy but left there at the age of two. They were both factory workers. My father was a machinist, but after losing his job due to downsizing at Cherry-Burrell, a factory in Little Falls that specialized in the manufacture of pumps, he took various odd jobs until ending up working the night shift at a company that built cranes in Rome, New York. My mother was a garment worker employed by the local dress factory, where they worked by the piece, paid only for the work they performed, so, as she often told us, it was intense and grueling labor (especially during the hot summer months, for as I vividly recall, the factory was not air-conditioned).

Today we would have been classified as poor. Thankfully, my brother and I were unaware of it at the time, for my parents always seemed to have enough money to buy groceries and pay the bills. We never went out for dinner, but there really wasn't any place to go in our little town, and we took summer vacations by driving to various theme parks in upstate New York. We lived on a small street in a two-story clapboard house, but the upper floor was rented to our aunt and uncle, an elderly couple (as least they seemed that way to us all of our lives) who had an older son, but by the time we arrived he had already left home for a career in the Army. Because my mother and aunt spoke Italian at home, my brother and I heard and understood the language, but when we entered school, we refused to speak it anymore, wanting, naturally, to be just like everyone else. We were not told by our parents that we were adopted. I learned about it for the first time at

the age of about ten or twelve. One day when I was outside playing with my next-door neighbor Sharon, she told me, but I didn't believe her. When I confronted my mother, she said, "But we always told you that you were adopted." Of course, she hadn't, but the news was not devastating, as I learned it can often be for other adopted children. Rather, I loved it. In a small town like Little Falls with a population of fewer than five thousand people, virtually everyone seemed to know who we were, probably because we were among the few twins in town. Being adopted only made me feel that much more special. I have often thought about why the news was so welcomed and why, at the time I never cared to find my biological parents (as many other adopted children do). It may have been because I had an identical twin brother, and if I were to seek and find my biological father or mother, they would be only half as related to me as he was, so it made no sense. Besides, I was happy with the family I already had.

When we were in grade school, both my brother and I enjoyed drawing, especially when we received even the slightest degree of praise for our efforts. Our mother was a Sunday painter (literally), and when we were young, we assumed she was quite good. It was only later that we realized she was completely untrained, and her paintings look it. Nevertheless, at the time we did not yet know we were adopted, so we assumed we had inherited her "talent" and, by middle school, assumed the role of class artists. My brother even took lessons from a local painter who specialized in landscapes. We were brought up Catholic and went to the local Catholic school, St. Mary's Academy. There were only forty-five students in our class, and even though the nuns taught art, they did so by assigning projects that mostly involved copying images from books. There was no art history, per se, except for postcards that were circulated once a year that reproduced images by famous artists. When we

got to high school, it seemed logical for us to apply to college for a degree in the fine arts. I took myself more seriously than my brother and applied to Pratt, then considered one of the best art schools in America. I submitted a portfolio of pencil drawings, most of which, I later realized, were probably too traditional for them to even consider (I recall a portrait of Abraham Lincoln that I copied from a photograph, and a self-portrait). Even though everyone else in my school knew where they were going upon graduation, by the middle of the summer I had still not been officially informed by the admissions office at Pratt, but assumed that the portfolio I submitted was so good that it would only be a matter of time before they accepted me. It was devastating to learn in August—when all of my classmates were packing their bags and heading off to their respective colleges—that my application had been declined. All, however, was not lost. A guidance counselor in the local public high school arranged for me to enter into the freshman class at the State University of New York at Fredonia, a small liberal arts college south of Buffalo, about four hours from our home by car. SUNY Fredonia had been an all-girls school and, luckily for me, was then actively soliciting male students.

I was automatically accepted, and immediately enrolled in art classes during my first semester. One was a sculpture course taught by an outspoken and very critical professor, who didn't seem to like any form of art and didn't even think the discipline could be taught. I can't say that I disagreed with him, but it did make me wonder why I was going to college in the first place. The art history class that I enrolled in was even worse, for it was taught in a 200-seat auditorium at 8:00 a.m. As soon as the lights were dimmed, most of us went right back to sleep. I either skipped that class or dozed through it. My attitude toward college would change dramatically, however, when I was called by the Department

of Financial Aid and asked to come in for a meeting. They
wanted to know how I expected to pay for my education,
and I told them that naturally my parents would be covering
the cost. They told me that they had just ended a telephone
conversation with my mother, who said that she and my father
were unable to pay anything. Nevertheless, the financial aid
officer immediately informed me that I should easily be
able to finance my education myself, through employment
in their work-study program and through government and
bank loans. It was not until that moment that I realized I
came from a somewhat poor family, for although my father
and mother had provided for us at home, they were not in
a position to pay additional expenses. (It was only later that
I learned they had tried to pay for my brother's education,
but he went to Siena College outside of Albany, a private
university with a hefty tuition, so they only managed to pay
the first year.) When I became aware that I was paying for
everything myself, I never skipped a class again and started
to pay attention to everything my teachers were saying, even
in the art history class that met at 8:00 a.m.

Being alert and attentive, however, did little to change my
attitude about art history. I continued to believe that it was
unnecessary for the practice of making art, which, after all,
was supposed to concern itself with the present (or possibly
the future), but the way I reasoned at the time, not the past. I
found a copy of a test the professor gave every year, and even
with this cheat, I still only managed to get a C in the course.
Art history was clearly not for me, at least not yet.

The same attitude would encumber my efforts when I
transferred to the State University of New York at Buffalo
for my sophomore year, for even though the teachers were
better, I still only took art history because it was a required
component of the studio art curriculum. I took a course
in 19th-century European painting, which I actually found

quite interesting, because the professor—a young woman whose name I no longer recall—made the subject engaging. In one class, she said that the figures in Constable's paintings were "insignificant" when compared to the landscape that surrounded them. Since we were all required to write a paper on the subject of our choice, I wrote about how these figures were absolutely essential to Constable's vision, for without them, you would be missing the scale necessary to comprehend the grandeur of nature. She liked the fact that I had challenged a statement she made in class and, to my surprise, gave me an A. It was the first time I realized that an idea—even if it contradicted the thoughts of your teacher—could be valid, but I was still not convinced that the study of art history was worthwhile. In my junior year, I took a course in 20th-century art, taught by Jerome Rothlein, who had studied at the Institute of Fine Arts in New York, a graduate school that is considered to this day to be the finest art history program in the country. He was an exceptionally flamboyant individual who, more or less, showed slides, properly identified the names and dates of each work of art, but offered little more. Still, he was approachable and seemed to genuinely love the subject he was teaching.

Far more influential for me in college was a course I took in philosophy, and another in science. The philosophy professor was a young and arrogant individual, who drove to and from class in a sports car, which he parked in a conspicuous place right in front of the building where the classes met, so as to make sure his students saw him get in and out. From what I could tell, he wanted us to believe that his life was perfect. I admittedly admired his lifestyle, but no more than I could accept the value of art history, I could not fully comprehend why the study of ideas had any relevance. The final paper for the course was for all of us to write on Plato's famous allegory of the cave. I remember reading the

text carefully, but decided that there was a flaw in Plato's reasoning, and chose to write about that (since I did not believe people could be fooled into believing a false reality, even if they had not experienced actual life itself). When the professor handed our papers back, he announced each student's name and grade, and we went up to the podium in turn to retrieve our papers. He had distributed all of them except one—mine—which terrified me, for I thought he was going to announce how exceptionally stupid one of the papers was because it challenged an idea established in ancient philosophy. He announced instead, however, that only one paper went beyond what he expected, whereupon he took the liberty of reading mine aloud. I was flabbergasted. The nuns in St. Mary's Academy had convinced me that I was a B-/C+ student, and now I was being singled out as having written the best paper in the class. What was this all about? Although I was flattered at the adulation, I reasoned that it was just a fluke, caused more because I misunderstood the assignment than by any intrinsic quality the paper itself might have possessed.

The science class was completely different, but an equally rewarding experience. It was taught by a professor who had won many awards for his ingenious methods of teaching. I will never forget the first class, which met in the school laboratory. He asked us to gather into groups of five and passed out plastic bags containing several glass lenses of varying thicknesses, a single match, a candle, calipers, and a ruler. He told us that these were the only instruments necessary to find a formula for the focal point of a lens, and we had an hour to figure it out. It was a great exercise, for by the end of class, we had all done it. Although it may not seem like much now, it was this exercise that made me realize that you needed to utilize everything at your disposal if your quest was to get the right answer to a question. My final project

for the class was to test how color affected depth perception. For this, I constructed an elaborate box with parallel sliding dowels painted different colors. I asked my friends if they would participate in my test, carefully recording the results, but only determined that they varied so much that no real pattern could be discerned. My teacher gave me an A for effort, which taught me another lesson: if you work hard enough, you can be rewarded for that alone.

In my junior year, I decided to apply to the foreign study program in Italy, for I took a course in the Italian language and realized that although I could understand much of what was said, the ability to speak had seemingly escaped me. I had always wanted to go to Italy, because I had fond memories of the many wonderful stories that my aunt told me of her childhood there, especially herding sheep from Vagli Sopra, a small town in the mountains where she lived north of Lucca, to Pisa every fall, and going back to retrieve them the following spring. She told me that while walking the sheep she could see the Leaning Tower of Pisa in the distance, and I was anxious to see that, too. The SUNY program took place in Siena, a perfectly preserved medieval hill-town in the center of Tuscany. It was designed for art students, who were to be enrolled in the local art schools, where they would be taught painting and pottery and take an obligatory course in Italian Renaissance art. About twenty students enrolled in the program, and we were told that when we arrived in Italy, we would each be assigned a family to live with during the four months of our stay. We flew out of New York and landed in Paris, where one of the first things I did was to take a photograph of a toilet with a pull-chain, something I had never seen before (it was nothing compared to toilets I would later encounter in other parts of Europe that were nothing more than holes in the ground). With jet lag, we all slept on the bus ride to Italy, and I awoke right beneath the great

dome of Florence Cathedral, a sight that visually over-whelmed me. We took a quick tour around the city and arrived in Siena at nightfall, where I was greeted at the bus by the father in the family that was assigned to me. His name was Ilio Paolozzi.

Mr. Paolozzi had a pitted face, wore a broad-brimmed hat and a trench coat and, to me anyway, looked like a gangster. While we walked from the bus to his home, he gently held the back of my elbow. I did not understand this gesture at the time, but I would later learn that it was a custom in Siena among men who walked the streets during the *passeggiata* every evening. When we got to his home, I met his wife and son, who showed me to my room. That very first evening I got up on top of a chest of drawers to adjust a picture hanging on the wall and, not realizing that the surface of the chest was made of colored glass, crashed straight through the entire piece of furniture. I searched through my mind for the words to tell them that I was sorry, but simply could not come up with them. They seemed to understand, but it was not a particularly auspicious beginning. That would all change when I got to know Mr. Paolozzi better, for he was a wonderful man who enjoyed speaking with me every evening. As a result, my Italian improved rapidly, to the extent that I was fluent within a few weeks. I enjoyed the classes I was taking except for one: art history. The professor was an old Italian codger who thought that the history of the Italian Renaissance was nothing more than a series of names and dates presented in chronological order, which we were expected to memorize and spit back to him on tests. As expected, I did miserably, but on the various trips that we took throughout Italy—Venice, Rome, Florence—I saw a great deal of art that burned itself indelibly into my memory. After the program ended, I bought a motorcycle and decided to tour Europe, visiting all the major city centers

and the museums in them, not necessarily because I wanted to know anything more about art history, but because I really didn't know where else to go during the day. (I had the nights covered, for I would go to wherever young people congregated in the evening, hoping to meet young women, an activity for which I was regrettably ill-equipped and at which, as a result, I was woefully unsuccessful.)

When I returned to Buffalo to complete my last year of college, I began to worry about what would happen if I left school and could not find any form of gainful employment as an artist. I therefore switched my major from the applied arts to education, taking courses in how to teach art (which was a bit ridiculous, since I still believed that art could not be taught). All I can remember from the experience is that I was assigned to sit in on a third-grade class in a suburb of Buffalo, and the teacher would occasionally allow me to address the class. He once even permitted me to bring all of the children on a tour of the Albright Knox Art Gallery, which was located on Elmwood Avenue across the street from the university. That was a big mistake, because the children quickly discerned my inability to control them and went on a total rampage. Two of them decided to hang from a Noguchi sculpture, whereupon I can actually recall having told myself for the first (and probably last) time in my life that I needed a drink. When I was finally graduated, there were no teaching jobs available, so I decided to join my brother, who was in his last year at the State University of New York at New Paltz. There I took a one-person graduate class in painting from the chairman of the department. Having decided that painting was no longer a viable activity for me—nor anyone else, for that matter—I took all of the pigments that were left in my supplies and mixed them together, forming a putrid green that I proceeded to paint in a series of opaque stripes (alternating between glossy and matte) across ten large

canvases. It was 1970, the era of student riots and Vietnam was still upon us, and this rejection of convention made all the sense in the world, at least to me and my instructor, for he gave me an A.

There were still no jobs to be had, so I decided to take some time off and go to California, where my aunt and cousins lived, who graciously put me up (or more properly, put up with me) for nearly a year. I loved living in California, especially because there I was able to spend time with my cousin Albert. Although Al was only a few years older than my brother and me, we idolized him, but he had moved with his family to El Monte (an eastern suburb of Los Angeles) when we were still children. Through Al and his brother-in-law, Dan, I was able to secure several odd jobs in construction, but I quickly realized that such a back-breaking profession was not for me. One day I noticed an advertisement in the *Los Angeles Times* for a salesman in a gallery on La Cienega Boulevard. I went into the gallery and discovered that they represented European contemporary artists who painted in a retardataire Impressionist style that I loathed, very vulgar and commercial (the sort of painting you associated with cheap hotels). To my surprise, the gallery manager hired me, although, I'm afraid, he took a greater interest in me than in my ability to sell pictures. On the day I was scheduled to begin work, I never showed up. Instead, I applied to the M.F.A. program at the Art Institute of Chicago (AIC), submitting photographs of the green paintings that I had made upon my decision to stop painting, accompanied by a letter explaining the rationale for having made them. To my surprise, they not only admitted me into the Painting Department but awarded me a scholarship! I spent the next two years in Chicago trying to figure out a way to make art that was invisible, now prompted not by my experience as a painter but by the work of an artist whom I came to idolize

to a fault: Marcel Duchamp.

My first encounter with the work of this highly influential artist occurred in high school when I saw a reproduction of his *Bicycle Wheel* on the outer slipcase cover of *The World of Marcel Duchamp*, a book by Calvin Tomkins in a Time-Life series to which my mother had subscribed. At first, I assumed that it could not be art, but then suddenly concluded it was, a realization so shocking and unexpected that it has engrained itself in my psyche for life. As an undergraduate, another event occurred involving Duchamp that was equally momentous. For a brief period, he and I were actually in the same room together, although I was unaware of it at the time. In my first year at Buffalo State, I attended a performance of Merce Cunningham's *Walkaround Time*, but, unfortunately, left early. I had not realized that Duchamp was seated in the audience a few rows ahead of me. He was there because the set consisted of large plastic inflatables on which Jasper Johns had silkscreened details of Duchamp's *Large Glass*. When the performance ended, he got up on stage and made a curtain call, as I would only learn from a photograph published years later. My chance to meet this guiding light of my artistic life would never occur, for he died seven months later in Paris. I have come to think about the incident as two ships passing in the night, but in this case, more like a giant ocean liner that quietly and unknowingly just missed colliding with a small row boat. From that point onward, I have never left a performance or event of any kind before it ended, no matter how boring or insufferable.

Now here I was as a graduate student attempting to re-concile the ideas Duchamp's work contained with my own artistic practice. If the logic of the readymade is followed to its inevitable conclusion, there is really no reason to produce art, especially not painting, which, by then, had seemed to long outlive its purpose. But it was a contradictory position

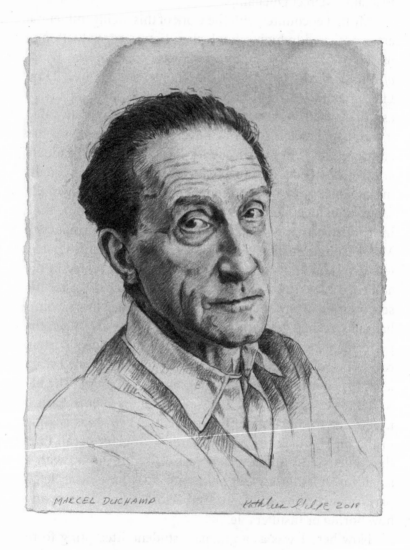

Kathleen Gilje
Marcel Duchamp, 2018
Colored pencil on stained paper, 13 ⅝ x 10 ⅝ inches

to be in, for I was, after all, a student in the Department of Painting, so I decided that my only option would be to make paintings that were invisible, that is to say, not visible as works of art unless their location was pointed out. That way they would exist and not exist at the same time. When my first critique was held, my teachers sat on four or five stools that I had arranged in the middle of a studio, and I explained that I had prepared for their consideration three works of art: I had applied rings of paint squeezed directly from the tube onto the underside of their seats (visible only when the location was disclosed); I outlined a proposal to erect a brick wall to be painted with the same white pigment as the rest of the room (hidden in plain sight); and I had traced a line in charcoal around the entire school (which was only understood as art when identified as such). Naturally, they thought I was crazy. I took this same line of reasoning to its extreme when a friend and I prepared a dinner for the four instructors on our committee who were responsible for signing off on our final critique. I prepared a statement that declared I was showing them nothing, stipulating that even the statement could not be considered a work of art, while my friend served them a dinner she had prepared, which she announced was her final project. They all accepted our reasoning and signed the papers necessary for our graduation.

During my second year of study at the Art Institute, I took an art history course with Whitney Halstead, a legendary teacher who was a great specialist in Outsider Art. Along with Ray Yoshida (who taught painting at the school), Halstead championed the work of the Hairy Who, a group of local figurative painters from the 1960s who derived much of their inspiration from Surrealism (which was then actively collected in Chicago). Halstead was a thin and gentle person who, to me, often looked sickly and resembled the male figure in Grant Wood's *American Gothic* (a painting

that is, coincidentally, in the collection of the Art Institute of Chicago). Though I had no experience whatsoever in art history—other than the few courses I had taken as an undergraduate (in which I had fared poorly)—Mr. Halstead offered me a job teaching the survey course for the spring semester, my last year at the AIC, saying only that he thought I would make a good teacher. I accepted and began preparing immediately, purchasing a copy-stand so that I could prepare slides taken from art history books, which I read cover to cover, this time taking detailed notes for my future classes. To my surprise, I enjoyed teaching, for I approached every subject thematically, informing my students at the beginning of each class what it would be about, and trying within the allotted time period to present everything I had prepared as concisely and clearly as possible. The only problem was that I felt I required a complete knowledge of every subject covered—especially the most recent information available— so I spent a great deal of time in the Ryerson Library of the museum reading everything I could get my hands on. I started with Cave Art, immersed myself in the literature, and probably ended up knowing more about Stonehenge than anyone wanted to hear. I did the same for Egyptian and Greek art, but it slowed down the process so much that when the course ended, I had only made it through to the Italian Renaissance, when I was supposed to have concluded with modern (that same deficit continued throughout my teaching career).

For my final thesis at the Art Institute, I arranged for two nude models to play chess with one another on a board of my own design, using chess pieces that consisted of nothing more than rectangular aluminum blocks on which were stenciled the names of the individual pieces. For those familiar with Duchamp's work, the image that came to mind was the memorable photograph of the artist playing chess

with a nude model during his retrospective exhibition at the Pasadena Museum of Art in 1963. But even those who recognized this historical precedent thought that I was contributing little to the prevalent artistic concerns of the day. I can still clearly recall my graduate advisor saying that he thought it was strange that such an intelligent young man couldn't make better art. He was entirely correct. Everything I made was derivative, more an attempt to pay homage to Marcel Duchamp than to create an original work of art. At one point, I realized that the explanations I was providing for my work were more interesting than the work itself, so there was only one direction to pursue. Art history was calling me.

While teaching that first course in Chicago, I learned that my brother had switched from studying art to studying art history, and that he planned on attending Columbia University for graduate work. I decided to stop making art myself and applied to study art history at the Graduate Center of the City University of New York, then reputed to have the best program in the country for the study of modern art. I was convinced that I would have no problem getting in, but just as I was rejected from Pratt while in high school, I was shocked to be informed that CUNY rejected my application as well. Undeterred, I still left Chicago and moved to New York, believing I would find some other way to get into their program, for I had already learned that the back door was as honorable as the front, just so long as you got in.

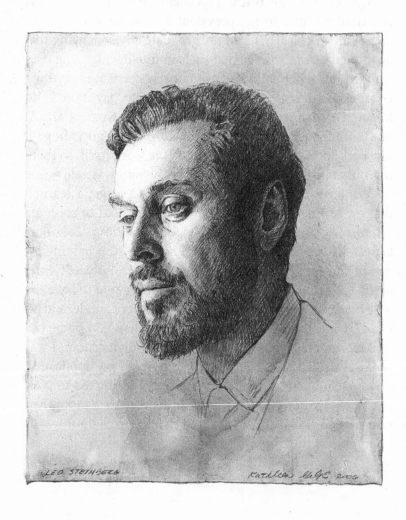

Kathleen Gilje
Leo Steinberg, 2006
Colored pencil on stained paper, 13 x 10 ½ inches

LEO STEINBERG

I heard the name Leo Steinberg for the first time during my last semester at the School of the Art Institute of Chicago. The friend with whom I shared my final critique worked in the museum bookstore and gave me copies of whatever books I expressed an interest in having (I suspect that they were pilfered from the stock room, but never asked). For some reason, I wanted Steinberg's *Other Criteria: Confrontations with Twentieth-Century Art*, which came out in 1972, not necessarily because I knew anything about the author, but because I knew he was an important and influential writer and felt that I should have a copy of his book in my growing library. I cannot recall having read the book while living in Chicago, but in 1973, shortly after moving to New York, I read it, for by then I had learned that Steinberg taught at the Graduate Center of the City University of New York (CUNY), where I wanted to study. *Other Criteria* consisted largely of previously published articles, but the one that grabbed my attention most was his essay on Jasper Johns, an artist whom I had admired but not really understood (except in a superficial way, as the artist who had broken out of Abstract Expressionism and made flags, targets and maps, object-paintings that were considered precursors to Pop). Steinberg approached Johns's imagery as an inquiry, asking the sort of questions that we might all ask, but no one bothers to answer (like "What does it mean?"). He responded to these questions in a clear and non-dogmatic fashion, inviting readers along on a journey through his mind, which was, if the writing was

any indication, exceptionally sharp and brilliant. It reminded me of my science professor as an undergraduate, who gave you the tools necessary to solve a given problem but who let you solve it for yourself. Steinberg was doing precisely that, but as readers, we were there to watch him do it, conveying the experience by means of a seemingly effortless prose, where every sentence presented a revelation. I could not wait to study with this man.

Shortly after moving to New York, I called the Art History Department at the Graduate Center and asked to speak with someone who could explain why I was rejected from their Ph.D. program. I was given an appointment with Professor Milton W. Brown, chairman of the department, who was surprisingly understanding of my predicament, for as I would later learn, he was an artist himself before switching to art history. He told me that an M.F.A. degree did not qualify for entrance into a Ph.D. program in art history, and although I had received enthusiastic recommendations in support of my application, he did not know any of the people who recommended me. I had mistakenly assumed that Whitney Halstead, who had written a letter on my behalf, was "famous," but Brown said he had never heard of him. It was at that point that I realized what it took to be known in the world of art history. You could be a great teacher, but you only achieved recognition in your field when you published books or articles that appeared in well-known and respected art journals. Even though Mr. Halstead had written a few articles—mostly on the enduring influence of Surrealism among artists in Chicago—he was completely unknown outside the city. Brown suggested that if I still wanted to go to the Graduate Center, I take a course at one of the branches of CUNY, so that at least one of the professors could get to know me and perhaps recommend my application. I can't remember exactly who suggested it (it might have been

Professor Brown), but at some point I enrolled in a course
taught by Professor Steinberg at Hunter College.

The course was on Leonardo da Vinci, not exactly
the subject I had come to New York to study, but a great
Renaissance artist whom I had admired from childhood.
Besides, I was fluent in Italian and, because I had studied
in Siena, developed a considerable knowledge of Sienese
painting of the 13th and 14th centuries (Duccio di Buoninsegna,
Simone Martini, the Lorenzetti brothers, etc.), which, I
felt, was an appropriate introduction to this course. To my
surprise, I was the only student in Professor Steinberg's
class who spoke Italian, and I think it was that ability that
first drew me to his attention. Although he could read the
language, he was unable to speak it as well as I could. Since
the course involved a detailed examination of Leonardo's *Last
Supper*, which Steinberg had spent years studying, he began
the first class by showing various depictions of the subject in
Italian art, beginning with Duccio and demonstrating how it
had changed over time to Giotto. During his presentation,
he had made a minor mistake (confusing Pietro Lorenzetti
with his brother Ambrogio), so at the end of class, I went
up to him and discreetly pointed out the error. He was most
appreciative, and because I had pronounced the Italian
names without an accent, he asked how well I spoke the
language. When I responded fluently, he acted impressed,
but said nothing more. A few days later he called me. I can
no longer recall the reason, but I do remember him saying
that if I wanted to make a contribution to the literature, I
would have to make certain that the facts I relied upon were
indisputable. What struck me most in our conversation was
his use of the word "contribution," for until then, it had not
even occurred to me that I would ever be in a position to
make a contribution to any subject in art history, least of all
to the vast and endless literature on Leonardo. That would

all change as the course progressed, and I was once again presented with an opportunity to attract Professor Steinberg's attention, this time not for my ability to speak Italian, but for an observation I made about Leonardo's *Last Supper*, a detail pertaining to its perspective that he had not previously noticed.

At the end of class one week, Professor Steinberg discussed a detail in Leonardo's *Last Supper* that he told us had baffled copyists and scholars for centuries: the vertical bands that flank the painting at the edge on each side. He drew on the blackboard a diagram that he said came to him while on a plane ride and he sketched onto a napkin (he had a great natural facility as a draftsman). He explained that those bands could be read as three things simultaneously: a recessional element of the side walls on the near side of the foremost tapestries; a decorative border that echoed the moldings surrounding the three lunettes above; and, at the top and bottom, a mitered framing element for the rectangular composition of the picture. I raised my hand and blurted out "There's a fourth possibility." Somewhat amazed that anyone could think these bands had yet another function, Steinberg asked me to elaborate. I tried to explain, but said that I could do so more convincingly if he let me have the chalk, so I went up to the blackboard to demonstrate. To my way of seeing, these vertical bands represented the left and right recessional elements of piers that supported the architrave above, but their faces or fore portions were invisible to viewers, buried within the wall of the chamber at the flanking edges of the painting. Steinberg was visibly stunned. He had not thought of this, but immediately recognized that it was a distinct possibility, especially since my reading of the perspective finally allowed additional space for the thirteen figures to dine in peace (which had earlier been thought by scholars to have been a spatial mistake on Leonardo's part). When I started to

discuss the lower part of the picture, Steinberg pointed out that it was too badly damaged to determine what Leonardo had done there, whereupon I said, "But he must have done something." Years later, Steinberg would characterize this exchange as the best he had experienced with a student in his entire teaching career.

When Steinberg published his essay on the *Last Supper* as a complete issue of *The Art Quarterly*, he revised his description of the perspective and included a footnote to me. From that moment onward, I was determined to work out the full perspective of the painting and publish my findings, crediting Steinberg for having directed my attention to this detail in a footnote of my own. I did precisely that, but it took six years and countless hours of research in a labor-intensive effort to reconstruct the perspective schema of the painting, since I insisted upon using the same method of construction that Leonardo had: the *costruzione legittima*. Especially time-consuming was drawing, inking and taping the many diagrams I needed to explain my discoveries (this all before the age of computers and Photoshop), but I must confess that this was probably the most enjoyable part of the entire process, for it brought me back to making art, albeit not the type that would make me the famous artist I had aspired to be in art school. When the essay was finished, I sent a copy to Professor Steinberg, who told me that he thought it was a brilliant analysis of the perspective, but a bit longer than most magazines would consider publishing (with various appendices, it added up to about 120 double-spaced, typewritten pages). He recommended that I have his assistant, Sheila Schwartz, help me through the editorial process, which she graciously did. In two unpaid sessions that took two full days, Sheila very generously took the time to teach me more about writing than anyone ever had, helping me not only with grammatical problems but, more

importantly, with syntax. "No sentence should be written," she cautioned, "without the reader fully understanding why they were meant to read it."

I submitted the essay, cut to about half its original length, to *The Art Bulletin*, the most highly respected professional journal in the field of art history. To my delight, it was accepted for publication by the editor-in-chief, Kathleen Weil-Garris, only to be rejected a few months later without explanation. When I sought one, she was not forthcoming, saying only that she no longer thought it was appropriate for their journal. When I complained about this situation to Professor Steinberg, he told me that she had called him to ask what sort of a person I was. Steinberg claims to have given me a glowing recommendation, but did tell her that he thought I was "driven." Apparently, that was enough to scare her off, so I was forced to seek publication elsewhere. Eventually, the article found its place in the pages of *Arte Lombarda*, a scholarly Italian art journal that is not widely circulated in America. If nothing else, I reasoned, at least it would be published in Milan, the city where Leonardo lived and the *Last Supper* resides. When printed, the article ended up being twenty-six pages in length, but when the publication arrived, I was appalled to discover that the printers had dropped a line of text and, worse yet, failed to reproduce one of the diagrams in its entirely, inadvertently eliminating a letter of reference and thereby making my description and discussion of the painting's "accelerated perspective" impossible to comprehend. I immediately wrote to the editors demanding that they publish an erratum in their next issue, but they replied that such things were never done in their journal, and they refused. I would later learn that whenever Professor Steinberg submitted an article for publication, he would have the publishers sign a contract beforehand stipulating that any change made to his writing—however insignificant

(for example, a misplaced comma)—would result in their having to pay a penalty of $1,000 for each error. I would later come up with an even more effective method, by publishing my own writings and thereby placing myself in a position of being able to take full responsibility for any mistakes—factual or clerical—that the finished product might contain.

Despite my disappointment with these errors, after six years of arduous effort, I thought the appearance of this article was worth celebrating, so when offprints arrived, I immediately invited Professor Steinberg and Sheila Schwartz to a dinner at my small apartment, a four-story walk-up on the Upper West Side of Manhattan. I also invited my brother Otto, who was then taking courses at Yale University for the completion of his Ph.D. in 17th-century Dutch art, and a girlfriend of mine at the time. As luck would have it, Easter was soon approaching, so I arranged for the dinner to take place, appropriately, on Holy Thursday evening (Last Supper night). I prepared a lasagna dinner (all I was capable of cooking at the time), and asked my guests to sit on the same side of a long table that I set up in the middle of my living room, mimicking the position of the apostles in Leonardo's painting. I inscribed Professor Steinberg's copy of the offprint as follows: "The next time you ask your students such an interesting question, please be aware of the fact that you may be setting one (or more) of them up with a five (or more!) year obsession. / Thank you for asking it." A few days after the dinner, Sheila Schwartz called to thank me for having invited her, but she pointed out that in my acknowledgments, where I stated that the article could not have been published without her editorial help, I accidentally misspelled her name (as "Schwarz" instead of Schwartz). She dismissed the error, but since she had taught me everything I knew about writing, I was embarrassed and humiliated. Apologize though I did, I have never found a way to properly

make it up to her.

While still enrolled in the Leonardo course, I received word that I was accepted into the Ph.D. program of the City University, without having had to apply again. Clearly this was the result of Steinberg's intervention, but I never asked and the subject never came up. I immediately enrolled in a course that Steinberg taught at the Graduate Center on Cubism, which began with a probing analysis of Picasso's 1907 *Self Portrait* (National Gallery, Prague). Nearly the entire first lecture was focused on a straight black line that went from Picasso's right ear to the fold at the side of his upper lip, marking the planar dimension of his right cheek and, at the same time, reflecting the position of a contour line that described the opposite side of his face. Until then, I was under the impression that only artists like Leonardo and Duchamp could infuse a work of art with the degree of intellectual rigor that I thought was necessary to make great art. Steinberg taught me that artists express their ideas visually, and if they were profound thinkers like Picasso, those ideas were often buried deeply within the work of art and it was our job to simply uncover exactly what the artist intended to convey. Even though I was a matriculated student in the modern art program, at the time when this class was given, I had still not made up my mind if I would pursue a career in modern or Renaissance studies. I was still working on the Leonardo project, and I learned that Steinberg's next class at Hunter College would be on Michelangelo. It was 1975, which marked the 500th anniversary of the artist's birth, so I was unable to resist.

Like all of Steinberg's classes, each lecture was fascinating, driven almost entirely by his endless quest to find meaning in the artist's work, usually in places where no one had ever thought to look before or, if they did, arrived at what he felt were mistaken conclusions. In Michelangelo's case, he seized

upon an innocent notation the artist had made on the back of an envelope listing various food items, a menu that was accompanied by thumbnail sketches, probably to help an illiterate housekeeper. Steinberg noticed that the sketches grew gradually in size until they occupied nearly the entire sheet, a tendency he related to Michelangelo's lifelong penchant for expanding projects until they attained proportions that made them physically impossible to realize. Like any good lawyer, throughout the class Steinberg continued to ask questions for which he knew the answers, but at the very end, he asked all of us to go home and prepare a paper on the same subject: "Eve's Idle Hand." At the time when he asked us to do this, the *Temptation* scene from the Sistine Chapel ceiling was projected on the screen, so, if nothing else, we all knew where to look. I began the assignment by going to the Frick Art Reference Library and examining detailed photographs of the fresco, where I noticed that Eve's right hand had an upraised central digit, mimicking a common vulgar gesture known to everyone today, but I had no idea if it carried the same meaning in 15th-century Italy. I noticed that the finger was pointing directly to her sex, while her other hand (Steinberg had warned us that Michelangelo's figures were all ambidextrous) carried in its palm a cylindrically shaped fig leaf, to which were attached below a pair of unripened figs, which, to my mind, resembled a scrotum. I also noticed that the same digit served another function in pointing to two other depictions of Eve on the ceiling where she was still without sin, that is, before eating from the Tree of Forbidden Fruit and being cast out of the garden (a portion of my essay was called "The Three Faces of Eve"). Steinberg published my paper and fourteen others in an issue of *The Art Journal*, making it then my first publication in a traditional art history magazine (my article on the *Last Supper* would not appear for a number of years).

When each class ended, Steinberg would invite a select group of students to join him for dinner at a nearby restaurant (he was a bachelor and would otherwise eat alone). I was thrilled to be asked along, for every minute spent in his company was exhilarating. No matter what he talked about, every subject struck me as profound, and I was thoroughly mesmerized. You had to be on your toes when conversing with him, since he would habitually correct your grammar, resulting, at times, in some embarrassment for the student. I once wrote him a letter from Italy that he returned with spelling corrections in red pen, which he said he would not normally do for anyone else, but he considered me a special student who deserved the extra attention. I was not insulted, as one might assume, but actually considered his motive a compliment and, from that moment onward, never wrote to him again without making sure that every word was spelled correctly. For some reason, Steinberg considered me an exceptionally intelligent person. I'm not exactly sure why, but I think it was probably due to my observation about the *Last Supper*. Since he had been looking at Leonardo's painting for years and never noticed this detail about its perspective, he probably assumed that anyone who saw more than he did must be intelligent—not as intelligent as he was, to be sure, but at least someone who had potential. Anyone who met Professor Steinberg realized almost instantly that he had an exceptionally favorable sense of his own intellect, an ego that—because of his staggering brilliance—was entirely justified, or at least it seemed so to me.

No matter what Professor Steinberg might have thought of me, he was exactly the sort of teacher I wanted to be, especially since it was evident from the beginning that his intellect was attracting not only people like me, but also girls, and lots of them. They flocked to his side like groupies at a rock concert, and it seemed as though he could have his

pick of any. I never actually thought he would indulge in any of these temptations until I dated a young woman a few years later who confessed that she had been among his many intimate acquaintances. I was appalled, because I thought he was too old to be dating anyone so young, especially one of his students, a practice that was considered prohibitive in most universities. At the time, he was only in his mid-fifties, but I was half his age. I must have told the girl that I thought he was "a dirty old man," because a few weeks later he called and, without explanation, asked me how old I thought someone had to be to be considered a dirty old man. He pointed out that no one said that about men in their forties. Was it fifty, or maybe sixty? He really wanted to know. Of course, I had no answer, but I knew perfectly well why he was asking.

Irrespective of age, most people found Steinberg strikingly attractive. He spoke softly with a slight English accent (from the years when he lived in London), and his well-trimmed beard gave him the appearance of a Hollywood actor from the 1930s and '40s, *à la* Ronald Coleman or Vincent Price (who, coincidentally, had a degree in art history from Yale University). Although I did not know it at the time, Steinberg was then secretly seeing the wife of one of my best friends. She once told me that Steinberg was the best lover she ever had. When I asked what made her say that, she said: "He spent a great deal of time seducing me, and when we were together, he made sure I left satisfied." For me, that was an incredible revelation, something I have attempted to emulate in every relationship I have had from that time onward. Unfortunately, I never shared this information with Leo, for he probably would have been proud to learn that I gained that insight from him, more so than anything he might have taught me about becoming an art historian.

Once I mentioned to my friend's wife that I noticed Steinberg grab a handful of toothpicks from a restaurant as

he was leaving. This information got back to him (since I was unaware of the fact that he was seeing her at the time), and he called me, explaining that he was not taking these toothpicks because he was cheap, but because he could not get mint-flavored toothpicks anywhere else, so he had no choice but to "appropriate" them from the restaurant. It was a curious call, because it was clear that he did not want me to think he was cheap and he did not want me disseminating this information to anyone else, lest it affect his reputation, particularly among those who found him otherwise attractive, especially the women. As I would learn over the years, however, Steinberg was intrinsically parsimonious. He did not like spending money, especially on himself. His white shirts were always threadbare, and he seems to have worn the same blue blazer and gray pants for his entire career. His one continuous indulgence was smoking. In the years at Hunter College, it was a pipe, which lent him an elegant and sophisticated appearance. When he was told by a doctor that it caused white spots on the back of his throat that could turn cancerous, he switched to low-nicotine cigarettes, which he chain-smoked, working up to four and five packs a day. Indeed, smoking became so much a part of his identity that he resisted any attempt to stop, even after all the evidence had been disclosed on how dangerous it could be to your health. When smoking became prohibited on airplanes, for example, he would not even take a direct flight to Europe, for he needed to stop halfway to get out and have a cigarette. When it was no longer allowed in restaurants, he stopped going. Even when he delivered a lecture, he sometimes stopped in the middle for a smoke, and when that was not allowed, he would refuse to accept the invitation to speak. For years, he was the only person allowed to smoke in the lecture hall of the Metropolitan Museum, an indulgence they permitted because he was such a great lecturer.

Leo Steinberg gave the best lectures I have ever heard. From the moment he began, whatever he had to say was so engaging that you hung on every word. In almost every presentation, he began with an inquiry into works of art, whether it was a painting by Picasso or a sculpture by Michelangelo, a question that often addressed a situation that could be interpreted in one of two ways. He would then spend the rest of the lecture explaining how it was both simultaneously. He was so good that I once came up with the idea of an art-historical face-off, where two art historians renowned for their lecturing abilities opposed one another onstage, but in order to test their skills, each would have to speak following slides that the other lecturer selected, without having seen them beforehand. Steinberg accepted the challenge, but, unfortunately, I was unable to find a single art historian willing to oppose him. I once arranged for him to speak at a newly opened museum in Vero Beach, Florida, directed by a friend of mine. Steinberg was handsomely paid and accepted the invitation. When it came time for me to introduce him, I told the audience that I thought he was a genius, explaining that he thought more profoundly about a given subject than any other art historian known to me. Unfortunately, the lecture went badly, the worst I had ever heard him deliver. Because he was without the assistance of Sheila (his usual projectionist), the slides did not advance in accordance with his instructions, whereupon he got confused and conveyed his frustration publicly. At a reception that was held in his honor after the event, he took it all out on me, saying that one can never introduce someone as a genius, for no one short of Einstein could live up to such an exaggerated billing. He was right, of course, but as coincidence would have it, my remark drew the attention of a man who attended the lecture and who, at the reception, asked me to explain exactly what I meant by using the word "genius." He said that

he worked for the Asia Society and was on some sort of committee to identify geniuses in various professions. I told him that, to me, a genius was someone whose brain was not lazy, someone who pushed himself or herself to think deeper into a subject than the degree to which an average person was capable. A year or so later, Professor Steinberg was the first art historian to receive a MacArthur Prize, the so-called genius grant that came with a sizeable financial award. When I later told Professor Steinberg about my encounter with this gentleman after his lecture, he dismissed the possibility of my involvement altogether, saying that he was recommended by many other more highly qualified individuals, and my conversation with this anonymous man was likely inconsequential.

I never tired of Steinberg's approach to art history, and attempted to emulate it myself in my own writings and public lectures. Not everyone agreed. When his book on Michelangelo's Paolina frescos was published, for example, it was given a devastating review in *The New York Review of Books* by E. H. Gombrich, the noted English art historian whom everyone in the field admired, including Steinberg. I happened to be working for Professor Steinberg at the time, completing a series of diagrams to illustrate his book on the Borromini Chapel (the subject of his doctoral dissertation), and one afternoon, while walking to his apartment, I saw a copy of the newspaper and purchased it for him. I had not yet had a chance to read the review myself, but the moment I handed it to him, he went straight into his bedroom and did not emerge for two hours. When he did, he was visibly distraught. It was clear to me that we should not talk about it, so nothing was said for the rest of the afternoon. Basically, Gombrich accused Steinberg of over-interpretation. "He has produced a book to be reckoned with," wrote Gombrich, "but a dangerous model to follow." Rather than fight back,

which was his instinct in all other cases when his writing was challenged, Steinberg recoiled and, uncharacteristically, never said anything about the review, neither publicly or, to my knowledge, privately.

In all of the years that I knew Leo (by now I was addressing him by his first name), he was always open to what others had to say about a work of art, even if he disagreed. On one occasion, however, when he was preparing his book on the Paolina frescos, I suggested that in the *Crucifixion of Saint Peter*, a figure in the center of the painting reaching down into the hole where Peter's cross is to be placed is attempting to dislodge a rock. If that were so, then I reasoned that this action might represent an ingenious visual pun on the name Peter, which, as everyone would have known, is derived from the Greek word for rock, as in the pun spoken by Christ Himself, who designated Peter His earthly successor with the words "Thou art Peter and [upon] this rock I will build my church" (Matt. 16:18). Steinberg, however, flatly rejected the theory. He insisted that Michelangelo intended this figure to represent a devout pilgrim reaching down into the sacred place where Peter was thought to have been crucified, retrieving sand in the form of a sacred relic (as was a custom in those days). Since Steinberg had always pointed out that nothing in a great work of art is either black or white, but that a combination of the two could yield a more convincing analysis, I could not understand why he refused to consider both of these ideas as equally valid, functioning simultaneously to give the image an enhanced and more nuanced meaning.

In the early 1980s, Steinberg began gathering information for what could be considered his most controversial book, *The Sexuality of Christ in Renaissance Art and in Modern Oblivion*. Steinberg noticed that in many deeply religious examples of Renaissance art, the groin of Christ—either as

a child or after death—is given intentional emphasis, either
exposed for all viewers to see, or fondled in an openly explicit
way by the Virgin Mary or an attendant saint. For centuries,
this observation was never talked about, or, if seen at all, was
talked away, for the subject was not considered appropriate
within the context of Christian piety. It is, nevertheless,
there, hidden in plain sight in countless examples that
Steinberg cites and reproduces. He argues that the open
display of Christ's genitals was a means by which to reveal
the ultimate symbol of His humanity: God made man. As
might have been predicted, the book was greeted with a furor
by critics. Despite the preponderance of visual evidence,
some remained unconvinced, whereas others felt that the
observation was unnecessary, for there was no need for true
believers to be reminded of Christ's Incarnation. A number
of Steinberg's colleagues and personal friends felt that he
was projecting, that is, somehow compensating for his own
sexual inadequacies (he was only in his early sixties when
the book first appeared) by discussing the sexual prowess of
Christ, who—other than his obvious gender—is presumed to
be without sexual identity. Unlike the case with Gombrich's
review of his Leonardo book, Steinberg carefully gathered
all the reviews of his *Sexuality of Christ* and responded to
each in a new edition published thirteen years later. This
was Steinberg at his best, battling anyone who objected to
his way of thinking, in a clear and systematic fashion. He
would allow works of art to change his mind, but not other
critics. Indeed, when Jasper Johns later recalled his writings,
he was most struck by how Steinberg was willing to adjust his
point of view in accordance with what he was looking at. "I
was impressed with Leo Steinberg's comments on my work,"
Johns later remarked, for "it seemed to me that he tried
to deal directly with the work and not put his own map of
preconceptions over it. He saw the work as something new,

and then tried to change himself in relation to it, which is very hard to do."

I got to know Jasper Johns in the early 1990s. We met on several occasions before that time, but I had the opportunity to know him better when I was commissioned by the Gagosian Gallery to write a catalogue essay on his painting *According to What*. Robert Pincus-Witten, a former professor of mine at the Graduate Center and chairman of my dissertation committee, had withdrawn from academia to work for the gallery and had hired me to write on this painting because he felt it contained unmistakable allusions to Duchamp's *Tu m'* (more about my interaction with Pincus-Witten and this project follows in Chapter IX). I dedicated the essay to Leo Steinberg, "who," as I wrote, "taught me to look in order to see." As soon as the catalogue appeared, I rushed a copy over to Leo, but heard nothing. For quite some time, I thought he had missed the dedication, although I could not see how, since it appeared on the first page of text. His lack of acknowledgement left me mystified. I would eventually learn what caused it at a dinner party thrown a few weeks later at the home of Steve Mazoh, a private dealer who knew about my friendship with Steinberg and Johns. At the dinner, Johns sat to my left, Leo to my right, and the noted art historian and critic Barbara Rose directly across from me. I finally mustered the courage to ask Leo if he noticed my dedication, to which he responded flatly, "Yes," but offered nothing more. When I asked if something bothered him about it, he said, "The dedication didn't, but the text did." When I asked why, he said that I had failed to cite his writings on Johns in any significant way. He was right. I actually did neglect to cite his writings, but I was under the mistaken impression that he would realize that my entire article was in his debt, an approach and way of thinking that was derived directly from his example. It was at that point that I promised myself

never to get so invested in my own writings that I would feel neglected when they were not cited.

In all of the years that I knew Leo Steinberg, I wanted to find a way to get to know him better. We had dinners together on various occasions, sometimes with colleagues such as Jack Flam, another professor at the Graduate Center whom we both liked. Because I had a car, I would occasionally drive him to various places outside of the city where we had been invited. During the summer months, we were often asked to spend a weekend at the country home of Steve Mazoh in Rhinebeck, New York, about two hours north of the city. There we would read, relax and socialize, for Steve would often invite some pretty impressive guests, like Ellsworth Kelly and Jasper Johns. Once, when Leo and I were floating on inflatables in Steve's pool, I remarked that we were experiencing a sensation that must be close to what we feel at death, for only then are we released from a force in nature that we have no choice but to endure, and that is the continuous tug on our bodies by gravity. The only release we can experience is during sleep, which, I said, is probably why they refer to death as "the big sleep." I wondered if Michelangelo might have given any thought to this observation while painting the Sistine Chapel ceiling, for the figures appear to float in space; if so, then he might have been intentionally conjoining the concept of man's creation with the weightlessness experienced at death. For some reason, Leo thought this was a profound observation, and for the next two days kept coming back to it, wondering if Michelangelo might have experienced the sensation of weightlessness while swimming underwater with his friends in the crystal-clear waters of the Mediterranean.

Although I enjoyed these conversations with Leo, what I really wanted was to go to Europe with him, especially to Italy, where I could show off my Italian and he could show

me the various treasures he had discovered there over the years (he had a Touring Club Italiano guide that was filled with pencil notes in the margins and a list at the back of the book where he had methodically checked off every site he had seen). For one reason or another, we never coordinated our schedules, and because of his smoking, he eventually stopped going altogether (except with a couple in Chicago who were capable of tolerating this habit). We spoke frequently over the phone, at least once a month, and very openly about a variety of topics. Once he said that he and Sheila had discussed his lack of any meaningful friends, and she told him that if he wanted any, he had to work at it, making sure that he kept in periodic touch with anyone who meant something to him. Sheila must also have told him that he should make an effort to ask these people about themselves, to express some interest in what was going on in their lives; otherwise the friendship would be entirely one-sided and eventually terminate. For years, he would diligently call, even when there was nothing in particular to talk about. Although I would be a bit tense during these conversations (Leo would still correct you if you made any grammatical mistakes), I still enjoyed hearing from him. At one point, when we were discussing our respective sexual escapades, he made the comment, "But you are oversexed, aren't you?" I was shocked and appalled by the question. And I was quite distressed that he might have garnered this information from the one woman we had both known intimately, so I asked sharply: "What the hell does that mean?" He explained that he had heard I was capable of making love multiple times in one evening, to which I responded: "Doesn't everybody?" That ended the subject, and we went on to talk about other things.

When Leo turned seventy years old in 1990, I decided to give him a birthday gift that related to his study of *Les Demoiselles d'Avignon*, the great painting by Picasso in the

collection of the Museum of Modern Art in New York that marked the birth of Cubism. Shortly after *Other Criteria* appeared, Steinberg published an important, two-part article on the painting in *ARTnews* that was called "The Philosophical Brothel," so I thought that an appropriate gift would be to treat him to a prostitute, which, I imagined, could be rationalized as legitimate research. He had just had his prostate removed, and was curious to know if everything still functioned properly, so he accepted my offer with some enthusiasm. I made the arrangements through a woman on 57th Street who ran a discreet escort service in a rented apartment using only young women who were students from Queens College (or so she told me). I had been introduced to the woman by John Rewald, who made frequent use of the establishment. Leo and I met at Wolf's Delicatessen beforehand, where I had never seen him so nervous. He tried to drink a cup of coffee, but his hands were shaking so badly that he had to stop. I assured him that there was nothing to fear, that everyone was very nice and would be understanding of any situation. Eventually we went up to the apartment, where we were greeted by the madam of the house, a woman in her fifties, and three girls, all in their early twenties. Leo was to select from among the three girls, but he was attracted to the older woman and asked if she would consider indulging him instead. She refused, and eventually Leo picked one of the girls and went off to a bedroom. He was in there for nearly an hour, while the remaining two girls tried to convince me to engage their services. I was then living with my girlfriend, Marie T. Keller (called Terry by her close friends), who eventually became my wife, so I refused, and all I can remember is that they said they only wished their boyfriends were as thoughtful and considerate as I was (it was easier for me than they imagined, since I was then very much in love). When Leo finally emerged, he

immediately informed us that everything went well, but he turned to the madam and formally asked her out on a date. She refused again. Later he told me that he called her several times, but she continued to refuse him, for she insisted that she ran a professional establishment, and dating one of her clients would be blatantly unethical. Go figure.

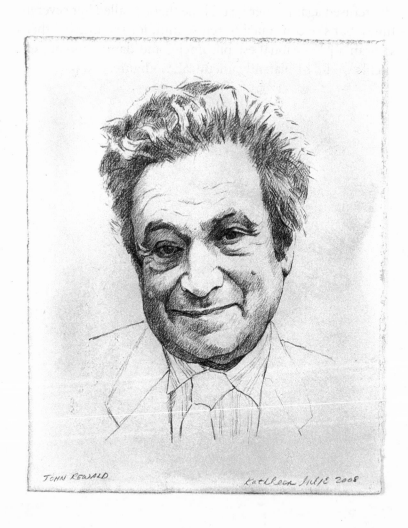

Kathleen Gilje
John Rewald, 2008
Colored pencil on stained paper, 12 x 9 ¾ inches

～ III. ～

JOHN REWALD

In 1976, Paul Rewald—son of the renowned art historian of Impressionism who had been one of my professors at the Graduate Center of the City University—died unexpectedly of stomach cancer at the age of thirty-two. I met Paul only once, when, as a student in Professor Rewald's class on catalogues raisonnés (inventories of an artist's complete production), he brought us all over to Sotheby's Parke Bernet, where his son, Paul, was employed. We went to see a drawing by Paul Cézanne that Professor Rewald was advising the collector Paul Mellon to purchase, a magnificent *Self-Portrait* in pencil from around 1880 where the artist stares sternly at the viewer with the coldness and solidity of apples on a plate. Rewald was the world's expert on Cézanne and was then in the process of compiling information for the publication of a catalogue raisonné of his paintings, a complete revision and update of one that had been published in 1936 and written by the Italian art historian Lionello Venturi. Rewald came to so thoroughly admire the art of Cézanne that he proudly named his only son—Paul—after him. Some of my fellow students regarded entering Sotheby's a betrayal of our commitment to academia, for it was a purely commercial establishment, but I disagreed. Here you had the opportunity to physically examine works of art, an unforgettable experience for the average art history student who was conditioned to seeing art only in the form of slides or color reproductions.

Paul Rewald worked in the Impressionist and Modern Paintings Department at Sotheby's, and when we arrived, he

was formally introduced to us by his father, who, one would assume, must have been proud to present his son working in such an illustrious and respected firm. Paul Rewald was young and strikingly handsome, tall and thin with soft features, deep brown eyes and, like his father, a head of thick, wavy jet-black hair. He wore an elegant gray suit and, only in his early thirties, displayed a confidence and professionalism that warranted respect, that is, from everyone except his father. In the presence of his students, Professor Rewald treated his son somewhat condescendingly, but we all thought little of it at the time, dismissing the behavior as, for whatever reason, typical of the rapport that often exists between a father and son. I assumed—and probably most of the rest of us did, too—that Paul Rewald had this important job at Sotheby's because of his father, for Professor Rewald was then considered not only the foremost scholar of Impressionism, but also a connoisseur in the old European tradition. Beyond knowing how a given work of art could be contextualized historically, he possessed an ability to determine whether a work was genuine or fake, a skill ignored or shunned by the average American art historian but widely practiced in Europe and, of course, a very valuable asset in any auction house.

When Professor Rewald's son died, I heard that a memorial service would be held for him at Campbell's Funeral Home on Madison Avenue and 81st Street, so I decided to attend in order to convey my respects. I met a fellow student there, Doreen Bolger, and upon the conclusion of the service, we stood in line to greet Paul's relatives at the door. I can remember shaking hands with Fran Weitzenhoffer, another student at the Graduate Center who worked closely with Professor Rewald, then with his first wife (the mother of Paul), with Sabine Rewald (Paul's widow) and, finally, with Professor Rewald himself. Until that moment, he seemed perfectly composed, but when we shook hands he broke

down and began sobbing uncontrollably. I did not know what to do, except I was immediately relieved when Fran rushed to his side to console him (it was then that I realized she was more than just his student). I walked out of the funeral home into the bright sunlight, stunned and speechless. I rode the bus down Fifth Avenue with Doreen, both of us returning to attend classes at the Graduate Center, which was then located in the basement of the Grace Building on 42nd Street across from the New York Public Library. As far as I could determine, Doreen, Fran and I were the only people at the service representing the Graduate Center. There were none of Professor Rewald's colleagues, whom I had expected to see. I do not know what possessed me, but as soon as I arrived at the school I went straight into the slide room and started yelling at everyone who was there, reprimanding the professors for not having attended the service. "After all," I said, "the son of one of your colleagues—his only son, for that matter—had just died, and the least you could do is attend the service and show your respects." All I can remember is that Professor Brown said, "We sent flowers," to which I responded, "That's not enough," and I stormed out of the room.

There can be no question that my behavior was uncalled for and inappropriate. I would not have blamed those professors if they had gotten together and had me expelled from the school, but I heard nothing more, at least not from them. Two days later, however, I received a call from Fran Weitzenhoffer. She asked if I could meet her and Professor Rewald at his apartment to talk. Apparently, she had heard about my outburst, and although by then I had already taken two classes with Professor Rewald, she thought I should get to know him better. I will never forget seeing him that day. Usually groomed and impeccably dressed, he was a complete physical mess. His hair was disheveled, and he was obviously very distraught. The most striking thing

I remember about him is that his nails were always glossy and freshly manicured, but now he'd bitten them to the nibs. Moreover, to my complete shock and dismay, he was smoking a cigarette, which I had never seen him do before (or since). He was shaking and, clearly, had nothing in particular to say to me, except that he wanted to thank me for having attended his son's memorial service. Fran had grander ideas, and suggested that I accompany John to Europe that coming summer. He had a home in the south of France, and because he had purchased a car from her and her husband Max but never learned to drive, they wondered if I would be able to pick up the vehicle from the port in Le Havre and drive it to his home. Moreover, since they knew I spoke Italian, she wondered if I would consider taking John on a driving tour of Italy, for he had always loved the country and wanted to see more of it. Of course, I jumped at the offer, not because I wanted to be someone's chauffeur or because I needed to see more of Italy, but because that would give me the chance to know Professor Rewald better, an opportunity few students were given. What I had not realized at the time, and which only occurred to me years later, is that Fran saw me as a potential surrogate son, not that I could replace Paul in any meaningful way, but that my presence alone might help to alleviate the inevitable loneliness that results from the tragic loss of a child.

Until that afternoon, I had known Professor Rewald in the same way that he was known to the rest of his students, that is to say, as a teacher, a person of great authority and commanding universal respect, who, for whatever reason, agrees to impart his knowledge to eager students only too willing to listen and learn. I first heard about him and his writings from Nancy Grove, a friend whom I had met in the Leonardo class taught by Leo Steinberg at Hunter College (along with Steinberg and Brown, Rewald was among the

professors who founded the art history program at the Graduate Center). She knew Rewald to be a marvelous writer, and one evening when we were together, she brought over a copy of his book *The History of Impressionism* and began reading aloud from it. He was indeed a highly skilled writer, particularly impressive after you've learned that English was his third language, and that he wrote the book only a few years after settling in the United States (he grew up in Berlin, studied in Paris and moved to America in 1941). The narrative is basically driven by chronology and biography, with virtually nothing said about the individual pictures reproduced in the book, except to place them within the framework of various events that took place in a given artist's life. It is traditional story-telling at its best. I immediately went out and purchased a copy of the book, along with his equally impressive and detailed *Post-Impressionism: From van Gogh to Gauguin*. I looked them over (as opposed to reading them from cover to cover) before enrolling in my first class with Professor Rewald.

His classes were unlike any others. They were not the usual lecture or seminar courses, but rather informal discussions that took place in the living room of his art- and object-packed apartment on Park Avenue. Students sat in portable chairs that he set up for the sessions. Facing them, he sat on his couch, next to which, like a sentry, stood a white antique wooden dog, and he began opening select items from his weekly mail. These letters were from galleries and museums, or other students and professors from around the world, the majority of whom asked specific questions relating to the subjects of Impressionism and Post-Impressionism. They ranged from where a given painting might be located to when he expected the next volume in the series to appear. From the onset, Professor Rewald had envisioned these books to form a trilogy, the third installment in the series

to be devoted to French artists who came to maturity in the wake of Post-Impressionism—Rodin, Picasso, Matisse, etc.—but that book never materialized (although he never told us this, it was probably due to the fact that in the intervening years, several other highly qualified publications on the same subject had appeared before he had a chance to write his). On one occasion, Rewald took the liberty of showing us his royalty statements for the publication of his *Paul Cézanne*, the first and most important biography on the artist ever written (which came out in 1950, but was reprinted in 1959), and his *Cézanne Letters* (which was reprinted numerous times, but which had come out in a revised and enlarged edition in 1976). The income he derived from these publications was shockingly low: I can recall that for his biography, it was $18; if I'm not mistaken, the letters book was even less. He showed us these statements in order to convince us that we should not become art historians and writers for the money that publications such as these generated, for no one could live on such a meager income, no matter how successful the books happened to be. Of course, he was being slightly disingenuous, for he was showing us only royalty statements for books that had already existed for some years and were only then appearing in subsequent reprints. Tellingly, he did not show us his statements for *The History of Impressionism* or *Post-Impressionism*, which were far more popular and widely circulated books. Still, the point was well taken, for it was clear that you could not have what he had—a lavish Park Avenue apartment and a home in the south of France—without some other source of income (he never let on to any of us what that source of income might be, but I would later learn he was on retainer with both Paul Mellon and John Hay Whitney, powerful collectors who paid him handsomely for his expertise and guidance).

Like most of my fellow students, I was thrilled to be a

weekly guest in Professor Rewald's home. Although we were usually confined to the living room, on one occasion he took us through his study, where a library table was positioned in the middle of the room surrounded by books that went floor to ceiling on one side, while on the other were waist-high shelves that allowed for the display of many beautiful drawings. There, I was shocked to see, hung original works by Pissarro, Signac, Vuillard, Redon and Cézanne. When I arrived early at class one week, I took a stroll down a hallway in his apartment that led to back bedrooms, and there I saw more drawings by Giacometti, André Masson, Hans Bellmer, Victor Brauner and others, artists whom I would later learn that Professor Rewald knew personally. I did not know exactly what he did to be in a position to acquire these important works of art; all I knew was that I wanted to do the same thing (I later also learned that many of the drawings were gifts either from artists he wrote about, or from dealers who wished to express their appreciation for sales that he helped to facilitate). One of my most vivid memories of Professor Rewald's apartment was its smell, the unmistakable effusion of an expensive European cologne. On a visit to the Gabinetto dei Disegni at the Uffizi in Florence, Italy, where I had an appointment to inspect an original Leonardo drawing, I detected the same distinct aroma, this time emanating from an old German professor of art history who sat at a nearby table examining other drawings. As a result, I came to associate this smell with success in my chosen field, and somehow imagined that all great art historians must be wearing it. I set about finding out exactly what brand it was, but I did not then know Professor Rewald well enough to ask him. I shared my quest with a girlfriend I had at the time, and, without my knowledge, she called Professor Rewald to find out the name of his cologne (an inquiry, he later told me, that delighted him). On the next gift-giving occasion, a

bottle of Bois de Vetiver was mine, and I have worn it ever since—although I must confess that it never smelled quite the same on me as it did on him, or for that matter, as it did on that old art historian in the Uffizi.

On our first trip to Europe, I met Professor Rewald in Paris, where he was staying at the Pont Royal, an elegant and classic four-star hotel on the Left Bank. I was staying in much less resplendent quarters, a small and dank hotel a few blocks away that was the equivalent of a student hostel. When we met, he had already purchased two first-class train tickets to Le Havre, where the car that had been transported by boat awaited us. I accepted the tickets, but asked Professor Rewald to please not pay for me again, for although he clearly had more money than I did, I thought it would make it impossible for us to view our friendship as equals. Generous though he was, in this case, he agreed, with the occasional exception made for meals, since he insisted on eating in restaurants that I simply could not afford. When we arrived at the docks in Le Havre, I was shocked to see that the car he had purchased from the Weitzenhoffers was an enormous gold-colored Buick convertible. It was an attention-getting car, to be sure, but considering the price of gas in Europe, filling up the tank promised to be painful. I can remember that he once paid over $100, which back in 1976 was an obscene amount, but this did not seem to bother him (this, too, was an expense I was willing to let him pay, for at the time I did not even possess a credit card). He loved touring with the top down, wearing a white hat with a floppy brim to protect himself from the sun. Although I thought he looked rather silly, it got worse when we arrived in the south of France, at which time he changed into a red-and-white striped shirt, white shorts, athletic socks and sneakers. To top it off, whenever we got out of the car, he strapped a large 35-mm single-lens reflex camera around his neck that gave him the appearance of the

quintessential American tourist (which, of course, he was anything but). When we arrived in Ménerbes—a quaint and picturesque medieval hill town—I attempted to drive the car into the middle of the village, where he had rented a garage. In order to get there, however, you had to pass through several exceptionally narrow streets (the side mirrors scraped the walls slightly every time the car was taken in and out of town). His home—which he called La Citadelle—was exactly that, a magnificent fortress situated at one end of the town, a medieval structure that he had completely renovated about ten years earlier.

The Citadelle was magnificent. Its only entrance was an arched wooden door set into a monstrous, nondescript stone wall. The door had to be unlocked with an old-fashioned skeleton key, as if you were entering a medieval stone fortress (which, indeed, you were). Inside, the first thing you saw was a long stone-vaulted hallway that ended with glass doors bearing latches and hinges designed by the Italian sculptor Giacomo Manzù (about whom Rewald had written a book in the late 1960s). Beyond the glass door was a terrace that took your breath away, for it was surrounded on three sides by magnificent distant vistas of the Provençal countryside. The *pièce de résistance* was an azure swimming pool cut into the living rock upon which the Citadelle was perched. Inside, every room was furnished with antiques, carved wood chairs, tables, four-poster beds and tapestries that made you feel as though you had been removed in time, except that, because the renovation was recent, the bathrooms and kitchen were furnished with the most up-to-date, top-of-the line facilities and appliances. I remember falling asleep that first night in one of the upstairs bedrooms (Rewald's was located in a wing on the first floor), thinking that this was luxury as I had never experienced it before. It was a home fit for a king, in this case, the undisputed king of Impressionist studies.

Upon awakening, I joined Professor Rewald at breakfast, which was served outside on an open terrace. He wore a brightly colored terrycloth robe and greeted me—as he did every morning—warmly. We were served by the housekeeper, whose husband was the caretaker of the property. On the walls surrounding the terrace were vines bearing open passion flowers, one of which had been cut from its stem and placed in a little bowl of water next to my dish. I had never seen anything like it. Professor Rewald—whom I had now begun calling John—explained that the flowers got that name because the black stamens resemble nails of the crucifixion, and the surrounding petals a crown of thorns. Occasionally a hummingbird would hover nearby sipping the nectar, for these birds were the plant's primary pollinator. Although I was overwhelmed with the astonishing beauty of my immediate environment, John dove quickly into a critique of current world events, as they were relayed to him through the pages of the *International Herald Tribune* (back home in New York, few knew that he was a devoted though surreptitious reader of the *New York Post*, which, because of its tabloid journalism, appealed to the city's lower-class clientele). At the time, Jimmy Carter was running against Gerald Ford for the presidency. In the wake of Nixon's resignation two years earlier, we were all certain that Carter would win, which, of course, he did. If nothing else, I was happy to learn that John supported a Democrat, as it was the party associated with more liberal ideals, which I supported.

After breakfast, I joined John in his study, which had fewer books than his library in New York. In the center of one wall hung a large painting of reclining Tahitian women that looked like it had been painted by Gauguin. Considering where I was standing, it could very well have been, but John immediately explained that he had painted it himself, in the form of an exercise to get to know the artist better

before writing about him. He further explained that due to the propensity for theft, he would never place valuable art in such a remote location, although no robbery had ever occurred during the time when he lived there. He had copies of all of his publications on one shelf of the library, and I asked if I could take his *History of Impressionism* and *Post-Impressionism* down to the terrace to read. He agreed, just asking me to avoid letting them drop into the pool. I read them while reclining in a hammock stretched between two olive trees at the very end of the garden, the only distraction being the continuous hum of cicadas, a sound that increased as the day grew gradually warmer. I was again struck by how well written the books were, and can recall wondering—as did my fellow students—if he had the help of a professional editor who accomplished this task for him. That notion was quickly dismissed when he handed me the manuscript for an article he was then preparing for publication, one that I had seen him hammering out on the typewriter in his study. It was written with the same effortless prose with which he spoke, engaging anecdotes interspersed with a chronological narrative while preserving a sense of flow that made reading—like listening to him—a pure pleasure. I spent the next week reading both volumes and took careful notes, preparing questions that came up during the course of my reading, which I asked John to answer when we met for dinner later that evening. A greater learning experience was virtually impossible to attain, and I consider myself fortunate to have had the wherewithal to realize it at the time.

Our travels in Italy took us through countless churches and museums. To my surprise and delight, John was as interested in hearing me talk about Italian art as I was in hearing him talk about the Impressionists. I introduced him to my Italian friend Girolamo DeVanna, who taught English literature at the University of Urbino. Mino, as he was known

to friends, was also an art historian, who knew the work of not only major artists of the Renaissance and Baroque periods, but most of the minor masters as well. Because of his vast knowledge and expertise, even on a teacher's salary, he was able to gradually accumulate a formidable collection of paintings and drawings. Since he never married and had no children, he would eventually donate the entire collection to the Regione Puglia, where he was from, forming the first national gallery of that region. Mino and John hit it off right away. John admired his wealth of knowledge, and no one could fail to notice his unstinting generosity. It did not matter what restaurant you went to, Mino managed to pay the bill before the dessert and coffee arrived (he would leave the table saying he had to use the men's room, when in actuality he was paying the bill, an act of deception I would eventually master myself). In subsequent years, Mino would accompany us on all of our excursions though Italy.

One summer we met in Florence, where John always visited the various antique shops on the south side of the Arno. He especially enjoyed these excursions with Mino, who seemed to know everyone in the trade and was always willing to negotiate a good deal on anything John was interested in purchasing. Once he came across a small painting of a human skull against a grass-green background, magnificently rendered in every detail. It was unattributed, but Mino thought it might have been painted by a 19th-century Italian artist named Luigi Pollastrini, for a similar skull appeared in a large painting by the artist that was in the collection of the nearby Palazzo Pitti. While viewing this item, John turned to me and asked if he could have a word outside. He told me that because Cézanne had painted skulls numerous times, he had a fascination for them, but he wanted to know from me if—because of the recent death of his son—people would think it too macabre for him to place something like this on

display in his apartment. I was flattered to be asked, and I told him that if people thought that, it would be more their problem than his. The reasoning was convincing enough, for he returned to the shop and purchased the painting. When he got home to New York, he had it framed in an ornate carved wood frame that cost more than the painting, and gave it a place of honor on the wall of his magnificent study.

After leaving Florence, John, Mino and I drove to the south of Italy, visiting sites in Naples and Calabria before heading down to Sicily. We took an excursion around the island to see the remains of Greek and Roman temples, all of which John dutifully recorded with his camera. To see more, we took a boat trip to Malta, where John learned from us that we were retracing the flight of the famous 17th-century Italian painter Caravaggio. After killing a man in Rome, Caravaggio traveled south, and wherever he settled for any period of time, a small school of Caravaggisti sprang up emulating his brazen style of painting. Bathing his subjects in light that seemed to actually strike the canvas surface, Caravaggio managed to recreate scenes from the Bible with a verisimilitude that convinced the faithful that they were witnessing the actual event. I shall never forget how enthralled John was in viewing Caravaggio's *The Beheading of St. John the Baptist*, which to this day still hangs in the place for which it was commissioned, in St. John's Cathedral in Valetta. When I pointed out to John that the rivulets of blood flowing from the severed head of the decapitated saint spill out onto the ground and form Caravaggio's name, he was mesmerized, looking at the picture as though it contained some secret message that spoke directly to him (perhaps because, as I would later learn, Cézanne signed many of his paintings with a blood-red pigment). From a tourist shop located within the oratory, he purchased an oversized postcard reproduction of the painting, which, when he returned to Ménerbes, he

propped up on the base of a lamp in his study, so that he could continue to examine the painting and further contemplate the possible mysteries it contained.

A similar reaction occurred to John whenever he viewed any great work of art, but he could be completely overtaken if it was an exceptionally important or beautiful work by Cézanne, the subject of his lifework. Since he was working on the catalogue raisonné, I asked if in the forty-some years that he had worked on Cézanne, there was any important painting by the artist he had not seen. To my surprise, he responded that there was one picture located somewhere in Italy, a portrait of the collector Victor Chocquet, which had been in the collection of Egisto Fabbri, a wealthy American-born painter who lived in Florence and was among the first to seriously collect the work of Cézanne. According to his records, John believed the painting remained with the Fabbri family, but he had no way of contacting them. I called Mino and asked if he could locate the picture. A few days before our next annual trip to Italy, he called and said he had made an appointment for us to view the painting in Florence at the home of one of Fabbri's descendants. Being that quite a few years have passed since this event occurred, some of the details of our visit are a bit vague in my memory, but what I do recall with precision is John's examination of the painting. Fabbri's relative had arranged for the picture to be removed from a bank vault, and when we arrived it was still preserved within a large wooden storage crate. We opened the crate and carefully removed the painting. The minute John caught sight of the canvas, his eyes never left its surface. He followed the painting as the owner carried it across the room and propped it up on the back of a large overstuffed armchair to facilitate viewing. In order to see it better, John dropped to his knees, and proceeded to examine every brushstroke with the care and attention of a forensic investigator at a crime scene. Just

then, Mino nudged me, and gestured toward John kneeling before the picture. Considering the fact that we were in the middle of Italy, what we beheld took on the appearance of a devout Christian worshiping before a Renaissance altarpiece. As in viewing the Caravaggio, John was clearly in awe, an admiration that verged on reverence in the face of such unquestionable artistic genius.

With the time and effort that John put into examining works of art, one could logically wonder why he avoided talking about individual pictures in his own writings, or why he shunned all theories or established conceptual constructs for interpreting works of art, especially those that had been utilized to reveal hidden meanings in the paintings of Cézanne. My guess is that John must have felt that many of these theories did little to enhance or otherwise clarify our understanding of the work, but served only to remove us further from the subject at hand, away from the physical experience of viewing the picture. I once asked John why he thought Cézanne often failed to continue the back of a table ledge in a perspectively correct fashion, a visual anomaly that had been the subject of much debate in the extant literature on the artist. He explained that it was probably because when Cézanne looked at one side of a canvas, he thought so deeply about how it should be structured that he failed to align it with the other side. It was, after all, only a picture, and Cézanne knew better than to simply copy nature, which a camera was already capable of doing. He was going for something deeper and of far greater significance.

John could tolerate whatever anyone had to say about Cézanne, but certain of the more convoluted interpretations got under his skin. He was ready to fight if he felt any of these ideas jeopardized or misrepresented the artist's intent, as he did when the so-called headhunters (those who claim to see heads and other objects floating about in the background of

paintings) aimed their spears in the direction of Cézanne. This occurred when Sidney Geist's *Interpreting Cézanne* appeared in 1988. Geist was a sculptor who had studied with Brancusi and, because of his many writings on that artist, was considered to be the foremost authority on his work. For whatever reason, toward the end of his life Geist undertook a detailed study of Cézanne, where he found an assortment of images in the paintings that he believed revealed subconscious messages the artist was attempting to express, most of which had to be deciphered through elaborate puns in French (in one case he said a painting contained the trace of six donkeys in the background, thereby generating a hidden signature, as in *six ânes* [six asses]). Rewald hit the ceiling. He refused to purchase the book, but asked to borrow mine in order to write a review (I lent him my copy, but he never returned it). His review was titled "Cryptomorphs and Rebuses: A Double Disaster Befalls Cézanne." Rewald lashed out against Geist for having written such a worthless book, and he sent a letter to Harvard University Press condemning them for having published it. This was vintage Rewald. Nevertheless, it is hard to disagree with him. He must have felt as though the great paintings to which he had devoted more than fifty years of his life were being reduced to a series of double-entendres and meaningless puns. He was incapable of looking the other way and letting such an egregious offense pass unchallenged.

John's unswerving attitude on a number of issues—both personally and professionally—earned him many enemies. He once let me read a long letter that he wrote to the telephone company attempting to straighten out a bill. In the letter, he asked them if they realized who their customer was, whereupon he recited a litany of his publications. How he thought that information would help to resolve the matter is beyond me, but he felt that his accomplishments should be recognized by absolutely everyone. Once, when we went on a

book-buying excursion to the Strand Bookstore in New York, he made this point abundantly clear. When he was paying for his purchases with a credit card, a checkout clerk asked him to provide identification. He held up his card to the clerk's face and asked, "Do you know who I am? I've written twenty-five books that you sell in this very store." Because his action mimicked a television advertisement for American Express that was in circulation at the time, everyone burst out laughing, whereupon, I must confess, I cowered away, not wanting anyone to know that I came in with this person. His ego was very fragile. Every year when the newspapers announced recipients of the MacArthur Grant—especially after Leo Steinberg had received one—he always felt that his name should be on the list; when it wasn't, Fran Weitzenhoffer told me, he would spend days in a deep depression. I came close to being among his permanent enemies when he called me at home one evening and, because I had a crying woman in my apartment at the time, explained that I could not speak with him, but that I would call him back later in the evening after the crisis had passed. He immediately quipped, "But then why did you pick up the phone?" I had no suitable answer, at least not one that I was willing to give in front of my distressed friend. After she left, I called him back, but he told me that now he did not have the time to speak with me, and slammed down the receiver. I was leaving for California the next day, so I sat down and wrote him a letter, trying to explain what had happened. He wrote back saying that the letter was insulting, that I should take lessons from him on how to write a proper poison-pen letter. All I could do was tell him that it was not my intention to say anything that hurt his feelings, but only to explain how his behavior hurt mine. I called Fran and told her what had happened. She recommended that I let it go, and that he would eventually forget it had ever happened. It was good advice.

Situations such as these occurred infrequently. By and large, our friendship continued unabated for over twenty years. We enjoyed one another's company and, other than during the summers when he was away in France, made sure to meet at least once a month for dinner. He loved to go to P.J. Clarke's, a legendary bar and restaurant on Third Avenue at 55th Street, or a small French bistro on 89th Street around the corner from where he lived. Our conversations covered a myriad of subjects. He grew impatient with the younger art historians and, after retiring from teaching, invented nasty homophones for their names: Linda Noxious, Rosalind Kraut, Robert Pincus-Twitten and Leo Swineberg (more about his regrettable exchange with Leo follows in the next chapter). At times, I found his sense of humor distasteful, but at least he had one, which, I would eventually learn, most art historians lacked. I remember another conversation in which I had proposed that, should I outlive him (not a certainty in those days), I would write an obituary with the title "John Rewald: A Whiskey Sour on the Sweet Side." It seemed appropriate to me because that was the drink that John inevitably ordered before every meal, and because he possessed a mercurial disposition, he could be both sour (especially to those with whom he disagreed) and sweet (as he usually was with me). His only comment was "Make sure they don't misunderstand the sweet thing."

John had nothing against homosexuality. Indeed, he prided himself on being completely open to any sexual encounter that presented itself to him, and he once confided in me that he had actually made love to a man—not a man exactly, but what could be more accurately described as a hermaphrodite. Through an escort service in Paris, he requested a girl to meet him in his room at the Pont Royal Hotel. When she showed up, he found her to be a strikingly attractive young woman. Even when she removed her blouse,

he said, her breasts were perfect, but likely too perfect to be real. Only when she completely disrobed did he discover that she had a tiny, nearly imperceptible penis. The prostitute apologized, whereupon John told her that there was nothing to be ashamed of, that everyone was built differently, and, according to his account, she continued to fulfill the needs of her customer. John never relayed these stories to me in the form of exploits, but as the sexual proclivities of an unmarried man whose interests were far-ranging and without inhibition.

One evening he invited me on a tour of the porn shops and sex clubs on 42nd Street, an invitation I accepted more out of curiosity than interest. I had always had an aversion to pornography, which might have been instilled in me by my Catholic-school upbringing, a prudish disposition that I was eager to relinquish. We began in a bookshop, where I was shocked to discover that they had a section labeled "pink," which, I learned, consisted of pictures of female genitalia. When I inquired why this section was called "pink," the store clerk replied: "Whatever color a woman happens to be on the outside, they're all pink on the inside." This was an intriguing classification, I thought, since when Marcel Duchamp developed his female alter ego, he called her "Rose," not only a common first name for a woman, but a word that also translated as "pink." I could not help but wonder if this same classification existed when Duchamp came up with this name in 1920, or if it existed at all in French porn shops at that time (something that to this day I have never been able to determine).

The rest of the evening did not go as well, for I was too embarrassed to be in these establishments, and I could not stop myself from continuously looking around to see if anyone noticed me. We went into a strip club, where I crouched in a corner, and then to a performance where a naked man and woman were actually having sex onstage before an audience.

This really made me uncomfortable, although John seemed to be thoroughly entertained. He was so impressed that the man could perform for such a sustained period that when the performance ended, he went up to the stage and gave him an exceptionally large tip. On a separate occasion, he invited me to his apartment and showed me photographs that he had taken of a naked, prepubescent girl seated on the stone spiral staircase of the Citadelle in Ménerbes. When I objected, he insisted that he had not touched the girl, but that she posed for him with the permission of her mother, who happened to work for him. At that point, I voiced an even greater objection, since it was obvious that the mother was placed in a compromising position, faced with the possibility of losing her job if she refused. He insisted that it was not that way, but rather, I should try to see the artistic content of the photograph. Needless to say, I remained unconvinced.

Since I was not married at the time, John once asked me if I would consider accompanying him to a bordello. I had no particular difficulty in finding girlfriends at the time, but the idea of engaging a woman in that capacity had admittedly intrigued me. Beatrice Wood, who had always been fascinated by the profession of prostitution, encouraged me to give it a try, just so long as I provided her with a complete report after my visit. So one evening John and I met at an establishment populated entirely by Asian women located above shops on 23rd Street. You entered into a large, loft-sized space that was illuminated entirely in bare red-light bulbs, whereupon twenty to thirty flittering young women descended upon you begging that you select them for the evening escapade. For reasons that I could not figure out at first, John always selected two women. Eventually, I concluded that, at his advanced age, he might have preferred looking rather than acting, for I was beginning to realize that John was the quintessential French voyeur (essentially the "dirty old man" that I had accused Leo

Steinberg of being). I selected a woman with an exceptionally kind face, for I believed she would be sympathetic to my lack of experience. She helped me to place my valuables in a locker, and she and another woman then disrobed me and gave me a thorough cleansing, not missing any part of my anatomy (apparently, cleanliness was a cardinal rule of the establishment). It was at that point that I realized the evening would be a complete failure, for I was so nervous that I could barely breathe, much less perform sexually. The woman I engaged was understanding and acted as though this sort of thing happened all the time. Upon leaving, I met up with John, who asked how things had gone. I told him, "It was great." He never asked anything more, so I said nothing.

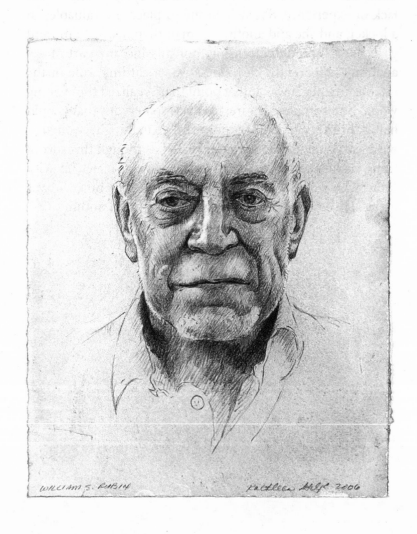

WILLIAM S. RUBIN Kathleen Gilje 2006

Kathleen Gilje
William S. Rubin, 2006
Colored pencil on stained paper, 12 x 9 ¾ inches

LEO AND BILL / LEO AND JOHN

Long before I met either Leo Steinberg or John Rewald, they had known one another professionally for years. With Professors Milton Brown and Robert Pincus-Witten, they founded the Art History Department at the Graduate Center of the City University, where I was enrolled. But they were never really colleagues, for their separate fields of study were so divergent that there were few opportunities for their paths to cross, that is, until an incident occurred in 1979—one that inadvertently and regrettably involved me—which forced a confrontation between them.

At the beginning of the summer, I met John at the Citadelle in Ménerbes and we sat down to prepare for what was now becoming one of our annual excursions through Italy. He asked if on our way, we could stop in to visit William Rubin at his home in Plan-de-la-Tour, a small village near the coast that was about two hours away, just off the route we would be taking to Italy. I was only too pleased, for Rubin was already a legendary figure in the world of art and art history, and I was anxious to meet him. He was director of the Painting and Sculpture Department at the Museum of Modern Art, and a figure of such stature that many feared him. Barrel-chested and physically robust, he spoke with a commanding air of authority, at times so forcefully and vociferously that some considered him a monster; indeed, I had heard a rumor that he once reprimanded the art historian and critic Rosalind Krauss so emphatically that she broke down crying in public (an incident that she denied ever happened). John needed

to see Rubin because Rubin's wife at the time (his third but
not last) was an art historian writing her dissertation on
Cézanne and had requested a consultation with him. When
we arrived at Rubin's home the next day, I was suitably
impressed. An Olympic-sized swimming pool sat before a
large and beautiful stone house, which, like the Citadelle in
Ménerbes, displayed little art, although posters of various
exhibitions that Rubin had organized for the Museum of
Modern Art hung throughout the home. After a few minutes
of introduction, John and Rubin's wife went into another
room, and I was left to spend the next two hours with Mr.
Rubin. He took me on a tour of the home, spending a great
deal of time in his glass-enclosed garden, explaining the
characteristics of every single plant it contained: its Latin
and English name, where it originated, the areas to which
it was indigenous, how it pollinated and even if it had been
used for medicinal purposes. We later walked through his
kitchen, where I noticed that he had a half-dozen large jars
filled with capers on the counter. When I asked about them,
he gave me a mini-lecture on their different tastes, what they
were best served with and where they were best grown and
cultivated. He seemed to possess an encyclopedic knowledge
of everything, a fact that would be verified when lunch was
served.

When we sat down at the dining room table, I noticed
hanging on the wall a framed photograph of Rubin with
Picasso. There he was looking into the camera and smiling,
his arm around the great artist as though they were old
drinking buddies. Picasso held in his arms his great 1914
Cubist guitar, which any art history student would have
recognized as one of the greatest achievements in the history
of early modernist sculpture. When I asked Rubin about
the photograph, he said it was taken at Picasso's home in
Mougins, about an hour farther down along the coast in the

direction of Italy, on the day when the artist decided to give this work to the Museum of Modern Art in New York. Since Picasso had been mentioned, I decided to ask Rubin about an exchange of articles with Leo Steinberg that had appeared a few months earlier in *Art in America* debating the origins of Cubism. In a long essay on Picasso's *Three Women*, Steinberg had challenged Rubin's theory that Georges Braque arrived at a Cubist depiction of space before Picasso; Steinberg contended that Picasso had found it independently through an examination of the paintings of Cézanne, and didn't need Braque's example to lead the way. Steinberg followed up this dispute with a subsequent article submitted to *Art in America* called "The Polemical Part," where he outlined his objections more thoroughly, to which he invited Rubin to respond. Rubin did so in an even longer article called "Pablo and George and Leo and Bill," wherein he attempted to address Steinberg's objections in a line-by-line rebuttal. Rubin told us that he had submitted his text to Steinberg before publication, asking if he objected to anything, and Steinberg only asked for the word "Talmudic" to be removed from his essay. At that point, everyone who was listening laughed, but I didn't, for I sheepishly had to confess that I was unfamiliar with the term. As soon as Rubin heard that, he launched into a detailed explanation of the Talmud and its history, emphasizing how hair-splitting debates formed an essential part of Jewish literature, giving examples as he spoke, an explanation that inadvertently resembled a Talmudic practice. Apparently, Steinberg felt the use of the word diminished the important role that the Talmud played in Jewish culture, and, within the context of a mere art-historical debate, the term could be easily misconstrued or, worse yet, taken as anti-Semitic.

Rubin and his wife invited us to stay the night and leave for Italy the next morning. John, however, insisted upon leaving right away. When we got into the car, I asked why

he refused to accept what I thought was a very generous and considerate invitation, and Rewald confessed to me that he could not tolerate Rubin over a prolonged period. He found him too overbearing, and used as an example the story of a dinner at an elegant restaurant in New York to which he was invited by Rubin. When he arrived and began looking over the menu, Rubin gently pulled the menu out of his hand and insisted on ordering for him. He explained that he knew their offerings well—what was good and what was bad—and he was in a better position to place the order. Coincidentally, I once asked the art historian Robert Rosenblum why he did not like Rubin, and he came up with the very same explanation, so, apparently, this was a pattern of behavior to which Rubin never imagined anyone would object. Later, when I got to know him better, Rubin asked me why John never accepted his many gestures of friendship. I pleaded ignorance, for I lacked the courage to tell him the truth, although I suspect that a person with his innate sense of self-confidence probably could have taken it. Rubin never expressed a single opinion that was not analytical and, at the same time, critical. Even when he wrote about Picasso, whose artistic genius he openly acknowledged, he could not resist pointing out his shortcomings, whether it be within a larger global context (how a work failed to address certain art-historical concerns), or the specifics of how a detail within a given composition failed to function formally with another.

When we arrived in Florence, John got a room in the Grand Hotel, and I stayed in a small pensione nearby. We met for breakfast in the morning at one of the outdoor cafés in the Piazza della Signoria, where John was busy writing postcards. He showed me one reproducing the famous sculpture of Hercules and Diomedes, which depicts two naked male figures wrestling, one with a firm grip on the other's penis, which, because of this one amusing detail,

made the card a popular image circulated jokingly among homosexuals. It was an odd card for John to have selected, so I asked, "Who are you sending that to?" He said, "To the editors of *Art in America*," adding, "You'll know why when you read the message." He handed me the card. On the verso, he had written: "Just discovered in Italy—though admittedly a little late—this illustration of the Talmudic struggle between Leo and Bill." This time, I laughed, since it was clear that he was making fun of the word to which Steinberg had objected, and whose meaning had been so carefully explained to me just a day earlier by William Rubin. When I said, "They're never going to publish that," he said, "Sure they will, especially after I add my address, so they'll know it actually came from me." I thought nothing more of the card at the time, but when we returned to New York, there it was—fully illustrated—in a section of the magazine reserved for letters to the editor under the heading "Dynamic Duo."

Leo Steinberg exploded, immediately labeling Rewald and the publication of this card as nothing short of anti-Semitism. It was a strange accusation, since John was Jewish and, like Steinberg, was forced to leave Europe during the Nazi advance. In fact, for years John would not even get into a German-made car, a position from which he eventually softened. I was willing to believe that Leo might have thought the joke distasteful, but I could not understand why he would accuse John of anti-Semitism. When I told John about it, he immediately wrote a thoughtful, handwritten letter to Steinberg apologizing for having offended him, saying that he never imagined they would publish the card and that his inclination for pranks got the best of him. Steinberg wrote back to Rewald right away saying that his apology simply "won't do," and referring to his postcard as an "anti-Semitic obscenity." He also told him that as a direct consequence of his actions, he and several other Jewish writers would never

again allow their writings to appear in the pages of *Art in America*, concluding with the sarcastic jibe: "No doubt, this decision on our part will be incomprehensible to you." Feeling partly responsible for this fiasco, I wrote to Leo saying that John openly admitted that the postcard was in bad taste and asking him to please accept his apology. Leo wrote back saying that he had appreciated my efforts to act as peacemaker, but, he posited, apparently neither I nor John really understood the full implications of what John did. He insisted that since Rewald's offense appeared in a public forum, he could only apologize in kind; thus his private letter was of no consequence. "I know perfectly well that Rewald is not big enough to do the right thing in this matter," he wrote to me, "just as *Art in America* has proved too obtuse to make appropriate action in the form of an *amende honorable*."

For the next six months, Steinberg did everything in his power to circulate knowledge of the incident and to discredit Rewald. He solicited letters of support from his colleagues, and, because they thought so much of him professionally, they were only too anxious to write in his defense. Letters were written by Arthur A. Cohen, a book dealer and writer exceptionally well grounded in Jewish history, who objected to Rewald's misuse of the term "Talmudic." Steinberg's assistant Sheila Schwartz immediately withdrew a book review she had written for *Art in America* that was slated for publication, and wrote a long and detailed letter to the editor explaining how Rewald's use of the term was anti-Semitic. She said that within the context of the postcard, it "mocks one of Judaism's most revered corpuses of knowledge and inspiration," and also "raises the frightening specter of those scurrilous sexual slurs which the Nazis used to aim at the Jews." There I thought she might have gone too far, but other letters followed from Wayne Dynes, a professor at Hunter College, and Phoebe Lloyd, a student at the University of

Pennsylvania and a girlfriend of Steinberg's at the time, who demanded that the magazine publish a retraction. Betsy Baker, editor-in-chief of *Art in America*, told me that she refused to publish any of these letters because the argument was ridiculous, but that did nothing to stop Steinberg. She felt that he got all the revenge he needed, because, as she learned, months after the incident had occurred Steinberg would not let it die. Whenever he attended a social event or gathering, he brought along a manila folder that contained the page from *Art in America* where Rewald's postcard had been published and copies of the letters he had received condemning the publication, volunteering to supply photocopies to anyone who took an interest in the controversy. Steinberg was so completely convinced that he was fighting on the right side of history that he called me one day to say that he had preserved all of these documents in his copies of Rewald's *Impressionism* and *Post-Impressionism*, and that after his death, I should retrieve them and do with them whatever I thought appropriate (in the end, these letters went off with the rest of his papers to the Getty, but Sheila was kind enough to provide me with photocopies).

For the next ten to twelve years, Steinberg and Rewald never spoke, but in the early 1990s, Leo called to tell me that he had run into John in the lobby of the Metropolitan Museum. They were both there to attend an opening, and, Leo explained, he noticed John standing all alone in a corner looking very old and dejected. He wanted me to know that he walked up to him and extended his hand. They exchanged greetings, he said, and acted as though nothing had ever happened between them. John later told me about the encounter, and basically thought it was Leo's way of apologizing. I knew better. Time, as they say, heals all wounds, but as we all know, the scars never wholly disappear.

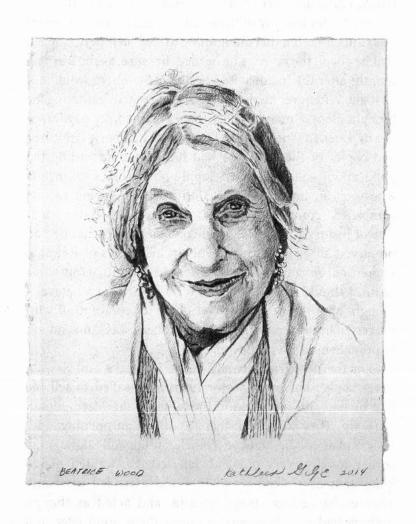

Kathleen Gilje
Beatrice Wood, 2014
Colored pencil on stained paper, 12 x 9 ¾ inches

～ V. ～

BEATRICE WOOD

I saw the name Beatrice Wood for the first time when reading the caption below a photograph reproduced in Robert Lebel's monograph on Duchamp: there she appeared in a picture with Marcel Duchamp and Francis Picabia that was dated 1917. In looking more carefully at the photograph, I noticed that the trio were surrounded by props, the sort of picture you had taken in a photographer's studio: she sat side-saddle on the back of an artificial bull looking directly at the camera and smiling as she held on to the brim of a large white circular hat, while Duchamp and Picabia appear behind her in a cart, all elegantly dressed for the occasion. I can remember asking myself at the time exactly who this woman was, and what the circumstances were that placed her in the company of these two avant-garde artists. The Lebel book provided very little information about her, except to say that she attended the near-nightly soirées that were held during the war years in New York at the apartment of Walter and Louise Arensberg, wealthy collectors of modern art who were Duchamp's most steadfast patrons in America. I also remember having seen her name listed on the label of a drawing shown in the Duchamp retrospective held at the Museum of Modern Art a few years earlier, which I had attended. I had the catalogue for that exhibition, where the drawing was credited as "Collection Beatrice Wood, Ojai, California." I had no idea where Ojai was, but because I wanted to know more about this woman, I decided to seek her out. The first thing I did was to pick up the phone and dial directory assistance (which is how you

found someone's telephone number in those days). I was given her number and decided to try calling right away. A woman with a very youthful voice answered the phone, so I immediately assumed that it could not have been the person I was looking for. Doing the math, I figured that Beatrice Wood would have to be ancient—if she was still living at all—and this person sounded too young. I do not know what possessed me, but I thoughtlessly blurted out: "I must want to speak with your mother." After a brief pause she replied: "My mother died in 1924!" She was clearly incensed by the question, for it implied that I assumed she herself must no longer be living.

After explaining the purpose of my call, she invited me to visit her at her home and studio in Ojai, which, she explained, was only about an hour's drive north of Los Angeles. I used to tell people that I jumped onto the very next plane, but it actually took me about a week to make the necessary arrangements and get out there. In the interim, she sent me a brochure for the Beatrice Wood Studio, where I learned that she made and sold pottery (at the time, I had not realized that she was a highly accomplished potter, among the most notable in the history of the crafts movement in California). The brochure contained detailed driving directions, so when I got off the plane, I drove a rental car straight to her home, which was situated on a hilltop above the picturesque town of Ojai. I will never forget our first meeting. When I arrived, she heard me coming up the driveway and came out to greet me. Because the pathway on which she emerged was surrounded by cacti and various tropical plants, and because she was slight of stature and dressed in an Indian sari, she took on the appearance of an oversized garden gnome. It was a terrible first impression, because as soon we began speaking, she made me feel as though we had been friends for years. To begin with, there was no question that she was openly

flirting with me, which, I would eventually find out, is how she treated any young man who came to visit her. Despite the fact that there was an enormous gap between our ages—I was twenty-eight and she was eighty-four—I must confess that I found her advances flattering. Although I didn't realize it at the time, this was an intentionally disarming strategy on her part, for it placed her into a position of control. When we sat down and the interview began, for example, she started to tell me about her past, coyly looking up at me and flapping her eyelashes as she relayed intimate details of her life, as though they were secrets she had been holding on to for years and was revealing only to me.

Eventually our conversation turned to Duchamp. I had not yet known about the depth of her relationship with him, and was naturally anxious to hear whatever she had to say. She explained that she could not tell me anything more about him until she told me everything about Henri-Pierre Roché, his closest friend during these early years in New York. It would be only a matter of minutes before she disclosed that she had lost her virginity to Roché and began seeing Duchamp shortly thereafter, but it all came to an end when she entered into a terrible marriage with a theatre manager in Montreal. I had imagined that there was a certain degree of promiscuity among those who attended those raucous parties at the Arensberg apartment, but this was the sort of information that I expected to learn—if at all— only after years of digging into archives and personal reminiscences. Now here she was telling me everything all at once. Even though I had a tape recorder running, I was trying to write everything down, but the information came at such a rapid-fire pace that I was unable to keep up with her. At that point I blurted out the most impertinent question anyone could ever ask, especially of someone you just met. "Were you intimate with that many people?" She looked at me sternly

and said, "Turn off the tape recorder." I was flabbergasted and thought that with one stupid question I had blown the entire interview. She sensed this and said, "Don't worry, you'll be able to turn it back on, but first I want to ask *you* a question."

"How many women have you slept with?" she asked. I immediately objected to the question, saying that I was there to interview her. "Well," she said, "you asked me, and now I'm asking you." No matter what I said, she insisted on getting an answer out of me, and intimated (although she did not say it) that the interview would be terminated if I did not respond. I had to think quickly, for although I'd had quite a few girlfriends in my time, I never kept a running score and, on the spur of the moment, could not come up with a number. She didn't want to know who they were, she explained, nor anything about what had happened, just how many there were. When I could not come up with an exact number, she said, "OK. Go home and think about it, but promise that once you've come up with a number, you'll tell me." It was at that point that I realized why she was asking the question. Just as I was trying to find out from her what escapades and romantic entanglements took place during those years in New York (the nitty-gritty of all history, one could argue), because the years of sexual activity were long behind her, she wanted to know from me if the free-love revolution of the 1960s was all that it was cracked up to be. Whatever her motives, it was at that moment that our friendship began. The dynamic changed immediately. She was no longer simply a repository of information that I needed for my work, but a person who genuinely wanted to know something about me.

After a few hours of my interviewing her, Ms. Wood said that much of what she was telling me was written in her autobiography, which had not yet been published. Naturally, I wanted to see that, as well as anything else from those early years in New York that would help in my research. She then

showed me her photo albums, which, I was astonished to see, contained countless pictures of all the people she was telling me about, none of which had ever been published before. Among the photographs were several of her, and I remember commenting on one in which she looked especially attractive. "You were really beautiful," I said, whereupon she quipped: "What do you mean, '*were* beautiful'?" I immediately said that I did not yet know her well enough to know if she was still beautiful, to which she replied: "Good answer." She also showed me her diaries from those years, where on each day, in just three lines, she recorded the names of the people she saw and brief comments about the various things she had done. She told me that I could make photocopies of anything that interested me, and she volunteered to have prints made of any of the photographs I wanted. Finally, she told me that many of the drawings she had made during those early years were preserved in a cardboard box in the bottom of her clothes closet. If I wanted, she said, I could have a look at everything in a leisurely fashion, for she took a nap every afternoon and would leave me in her sitting room with the materials.

The first drawing I removed from the box was inscribed at the bottom *Lit de Marcel / Après Webster Hall* and dated at the top *27 Mai 17*. It consisted of little more than a jumble of intersecting lines and patches of color. I assumed—somewhat naïvely—that it could not possibly have been made in 1917, for it was far too spontaneous and expressive and resembled nothing else that I had known from that period. It must have been made later and, if anything, backdated (as I had recently learned Kandinsky had done with a famous watercolor in the collection of the Guggenheim Museum). Before my visit to Ojai, the only drawing by Beatrice Wood I knew was a stick figure thumbing its nose to the world that was reproduced on a poster for the Blindman's Ball in 1917. My assumption

about the dating of these drawings was proven wrong the very next day when I visited the Francis Bacon Library in Claremont, California, a repository established by Walter Arensberg to promote his lifelong quest to prove that the writings customarily attributed to William Shakespeare were actually written by Francis Bacon. In the library I discovered that Arensberg had preserved about forty drawings by Beatrice Wood, several of which were executed on calendar pages of 1917. I immediately realized that those I had seen the previous day in Ojai were probably done in that same period. I called Ms. Wood and asked if I could come back up and have a more careful look at the drawings. She was delighted to see me again, and I was equally pleased to make yet another important discovery.

Back up in Ojai, I just could not get over what I had unearthed. Here in one place was a veritable gold mine of unpublished material. Beatrice Wood had documented the episode of New York Dada more intimately and thoroughly than any of its other participants. She had photographs, personal recollections, diary entries and now drawings that recorded actual events shortly after they had taken place. It was everything I needed to make a history of this period come alive. I could not have asked for anything more. But since I had begun to regard her as a friend, I instinctively wanted to know if there was something I could do to help her. When asked, she said that I might be able to help get her autobiography published. She insisted upon calling it *I Shock Myself,* for she envisioned it as an account of her romantic adventures in life; on the very last page of the text—which was a 438-page, double-spaced typewritten manuscript—she wrote: "I never made love to the men I married, and I did not marry the men I loved. I do not know if that makes me a good girl gone bad, or a bad girl gone good. All I know is that I have loved five men—and that I shock myself." She

wondered if I would be willing to circulate the manuscript among various publishing houses in New York. I accepted the challenge, but suggested that we might first try to get excerpts from the text published in an art magazine in New York. She thought this was a great idea.

As soon as I returned home, I carefully excised those portions of the text that dealt with Beatrice's years in New York and submitted them for publication to *Arts Magazine*, a monthly journal edited by Richard Martin, a friend and colleague who taught at the Fashion Institute of Technology. In her manuscript, Beatrice described a work of hers that was shown in the 1917 Independents Exhibition (the same show to which—under the pseudonym of R. Mutt—Duchamp submitted his notorious urinal), which consisted of a nude woman emerging from her bath to which she had attached (at Duchamp's provocation) an actual bar of soap. But the work itself was destroyed in the California flood of 1938. I asked her to recreate it, so that readers would have an idea of what the piece looked like. She gladly complied, and I submitted an image of the work to the magazine. To my surprise and to hers as well, it appeared on the cover of an issue devoted entirely to the subject of New York Dada. The publication contained not only excerpts from Beatrice's autobiography with an introduction that I had prepared, but a reproduction of her *Lit de Marcel*, the first drawing that I had discovered in her closet. It was the first major presentation of anything by Beatrice Wood within such an important historical context, and throughout the remaining years of her life, she maintained that it was the beginning of her discovery as an artist. Of course this was not entirely true, for she was already well known in the craft field, but this publication, she felt, propelled her work to an entirely different level of recognition, one where it could be appreciated by a far wider and more informed audience.

At the time when I met Beatrice, I had not yet made up my mind as to which period of art history I would specialize in: Renaissance or modern. I was still working on the perspective of Leonardo's *Last Supper*, but Leo Steinberg had left the Graduate Center to accept the Benjamin Franklin Professorship in Art History at the University of Pennsylvania. He still lived in New York City, and assured me that he would be available anytime during my research, but it was at that point that I had to decide whether I would transfer to another university and begin a serious study of Renaissance art, or continue to pursue a doctorate in modern art at the Graduate Center. At the time, I was enrolled in a course called "New York Dada and Its Affinities" taught by Robert Pincus-Witten, a young and charismatic professor of art history whose interest in this subject coincided with mine (more on this professor's influence on my career and life follows in chapter IX). We both considered Duchamp's readymades to be among the most important works of art in their day, although the quotidian artifacts that they ostensibly were did not serve as a powerful source of influence until the 1950s and 1960s. The subject fascinated me, for I had been interested in the work of Marcel Duchamp since high school and always wanted to study it in greater depth. During the years when I studied in Chicago and still thought I could become a famous artist, I produced work that was so derivative of his example that it lacked creativity on every level.

Curiously enough, my decision as to which career path to follow—Renaissance or modern—was resolved while riding a cross-town bus with my girlfriend at the time, a woman named Barbara whom I met while teaching in Italy, but who had finished her studies and was now living and working for a gallery in New York. She recommended that I stick with modern, for in her opinion, it was a far more exciting field

of study than investigating the lives and accomplishments of people who had died centuries ago. Besides, she said, since I loved the work of Marcel Duchamp, I might still be able to interview some of the people who knew him, although I had narrowly missed meeting him myself. Years earlier, while studying as an undergraduate at the State University of New York in Buffalo, I had been in the same room with Duchamp but had not realized he was there. He died a few months later, so I was determined not to allow a person's unanticipated demise to prevent me from ever meeting them. As soon as I got home that evening, I looked through my books to see which artists from that early period in New York were still living. The most important artists of the group were Duchamp, Picabia and Man Ray. Of the three, only Man Ray was still alive. I wrote to him saying that I was planning on devoting my dissertation to the subject of New York Dada, and asked if we could meet during my next trip to Paris. He never responded, and died a few months later. I was told later by his widow, Juliet, that he had received the letter, appreciated the inquiry and intended to let me interview him, but it was too late.

Although the principal participants in New York Dada were all gone, there were three women who were still living, all of whom I would eventually seek out and interview on the subject of my dissertation (which by now I had officially submitted as "New York Dada," since no book on the subject had been written, and I felt it was an exciting yet still largely unexplored subject): Gabrielle Buffet-Picabia, Picabia's first wife, who was in her nineties but still living in Paris; Louise Norton, wife of the poet Allen Norton and, later, of the Italian-born French composer of avant-garde music Edgard Varèse; and finally, Beatrice, whom I now considered not only a wealth of important information but a very close personal friend (when my book on *New York Dada* finally came out in

1994, I dedicated it to these three remarkable women).

From the time when I met Beatrice in 1976 until her death twenty-two years later in 1998, I considered her my closest friend and confidant. We spoke regularly on the phone and saw one another three or four times a year, whenever our schedules permitted. I went out to California on a regular basis, and, despite her age, during the early course of our friendship, Beatrice took three or four trips to New York, unescorted, always staying at the Barbizon Hotel for Women, a fashionable residence on the Upper East Side of Manhattan. During the day we visited museums and antique shops, and I once took her out to the Indian neighborhood in Queens to purchase saris, the only clothing she ever wore. She had fallen in love with India on a visit to the country, and I knew that she was a devout follower of Krishnamurti, the Indian spiritual guide associated with the Theosophical movement who settled in Ojai, which is what caused Beatrice to move out there. I knew nothing about Theosophy, and mistakenly assumed it was a religious movement, so I once asked Beatrice very delicately if she wore the saris because it was part of her religion. She said, "No, it's because I like chocolate and young men." When I said that I did not understand, she leaned over and whispered: "Silly man, I'm fat under here."

One evening, when we returned to her hotel, she asked me to come up to her room, for she needed help in setting up a contraption she brought with her, a triangular structure with ropes and pulleys that she used to hang upside down for ten minutes a day. She said that it was important for a woman of her age to maintain blood flow to the head. I assume it must have worked, for her mind was always quick and alert. When she was in her mid-seventies, she felt the onset of dementia, so she decided to combat the condition by subscribing to the *New York Times* and doing their crossword puzzle every day. She did exactly that until she mastered it,

solving the puzzle—even the hard one that came out on Saturdays—in less than an hour. People constantly asked for the secret to her longevity. She would always tell them that it was because she maintained an interest in young men, and because she always had so much work to do, things that she wanted to accomplish before contemplating the possibility of her demise. I, too, was mystified at what kept her going. I know that she ate a bar of chocolate every night, not the expensive type that everyone brought her as gifts, but cheap bars of Hershey's, which she kept in a stack in her refrigerator. Also, every night before retiring, she cut up a raw clove of garlic, placed it atop a cracker slathered with butter, and ate it. I'm not sure which one of these dietary supplements worked, or whether it was due to her being a committed vegetarian. Perhaps it was a combination of all these factors, but whatever it was, she lived in comparatively good health to a remarkably advanced age. The only malady that she complained about was a curvature of the spine at the base of her neck, one that developed when she was a teenager and caused her pain throughout her life. She spent a great deal of time seeking relief from this affliction. She had regular back massages, and acupuncture helped, but only for a few years. Although we never discussed it, it might have been her continuous struggle to overcome this pain that, ironically, gave her the strength to endure and persevere.

On one of her first trips to New York to see me, I arranged for Beatrice to deliver a lecture at the Graduate Center, and to visit the original apartment of Louise and Walter Arensberg, located at 33 West 67th Street. Unfortunately, that apartment had been completely renovated and looked nothing like it did during the heyday of New York Dada, but the unit directly above it, which was owned by the *Life* magazine photographer Philippe Halsman and now occupied by his widow, was untouched. Since I felt this would be an historic

event, I invited my professor Robert Pincus-Witten to join us, along with several other students from the Graduate Center, and we all visited the apartment together. The minute Beatrice entered the space, she began to tell us where everything was originally located, even the pictures on the walls. She especially remembered where they hung the Matisse over the fireplace, for her own conversion to modern art took place one evening while looking at that picture (an event she recounted in her autobiography). We were then allowed to visit the smaller studio apartment that Marcel Duchamp occupied, which was accessible to the upper level of the Arensberg apartment through a short hallway. There, too, she remembered the space vividly. She pointed out where a Murphy bed swung out from the wall, and the spot where he placed chocolate bars on the windowsill during the winter months. We all later went to dinner at the Café des Artistes down the street, but its décor had completely changed and Beatrice did not recognize a thing. Still, it was a magical evening, one that none of us will ever forget. Serving as our guide, Beatrice gave us a rare and privileged glimpse into a moment in time that, chronologically, none of us could have experienced, but which as art historians we all knew had changed history.

I was still feverishly at work attempting to get Beatrice's autobiography published and arranging for a show of her drawings. On one of my trips out to Ojai, Beatrice allowed me to take a selection of her drawings back with me to New York. I showed them to Anne d'Harnoncourt, who was then still a curator at the Philadelphia Museum of Art (later she would become its director). She loved the work, understood its significance and immediately scheduled a show, which was held in a long corridor of the museum in 1978. Beatrice flew out for the exhibition and, on the day of its opening, announced that the museum could have any of the works

it wanted for its collection. Anne selected the only painting in the show, *Nuit Blanche*, which was shown in the 1917 Independents Exhibition, and seven drawings. She also wanted *Lit de Marcel*, but Beatrice had already given that drawing to me, and it remains in my collection to this day. Upon the close of the exhibition, I arranged for the remaining works to be shown in a commercial exhibition at the Rosa Esman Gallery in New York, where Barbara, my girlfriend at the time, was employed as a receptionist. Arturo Schwarz, the dealer from Milan who was also the reigning expert on Duchamp and Dada, showed up and purchased four or five drawings, but from the standpoint of sales, it was not a great success. Beatrice herself dismissed her drawings, saying they were nothing more than "mere scrawls," but admitted that they took on the appearance of actual art when they were framed and hung on a wall. The show was accompanied by a small catalogue, for which I penned a brief introduction. I sent a copy to Leo Steinberg, who wrote telling me that he found my introduction enjoyable, but, he added, "[It's] too bad only that she had no talent." Of course, his definition of talent was someone possessed with the ability to render the objects of this world with convincing verisimilitude, so he was unable to see the value of these drawings as documents that provided rare and important views into history that we would not otherwise possess.

I experienced even less success in my efforts to get Beatrice's autobiography published. I carted the manuscript around to various publishers for four or five years and faced repeated rejection. Each time, they would hand it back to me without comment, until I realized that no one was actually reading it. I eventually learned that Suzi Arensberg, the great-niece of Walter Arensberg, was working as an assistant editor for Holt, a major publishing company in New York, so I called and asked if I could submit the manuscript to her. She

promised to read it. After only a few weeks, she called and asked me to stop by Holt's offices. When I arrived, I met four or five editors, all of whom, I was pleased to learn, had read the manuscript. They asked me to sit with them around a conference table to discuss their recommendations for publication. All of them agreed that the text appealed to too many divergent interests, and they listed no fewer than five: (1) people interested in pottery; (2) feminists; (3) art historians like myself, especially those interested in Duchamp; (4) India (three chapters of the book were devoted to her travels there); (5) people interested in Krishnamurti (whose many books were published by Holt). An autobiography, they contended, was only worth publishing when the person writing it was already famous, or if the writer focused in so tightly on one aspect of his or her accomplishments that it was more about that subject than about the person writing the book. Only then, they said, could the book be properly marketed and sold. When I relayed this information to Beatrice, she said that it would be impossible for her to rewrite the book. "I lived only one life," she said. "And this was the only way I know how to write about it."

The manuscript lay in limbo for another two years until I met Rick Dillingham, a potter who had studied with Beatrice at the Happy Valley School (on whose land Beatrice lived). When I told him about my difficulty in getting the book published, he said that he would be willing to lend $25,000 for a private printing, whereupon, in the form of collateral, I volunteered to give him five or six drawings and a complete set of the lithographs that Beatrice had produced in the early 1930s. At this point, Beatrice had entrusted me with all of her drawings, instructing me to keep those that I wanted but use the others in any way I saw fit, even as donations to museums (and I have made many over the years). Rick eagerly accepted my offer, and we arranged for the book to be

published by Peace Press, a printing company in Los Angeles. Beatrice sold copies of the book to anyone who visited her studio in Ojai, and they sold briskly, allowing her to pay back Rick Dillingham in less than a year (although by then he had grown so attached to the drawings that he decided to keep them; upon his death in 1994, they were given to the Santa Fe Museum of Art). Three years later, *I Shock Myself* was picked up by Chronicle Books, a major publishing company in San Francisco. Despite its diverse appeal—or perhaps because of it—the book sold well and, I am pleased to report, has already gone through two subsequent printings.

Since Beatrice was such a close friend, I decided that on one of my visits to Ojai, I would ask if she would teach me ceramics. I had taken a pottery course when I studied in Italy and knew how to throw a pot, but learned nothing about glazing and firing. She agreed, so I planned a one-week stay at her home (by now when I visited, she put me up in a back bedroom on the opposite end of her home from the studio). We spent a day making pots, and she showed me how to mix the chemicals to form a glaze. The most exciting part of the whole process was the firing, for you never knew how things would turn out. It all depended on the temperature of the kiln, and on the materials you threw in during the firing. When the doors opened, it was like looking into a treasure chest, especially if the luster glazes that Beatrice often used came out as she had intended, as they did on this particular occasion. It was pure alchemy, for clay taken directly from the earth magically transformed itself into gold. When the vessels cooled, we placed them on stands in Beatrice's showroom, where visitors came on a regular basis to meet her and purchase examples of her work. Within hours, the first visitor arrived, but by then Beatrice had gone into her bedroom for her usual afternoon nap. The woman purchased one of the vessels that came out of the kiln earlier that day for

$800, and I was very anxious to tell Beatrice as soon as she got up. A day earlier, she had complained that her electricity bill was quite high. I had no idea how well she was doing financially, but I thought this would be welcomed news.

When I told her about the sale, telling her that she had just earned $800, she said, "No, it's only $400, because I have to give half to my dealer." "Who's your dealer?" I asked. She said, "John Waller, who lives in Los Angeles." I was stunned. How could this person be earning half of what she produced when he hadn't even seen the work? "When and where did he last give you a show?" I asked. She said that he had closed his gallery—which was called Zachery and Waller—some years earlier but still continued to function as her dealer. Now I was angry. There was no question that Beatrice was shockingly naïve when it came to all matters concerning business, but, the way I saw it, this person was clearly taking advantage of her. I asked if I could call and speak with him about this arrangement, and she gave me his number. As soon as I got Mr. Waller on the phone, he became quite defensive, and when I suggested that what he was doing was unethical, he hit the ceiling, telling me that he would call his lawyer and bring suit against me if I continued to interfere with his business practices. Knowing that I had very little to lose (at the time I had virtually no money and few possessions), I invited him to go ahead and do so, for I believed that extracting a commission on the sale of work he had never seen verged on outright criminal behavior.

As luck would have it, the very next day two people walked into Beatrice's studio who changed everything. Garth Clark and his partner Mark Del Vecchio had visited Beatrice before, and they were now thinking about opening a gallery in Los Angeles devoted exclusively to ceramics, but did not want to take the risk unless Beatrice agreed to show with them. They could not have come at a better time. Because of her age

and reputation, however, I insisted that any agreement they make with Beatrice reflect a split in sales as 60% to her, 40% to them, and that whatever works they did not take for their gallery, she be allowed to sell in her studio without giving them a commission. They thought that was fair enough, and within a few months, after Beatrice's relationship with Mr. Waller was severed, contracts were signed and she was given her first show at the Garth Clark Gallery in Los Angeles (they later opened another space in New York, where Beatrice would also show). Over the years, the value of her pottery gradually increased, until, as Beatrice once said, "No one can afford to eat on my pottery except me." Indeed, when Clark and Del Vecchio closed their gallery in New York, they told a journalist: "Vessels by Ms. Wood have sold for more than $100,000." Later, they told me privately that this was a bit of an exaggeration, although some were known to have sold in the high five figures.

Garth Clark was reluctant to represent Beatrice's figurative ceramic production, and he wanted little to do with the drawings, delegating them to my domain. When I once asked him why he chose not to represent the figurative work, he explained that the humor it contained made it difficult for him to ask such serious prices for the traditional ceramic vessels. I understood and accepted his rationale, but still felt it neglected an important aspect of her work, one that best revealed her whimsical personality and, in some instances, her irrepressibly flirtatious nature. It was for this reason that I decided to organize a museum exhibition devoted to this work, which I proposed to the Oakland Museum of Art in the late 1980s. I thought they would be especially receptive to the idea, because some years earlier they purchased from the show I organized for the Rosa Esman Gallery her *Carte de Noël: What the Doctor Took Out,* a collage from 1937 that displayed a woman's torso with the central body cavity

open and filled with an assortment of desktop artifacts: a string represented the digestive tract, on which hung a small key, and below, a circular washer hung from a metal paper clip, which mimed the position of female reproductive organs (Beatrice told me that she was earlier operated on for a hysterectomy). This was the first work reproduced in *Intimate Appeal: The Figurative Art of Beatrice Wood*, the catalogue for an exhibition of that title that was held at the Oakland Museum in the winter of 1989–90, and traveled to the Craft and Folk Art Museum in Los Angeles the following summer. On the cover was reproduced Beatrice's *Is My Hat on Straight?*, a work that featured the figure of a woman seated on an ornate bench, her only apparel being a pair of laced black shoes, elbow-length black gloves and a large hat festooned with flowers from which hung a long red ribbon. The humor is obvious, for although the woman is exposed in all her glory to the public, her only concern is to know whether her hat is on straight, typical of the bawdy humor that so often appealed to Beatrice.

The exhibition also contained drawings, many of which were lent from my own private collection. Earlier, Beatrice had given me five examples of her famous *Blindman's Ball* poster of 1917, three of which I immediately donated to museums on the East Coast (including the Yale University Art Gallery and the Museum of Modern Art in New York). Since the Oakland Museum had agreed to put on the show, I gave them the last remaining example of the poster, other than the one I retained for myself. Reviews of the exhibition were universally positive, the majority seizing upon the fact that Beatrice was still an active and productive artist at the age of ninety-six. Rather than resent that sort of attention, Beatrice accepted it, for any publicity that reflected positively upon her work seemed worthwhile. What she resented was fame for its own sake. When she first told me about

her friend Helen Freeman, I did not know who she was, so Beatrice stopped and asked: "What is fame?" Helen was her friend, but at one time, she was also the most famous person she knew; she had acted in many Broadway plays, and even in some Hollywood movies, but was now—in the years after her death—completely forgotten. Fame, the way Beatrice thought about it, was fleeting and hardly worth the time and effort expended in desiring it.

With my many trips out west to visit her, Beatrice began to fear that I would get bored. She would always have some sort of gift waiting for me, a small piece of pottery or a drawing. Once I found an important early drawing, *Soirée*, resting on my pillow, a work that someone purchased from her in the 1930s for $5 and, having lived with it for some forty years, thought she would like to have it back. On another occasion, she was invited to a dinner in her honor held at the home of a wealthy German collector whom she did not really like, but she thought that I would be impressed by the surroundings. When we arrived, the collector handed her a packet of easy-wipes, telling her that she could use them to remove the caked makeup on her face. Beatrice was naturally insulted but said nothing, not wanting to create a scene. When we were leaving, she gestured to two attractive young women, who, she said, were coming back with us. Beatrice sat in the front seat with the driver, and I sat in the back between the two girls. We were not even halfway home when they both started aggressively coming on to me. I knew that something was up, because nothing like this had ever happened to me before, so I asked what they were doing. They refused to answer, but just kept giggling and wouldn't stop. When we got to Beatrice's house, she scurried in, and I demanded to know what was going on. They said that they were lesbian lovers, and Beatrice had asked them to make love to me. They agreed to do it because, they said, they loved her and

would be willing to do whatever she asked. I thanked them for the gesture, but said that it would not be necessary and politely asked them to leave. Beatrice knew that I liked young women, but this was going a bit too far. When she found out what happened, she was disappointed but understood.

The subject of prostitution had always fascinated Beatrice. By the time she reached her ninetieth birthday, she had not been sexually active for nearly a half-century, and she fantasized about being the madam of a bordello. She felt that the world's oldest profession had a rightful place in our society and should be legalized. What this position fails to acknowledge, of course, is that many women who become prostitutes do so because they have no other legitimate means of generating an income, and they are, therefore, victims of any society that permits this activity. Beatrice, on the other hand, thought about prostitution from a more romantic and somewhat naïve point of view. She actually believed that it could be used to solve the world's problems. "Women should not sleep with men just for money," she contended, "but to control and force them to change the way society works, especially as a means by which to prevent war." To illustrate her position, she once made a figurative ceramic sculpture of a couple *in flagrante delicto* and called it, appropriately, *Settling the Middle East Question*.

When Beatrice Wood reached her ninetieth birthday, I had already known her for some seven years. By then she was a highly accomplished and respected potter, famed worldwide for her brilliant lusterware glazes. She kept her age a secret. When asked, she would respond like a Hollywood celebrity (she had worked for a brief period as an actress in New York before moving to California), saying that such a question was inappropriate to ask of a woman. Whenever someone wrote to her asking for the year in which she was born, she would always reply, "1703." The recipient would

naturally assume that she had made a typo and correct the date to 1903, thereby making her ten years younger than she actually was (since she was born in 1893). She would continually maintain that she never lied about her age, and she didn't, of course, since the false information was reported by the person who assumed she had made a mistake. Lying about her age changed all at one moment, when she woke up on the morning of March 3, 1983, the day of her ninetieth birthday. I was with her on that day (as I was for nearly every birthday during the time of our friendship), and she awoke to make several important decisions that would affect her throughout the remaining years of her life. When we met for breakfast, she announced that she wanted to go into town. I asked her where we were going, and she said, "You'll see. Be patient." She got behind the wheel of her car and used several pillows to prop herself up to a position where she could see above the dashboard. We drove straight to the Ojai Police Department, where she went into the lobby and handed her license to a clerk at the front desk. When he asked what she was doing, she responded, "I'm ninety years old today. I do not think old people should drive," whereupon she left her license on the counter and turned around to me and said: "Now please drive me home."

When we returned to her home, I noticed that something had changed in Beatrice. Although she was always optimistic and upbeat, she seemed happier than I had ever known her. At the time, I did not question her about this change, but I would later figure out that on that day, she had made several other decisions about herself. She would no longer lie about her age, because she finally accepted it. She stopped dyeing her hair, but still could never stop herself from flirting with every man who came into her presence. It was an endearing quality, not one always appreciated by the man's partner, if he had one, nor by any outspoken feminists. When the

actress and singer Bette Midler once visited her at her studio, Beatrice told her that women should all lie at the feet of their men and praise them, whereupon Midler allegedly ran out of the studio screaming. Beatrice loved to provoke. On her ninetieth birthday, she also decided to go into her studio and make a series of large-scale chalices, each covered with her trademark iridescent glaze, vessels that were unquestionably the most physically powerful works of her career. What brought this on? The question is probably best answered by knowing how she responded to the remark made by an elderly man who visited her studio around this time. Since they had both reached a fairly advanced age, he was under the impression that they had a lot in common, so he was anxious to ask her the following question, which he probably assumed was rhetorical: "Nothing gets better with age, does it?" Without missing a beat, she quipped, "Sure it does. Fear of death." That sort of attitude—being completely free to speak your mind on whatever subject comes up—is, I suppose, a characteristic exhibited by many people of advanced age, but it was the way Beatrice spoke throughout her life. It was a quality that I noticed upon my first visit to her home and one that would never change.

In 1987, I was about to turn thirty-nine years old, and Beatrice informed me that I was getting a little too old for her liking. Many things happened to me in that year, events that represented a critical turning point in my life.

1987

The year 1987 began badly, or so it would seem. On the morning of January 19 I suffered a severe stroke (actually, a cerebral infarction) that left me partially paralyzed on my left side and nearly blind in my left eye, a traumatic and unexpected experience from which—thankfully—I fully recovered within six months. At the time, I did not know what caused it. Only years later would I learn that it was due to a congenital heart defect (I was born with an atrial-septal aneurysm in the upper chamber of my heart, which sounds lethal but which, in actuality, is commonplace and usually benign). I was told that a full recovery from a stroke was possible for people under forty, and since I was only thirty-nine, I was narrowly within the range and managed to pull it off. I had not thought about it previously, but when you are taken seriously ill like that, it means a great deal to realize that you have friends who care for your well-being. You find out exactly who they are when they take the time to visit you in the hospital. I will never forget, and forever harbor affection to the end of my days for those who came to visit me.

Unquestionably the most important visitors—from both a medical and emotional standpoint—were my brother and his wife Heidi, who was just about to give birth to their first child (and she would do exactly that two days after visiting me at the hospital). Inadvertently, they saved me from more permanent damage to my brain than would have occurred otherwise by arranging for a CAT-scan, which caused the doctor to place me supine, thereby increasing blood flow to

my brain and allowing me to regain consciousness (I was later told that if that had not happened when it did, I would probably still be on my back or, worse yet, someplace underground). Among the visitors at my bedside were Jack Flam (my friend and professor from the Graduate Center), John Cauman, Michael Sgan-Cohen and Susan Ginsburg (students from the Graduate Center), Hester Diamond (a collector and friend) and, finally, John Rewald, who said he was devastated to realize that I almost made my departure from the planet before he did. Beatrice Wood learned about my illness later, and was equally horrified to hear that I had come so close to death, which, because of the vast difference in our ages, she found unbearable to contemplate. The one person who was conspicuously absent was Leo Steinberg, whose apartment window I could see from my room in St. Luke's–Roosevelt Hospital. I later asked him why he never bothered to visit, and he said that he was quite concerned about my condition, but could not bear to visit anyone in the hospital. He explained that he was unable to do this for an even closer friend who died a few years earlier, because he could not endure the frustration of not being able to do anything to improve the situation. It was the best explanation that I would ever be given, and I realized that little would be accomplished by pushing it further. Everyone handles dramatic situations differently, and I suppose not confronting them—especially where you know there is nothing you can do—is as effective as any other way.

The incident changed my life. It left me with a determination to get some things done before it was too late. Since I had been in the Ph.D. program at the Graduate Center for over a decade, I decided that I needed to finish my dissertation as soon as possible. I had been gathering information for years, but now I decided to sit down and complete the writing, not allowing any outside projects to

interrupt. My motivation was quite simple: I knew many who had not completed their doctorates—earning the degree of A.B.D. (All But Dissertation)—and I was determined to have the letters Ph.D. follow my name in an obituary. Ironically, after I submitted my dissertation in the fall of 1987 (the degree was conferred upon me in the spring of the following year), I never once used the designation professionally. Instead, I had cards printed up that gave my name and, below it, the words "Pilot, Single Engine Land." I had obtained my pilot's license at the same time, and in the end I was far prouder of that accomplishment than any academic degree I possessed. Since childhood, I'd had a burning desire to fly, brought on, I suppose, by a terrible fear of heights. This same fear probably caused me to have repeated dreams of soaring through space, usually being chased by someone who wanted to inflict bodily harm. Once I began flying, the dreams went away, but not my fear of heights (which is probably why anything to do with airplanes continues to fascinate and attract me).

The year 1987 also marked the centennial of Marcel Duchamp's birth. Several institutions decided to celebrate the event, and because of my years of dedication to this one artist, I was invited to participate. The first was a symposium organized by Thierry de Duve, the Belgian-born Duchamp scholar, philosopher and art critic, held at the Nova Scotia College of Art and Design in Halifax, Nova Scotia. It was a quite a remote location for a conference on Duchamp, I thought, but they managed to get some of the most important Duchamp scholars of the day to present papers: Jean Suquet, a Frenchman who knew Duchamp and who had written on the "Juggler of Gravity," an element in the *Large Glass* that was never realized; William Camfield, the Picabia scholar who had organized a major exhibition on Duchamp's *Fountain* for the Menil Collection in Houston (which was scheduled to open before the end of the year); Herbert Molderings,

the foremost German scholar of Duchamp; Craig Adcock, who had written on Duchamp and the Fourth Dimension; Molly Nesbit, who taught at Vassar and had lectured often on Duchamp; André Gervais, a Canadian Duchamp scholar who had written many articles and books on the artist; and, finally, Rosalind Krauss, who was not a Duchamp specialist, per se, but probably the best-known art historian in the bunch, for she taught at the Graduate Center, was editor of *October* magazine, had written many influential books introducing French theory to American art history and enjoyed a wide and faithful following among younger art historians.

I delivered a paper called "A Reconciliation of Opposites," where I proposed that Duchamp's effort to resolve innate contradictions formed the basis of his work, a philosophical approach to the artist that was unusual for me, for until then, I had been primarily interested in factually driven history, information that provided individual works of art a broader context within the artist's life and times. The paper was fairly well received, but at the end of every presentation, questions were invited from the audience. I was a little nervous about this, for the questions could be asked in French, and although I could read the language fairly well, I was not conversant and worried that I might not understand them. Luckily, I experienced no problems, until the very end, when a strikingly attractive brunette wearing a black leather skirt and a tight pink mohair sweater slinked up to the microphone and asked me a question that I could not completely comprehend (and it was in English!). It didn't matter, because I managed to answer the best I could, and when the session ended, she walked up to me and asked what I was doing for dinner. I was shocked, for something like this had never happened to me before (nor, for that matter, since). I told her that I was free, and after dinner we spent the next three days frolicking in my hotel bedroom. The way I reasoned, I had worked on

Duchamp for nearly twenty years and on this occasion—his hundredth birthday—he decided to give me a gift, which I graciously accepted. After all, I was single, and since the *Large Glass* involved a Bride in quest of her Bachelors, I rationalized that the event was a physical enactment of the same theme that had preoccupied Duchamp in his youth. It all made perfect sense.

When the conference concluded, I flew back to New York on a plane with André Gervais, who had to switch flights before returning to Québec, where he lived. During the flight, he told me two facts about Duchamp's life that I had not known before: (1) he had an illegitimate child born in 1911 who was still living in Paris; and (2) the *Étant donnés*—the nude female figure lying on her back in an outdoor setting with her legs spread-eagled, viewed through two peepholes in an old wooden door in the Philadelphia Museum—was based on a secret girlfriend he had in the 1940s, a woman with whom Duchamp was desperately in love. These facts came as a shock, partially because I believed that the artist kept most of the women in his life at a distance, and that he would not allow himself to become seriously involved with anyone because it would only serve to inhibit his freedom. In his book-length interview with the French critic and art historian Pierre Cabanne, the first question he asked was: "Looking back over your whole life, what satisfies you most?" Duchamp's response was one that I had committed to memory, for I used it as a guiding principle in my own life. "I understood, at a certain moment, that it wasn't necessary to encumber one's life with too much weight, with too many things to do, with what is called a wife, children, a country house, an automobile." But this new information relayed to me by André Gervais—that Duchamp had a child and, at least once, had fallen deeply in love—contradicted everything I knew about the artist, particularly in light of what he said in

that interview a few years before his death. I was so enamored of everything that Duchamp did or stood for that, to the best of my ability, when it came to emotional attachments, I tried to follow his lead. Whenever a relationship of mine threatened to become serious, I instinctively cut it off. In the fifteen years since I had left Chicago, I had had only two long-term relationships, and they both ended disastrously. I was determined to never get involved with anyone ever again. The fact that Duchamp was able to let down his reserve opened the possibility that I might one day consider doing the same, should the right person ever come into my life. At first, I did not think this information about Duchamp's private life was pertinent to my study of his work. Over the course of the next five years, however, I would systematically gather as much information about these events as I could find, eventually determining that they were critical to the most ambitious works of art that Duchamp created in his lifetime—the *Large Glass* and *Étant donnés*—facts that would alter my view not only of his life but, unexpectedly, also of mine.

The next Duchamp event that took place in 1987 was held at the Philadelphia Museum of Art, an appropriate venue, since it held the largest collection of his work anywhere in the world (as part of the Collection of Walter and Louise Arensberg, which was left to the museum in 1953). I was invited to conduct a public interview with Beatrice Wood on October 17. I arrived in Philadelphia a day earlier and checked into a hotel that the museum had reserved, only to discover that the woman I met in Nova Scotia was also there and had insisted upon seeing me. We had a tumultuous half-hour session in my room, after which she asked if I could help get her into a dinner party that was planned for the next evening at the home of Anne d'Harnoncourt, by then director of the Philadelphia Museum of Art, and her husband Joe Rishel, a curator of European art at the museum. I told

her that it would be absolutely impossible, because Anne had already warned me that the space in her home was limited, and they expected many guests. She seemed to have accepted this explanation, and after she left I went over to the hotel where Beatrice was staying. I told her about my unexpected afternoon guest, a person I was beginning to tire of, since I felt that our romp was only designed to get something out of me.

My interview with Beatrice was conducted on the stage in the museum's auditorium, and nearly all the seats were taken. I can recall having seen a number of important people in attendance. Teeny Duchamp (Marcel Duchamp's widow) sat with her daughter Jacqueline and the artist Jasper Johns. Anne d'Harnoncourt introduced us, and we sat down and spoke while viewing slides that I had selected to guide the conversation. When I asked Beatrice about her relationship with Marcel, she brought up Roché again (as she had in my first interview with her) and informed all of us right away that she had "slept with both men, but," she added after a brief pause, "not at the same time." The remark brought the house down; everyone burst out laughing and applauded. What I did not notice at the time but learned later was that the comment caused Teeny Duchamp to get up from her seat and leave the auditorium. Frankly, I thought it was a rather childish reaction, since Beatrice's relationship with Duchamp had preceded hers by some thirty-five years, so any thought of jealousy would seem chronologically misguided. A few years later I visited Teeny at her home in Villiers about an hour south of Paris, which I did nearly every summer, usually with the intention of remaining in contact with her and to enjoy a friendly game of chess (she was a very strong player, far better than me). With Beatrice's permission, I gave Teeny a drawing that she had made of Duchamp seated in a chair. When another visitor inquired about who made the drawing,

I overheard Teeny say: "Oh, it's by an artist who used her relationship with Marcel to get famous." It was a cruel and nasty dismissal of a person whom I loved dearly, but I said nothing to Teeny, because she was now herself advanced in age and I did not think anything could be accomplished in objecting to her remark. Besides, I needed her continued support in my various projects on Duchamp, including a book of letters that I was in the process of working on at the time.

At the end of my public interview with Beatrice, I did something that was a bit out of character for me. I announced to the audience that I would not be forgiven if I did not do something they probably all would have liked to do themselves, so I bent over and gave her a kiss on the cheek. The auditorium erupted in applause, and Beatrice smiled broadly, looking more radiant than I had ever seen her. Later that evening we attended the dinner in her honor at the home of Anne d'Harnoncourt and Joseph Rishel. They lived in a beautiful brownstone row house on Delancey Street off Rittenhouse Square. It featured a large, double-height living room with windows overlooking the street and, off to one side of the room, a wood ladder that went to an upper loft. At one point as Beatrice and I were in a corner of the main room eating our dinners on paper plates with the rest of the crowd, we heard a lot of commotion and looked around. There, stark naked and descending with grace from the ladder, was the young woman I had met in Nova Scotia, whereupon the whole crowd burst into applause, for we all immediately got the joke: she was reenacting Duchamp's *Nude Descending a Staircase*. The only awkward moment was when she turned around and climbed back up the ladder, for that was not a vision that made any sense within the context. When her performance ended, Beatrice turned to me and asked: "Is that your little trollop?"

Two days after my return from Philadelphia, another important event occurred in my life. I moved from my small one-bedroom apartment on the Upper West Side (where I had lived for fifteen years) to a much larger, loft-sized space on Fourth Street and Broadway, into a building that had been recently converted into duplex condominium apartments. Sue Ginsburg, a student at the Graduate Center and a good friend of mine at the time, lived in the same building, and I had gone to visit her often, usually to attend informal dinner parties that included Jack Flam, Irving Blum (legendary director of the Ferus Gallery in Los Angeles), and John Coplans (former editor of *Artforum* and writer-turned-photographer in his late years). The conversations were scintillating, entertaining and memorable, but what I envied most was the spacious surroundings of Sue's apartment. When a similarly configured unit came up for sale in her building, I wanted to buy it, but a real estate broker who showed me the space told me that I could never afford it. Although I resented the comment, I had to confess he was right. On a teacher's salary, I could ill afford to purchase such a lavish dwelling, but I did have one asset that I was previously unwilling to part with: a collection of about fifteen works by Marcel Duchamp that I had quietly assembled over the previous decade. There were several original drawings and a number of important, limited edition works, including four readymades from the Schwarz edition that I had purchased after they failed to sell at an auction in 1985 (this included the snow shovel and even the urinal). I thought of myself as a collector at the time, so I would never have considered selling these works unless I were desperate, which, at the time, I was.

I still did not know what caused the stroke I experienced earlier in the year, but thought that it might have been the result of stress. In my small apartment on the Upper West

Side, I could hear every footstep of the person who lived above me, and it was beginning to take its toll on me both physically (we did not share the same sleeping habits) and psychologically. The new apartment that I was looking at had concrete floors and ceilings, eliminating that problem. In order to raise the money to buy it, I decided to try selling my Duchamp collection. As luck would have it, Dina Vierny, a dealer from Paris and an old friend of John Rewald's, was looking to buy works by Duchamp, for she wanted to have an exhibition at her gallery in Paris. She also planned to include the works as part of a larger collection that would form a museum in the name of Maillol (the great French sculptor of female nudes, whom she knew personally and whose estate she represented). When I pointed out to Ms. Vierny that Maillol had nothing to do with Duchamp, she agreed, explaining that her overwhelming interest in Maillol had caused her not to give Duchamp the attention she felt he deserved as the important artist he was, and she wanted to make up for it while there was still time. I not only sold her my entire collection of work by Duchamp, but also received a commission on the purchase of other works by the artist that I found for her among various dealers and collectors in New York.

Ms. Vierny wired the money directly into my bank account in New York, which made me feel momentarily rich, but simultaneously depressed, for I was now left with having to relinquish physical possession of the work I loved. She asked me to bring everything over to the gallery of Klaus Perls, a dealer on Madison Avenue with whom she had conducted business; he would arrange to ship the work to Paris. On the day when I dropped it all off, I took one last look at everything and began to choke up. When I attempted to get a receipt from the young man working at the counter, he noticed my distress and asked if I was upset about having

sold the work. When I responded in the affirmative, my voice broke, whereupon he lit into me like a drill sergeant. He severely reprimanded me for getting emotional over inanimate objects, which, after all, he said, only existed for the indulgence of the mind and eyes. He thought it was an especially naïve way to act with works by Marcel Duchamp, for they were essentially conceptual in nature and, even without the object that represents the idea, you always have the concept to take home with you. "People should cry over the loss of people," he said, "not works of art." Of course, he was right, and I needed the lecture at the time, for it allowed me to leave the gallery without the sense of loss that I might otherwise have felt. What I had not realized at the time and only learned later was that this young man who gave me the receipt was the former lover of Klaus Perl's son, who had died a few months earlier of AIDS.

With the funds this sale represented, I was able to purchase the new apartment on October 19, 1987. When I came out of the closing I called my brother to tell him the good news, only to have him tell me that the stock market had collapsed earlier in the day. It was Black Monday. Due to a frenzy of selling that began in Hong Kong, the Dow Jones Industrial Average experienced the largest single one-day percentage drop in its history. I didn't really feel too bad about it, however, since I knew that I would remain in the apartment for quite some time, hopefully long enough for it to regain the value it had suddenly and unexpectedly lost (which, in fact, is exactly what occurred when I sold the apartment to move into an even larger space in the same building five years later).

Many of the events that occurred to me in 1987 were a result of having had a stroke earlier in the year, in part, I suppose, because I suddenly became aware of the fact that life was a gift, and I had better do whatever was in my power

to live life to its fullest. What I did not realize at the time was that the experience would significantly contribute to my meeting and marrying the woman of my dreams. After some twenty years of chasing one girl after another, I finally found someone with whom I could develop a serious and meaningful relationship. "Found" is not exactly the right word, for I had known Terry for some fifteen years. We first met when we were both students at the Art Institute of Chicago. She was one of the most wonderful people I had ever known, not only attractive but possessed of an endlessly entertaining sense of humor. I had another girlfriend at the time, so for some months my relationship with Terry remained platonic. Still, I enjoyed every minute I spent in her company, so I kept making up excuses to see more and more of her. Once when we were walking though a grocery store together, she said that she loved eating salads and if she were rich she'd buy every bottle of salad dressing on the shelf. Without saying anything, when Christmas came, I gave her a large box filled with every different flavor of salad dressing the store sold, a gift she never forgot. When our friendship progressed to romance, I was still not in a position to settle down, but apparently she was. Shortly after graduating, we both moved from Chicago to New York. I took over a job my brother had teaching advanced-placement art history in a private high school on the Upper East Side, and she worked in the registrar's office at the Museum of Modern Art. We remained friends, and I was even invited to attend a reception at her home following her first marriage. As a gift, I gave her a set of mounted and framed sugar packets bearing the portraits of famous women from history—from Annie Oakley to Helen Keller—but the one positioned in the center was a portrait of Terry at eight years old that I had carefully drawn, copied from a photograph that she had given me years earlier.

Years went by. Terry got divorced and even married again, but I always kept in touch with her. I also learned about what was going on in her life from her brother Tommy. He lived in Chicago when Terry and I were at the Art Institute, but moved to Los Angeles and got married. I saw him on occasion when I went out to visit Beatrice Wood, and even stayed in his home until he and his wife had a child. He was a professional photographer, and took a memorable portrait of Beatrice striking a pose on the back terrace of her home in Ojai, against a dramatic backdrop of distant mountains. He had the same sense of humor as Terry, which I always enjoyed. After I had recovered from my stroke, I called him and told him all about the incident, which he relayed to his sister. By then, Terry was living in Allentown with her second husband, but things were not going well. She called me in shock, not having known anything about my condition, but I assured her there was nothing to worry about, that it should never happen again (just so long as I took a low-dose aspirin daily).

Nearly a year went by, and I called her on the occasion of her fortieth birthday, only to discover that her husband had not planned anything, which I considered appalling. I invited her to meet me at the Allentown airport. In order to remain current as a pilot, I had to fly on a regular basis, so this seemed like a good idea, since I was running out of destinations within range of my home airport in Somerset, New Jersey. I picked her up in Allentown, and together we flew to a small airstrip in Northern Pennsylvania to have a late lunch. Neither one of us had realized how late it was getting, so rather than return her to the Allentown airport, I decided to fly back to Somerset. By the time I was ready to land, it was pitch black, and I remember asking if she was afraid, for I had very little experience flying at night. "There's nothing I can do," she said. "So what's there to be afraid of?" We landed

safely, but as luck would have it, when I picked up my car, it was dark where I was parked and I drove into a mud bog. The impacted wheel rim made it impossible to go more than forty miles per hour. As a result, by the time I got Terry home, it was well past midnight. I asked if she would ask her husband if I could spend the night in a spare bedroom, which I thought he would understand, since my car was partially disabled and it was so late. She went into the house and asked, but returned to tell me that he would not allow it, for he suspected we were having an affair. We were not, of course, but I must confess that I spent the next four hours driving home wondering why we weren't. After all, I had already been punished for something I hadn't done, so, I reasoned, why not do it?

Gradually over the course of the next year we began seeing more and more of one another, until everything came to a head during the summer of 1989. But then another complication arose in my life, one that involved a woman whom I had met a few years earlier in Milan.

HANNAH AND JOHN

In January of 1989, during one of my summer trips to Italy to visit my friend Mino, I met Hannah Niemand, an attractive, nineteen-year-old German woman, near the entrance to the Poldi Pezzoli Museum in Milan. Mino had told me that this particular museum was a former private residence that contained many great examples of Renaissance and Baroque art, and I looked forward to visiting it with him. As we approached the entrance, Hannah was standing near the front door seemingly waiting for someone. Since I was not then yet romantically involved with anyone, I decided to try speaking with her, just to see how far it would go. When I approached and asked a question in Italian, she ran away from the building, clearly convinced that I was just another Italian hitting on a blonde foreigner. I immediately apologized, but this time spoke in English, whereupon she was instantaneously more welcoming and receptive. We had a delightful tour of the museum, for I was always anxious to impart my knowledge to anyone willing to listen, especially a beautiful young woman. Mino and I had dinner with her afterward, where I learned she was from Hamburg, the very city in Northern Germany where my father grew up. My father always told me that he spoke *Plattdeutsch*, which, he thought, was a lower form of the language. She explained that it was still spoken in Northern Germany and the Eastern Netherlands, and she gave me examples of how the language differed from High German. I can recall thinking to myself how John and Leo would enjoy meeting her, since they were

both linguists of sorts, shared a common language with her and, I was fairly certain, would like being introduced to such an attractive young woman. When Mino and I deposited her at her hotel later that evening, she apologized for not being able to invite us in; her boyfriend was waiting for her in their room, she explained, and would likely be very upset. The way I saw it, it was hard to blame him, for she was an alluring person on many levels. We parted company, exchanging addresses and phone numbers, but I never thought I would see her again. When I returned to New York at the end of the summer, however, I received a letter from her, and we entered into a casual correspondence.

In the fall of 1989, she sent me a letter saying she was planning a trip to New York and would like to see me again. This sent me into a panic, for by then I was already seeing Terry, the woman who would eventually become my wife. She was then still living in Allentown, but we saw one another on weekends; either she would come in by bus to see me, or I would drive out to see her. Clearly, I could not have a young woman like this staying with me in my apartment, not because I thought it would be too much of a temptation, but because of my ongoing relationship with Terry, it simply did not seem appropriate. When Hannah arrived, I met her at the airport and took her to my apartment, where I installed her in a guest room and explained my situation. Thankfully, she completely understood and said that she would stay with her former boyfriend (the same one who waited for her at the hotel in Milan), who was then a student at Rutgers University and was living near the school in New Jersey. I felt bad about abandoning her, however, so in the form of a minor consolation, I proposed introducing her to two German-speaking friends of mine, John Rewald and Leo Steinberg. Both men were unmarried and considerably older than she, I warned her, yet they were both charming in their own

separate ways and I thought she might enjoy their company. The next day I called and made the necessary introductions, never imagining that it would amount to anything. She called a few days later and thanked me warmly for having introduced her to such profoundly interesting people. From what I understood, they enjoyed her company as well, but to what extent, I had no idea. I figured they were grown men and could fend for themselves. It seemed best not to interfere, especially since I was very much in love with Terry and had no interest in knowing anything more about what Hannah was or wasn't doing.

As I would only learn a few months later, she was doing plenty. I knew that she would enjoy meeting Leo, because she had a deep interest in James Joyce and, in particular, his epic novel *Ulysses*. Leo held Joyce in exceptionally high regard and considered *Ulysses* the absolute pinnacle of Western literature. He read the book yearly and loved reading it aloud to anyone willing to listen. He had exactly the voice for it, soft and melodic, with just enough of a foreign accent to transport the narrative from the written page to Dublin. I have always contended that for Joyce's writings to be properly appreciated and understood, his words, much like poetry, need to be heard rather than read. Once Leo began reading, it was hard for a listener to be anything but mesmerized. He carefully enunciated every syllable and committed long passages of the text to memory. I have no idea what stopped Hannah and Leo from seeing one another, but I have a suspicion that it was because in their brief relationship she had offered nothing in return. Not so with John. I remember that he hit it off with her so well that he called me with the excitement of a little boy in his voice. He was enthralled by this beautiful young German woman, for she came from Hamburg, the city in which he was raised. She was the quintessential blonde *shiksa*, the Yiddish term for an attractive non-Jewish girl

who tempted Jewish men but whom they were not allowed to have. John would certainly have been familiar with the type from grade school, the girl he worshipped from a distance but could never attain because she was out of his league and came from a different religious background. This time, however, despite the vast differences in their age—some fifty years (he was in his late seventies and she was in her early twenties)—it looked like he might have a chance of getting her, should she be willing to accept what he was offering, and should he be willing to accept conditions she imposed on him in return. Indeed, he told me that he wanted to marry her, which came as a complete shock. I would not have believed it, had I not understood his motives.

For nearly the entire time I had known John, I was well aware of the fact that he was in love with Fran Weitzenhoffer. She, too, was considerably younger than he, but by an almost-respectable thirty-year difference (not fifty!). Once when John was rummaging around in his desk, I noticed some drawings in his top drawer that he had made for the design of spoon and fork handles; they were made entirely of the intertwined initials JR and FW. When I asked him about these drawings, he said that he had made them for a silverware set that was never made, for the union those letters represented never materialized. I did not ask anything more, but his feelings for her were obvious. One day when I was with John at the Citadelle, he woke me up at 4:00 AM to tell me that he was flying to Paris and taking the Concorde to New York because Fran had been suddenly taken ill. Years earlier, she had been diagnosed with breast cancer; now, some five years after surgery and chemotherapy, it had reappeared, having metastasized to her lymph system and bones. John was paralyzed with fear. Married or not, she meant everything to him. She was an accomplished scholar in her own right, having published her dissertation on the

Havemeyer Collection and edited two volumes of John's collected essays.

Fran knew about Hannah and, despite the fact that she remained married, did not approve. On one of my visits to her in the hospital, she was livid over the fact that John—who, coincidentally, was in the same hospital at the same time (undergoing a quadruple bypass)—had hung a picture of Hannah in his room. I went up to visit him after his surgery and was surprised to discover that the photo was on display at the foot of his bed. When I asked him about it, he said that Hannah had returned to Germany and could not be with him, so he thought it was perfectly appropriate to display a picture of her instead. He had given up on Fran, not only because she was unwilling to leave her husband, but, I suspect, because she was about to leave all of us. I went to visit her in the hospital a few days before she died. By now she was ravaged with cancer, her entire body distorted into the shape of a human pretzel. She was racked with pain, and I begged her husband to do something about it. He said that he was powerless, the doctors would not allow him. I could not bear to witness her agony, and vowed that if any such thing were to happen to me, I would make an arrangement with someone I trusted to quietly put me out of my misery. She died in 1991 at the age of forty-six.

The last thing Fran asked me to do was clean out her office, a small studio apartment on the Upper East Side. A few weeks after she died, I met her husband Max there. It was cluttered with papers and files that pertained to her work on the Havemeyers, which Fran asked me to donate to the Metropolitan Museum of Art, which I dutifully did (and for which they were very grateful, acknowledging her gift in a catalogue that they published on the collection a few years later). Max asked me to pack up the books in cardboard cartons, for they would all be sent to the University of

Oklahoma, where he went to school. He told me that I could take whatever I wanted, but all I could find was a portable photocopy machine (which I have never used) and a copy of Alfred Barr's wonderful 1951 MoMA catalogue on Matisse, with a dust jacket that Matisse himself had designed. Also lying on her desk was a powder-blue envelope addressed to "Monsieur John Rewald, La Citadelle, Ménerbes." It contained a seven-page handwritten letter in which she chastises John for his fascination with teenage girls and reprimands him for his involvement with one in particular, another young German girl who had preceded Hannah. She reminds him that he is seventy-six years old, but she is forty-four, and can no longer tolerate his insensitivity toward her. "I cannot bear to maintain my role as your long-suffering, sympathetic whatever I am, at this point, I am not sure exactly what my role is, but whatever it is I relinquish it because I am too hurt, too pained, and too anguished to suffer this way repeatedly." She implores him to "take it easy with the German girl, do not get too excited, do not go overboard." She even tells him that if he contemplates marriage he should have the wherewithal to consider a prenuptial agreement, for other-wise he could risk losing everything. "I would suffer acutely to hear or learn that you would be out on the street with nothing left in your advanced years," she wrote. "I look forward to the day when I no longer care," she concluded, "which will mean I am indifferent and will not have to suffer as a result of your romances. I am certainly not there yet but plan to work hard in this direction."

When I read this letter, my heart sank. I felt terrible for what Fran had gone through, and I realized that John's liaison with this new young fräulein—Hannah—was probably even more serious than I had imagined. Until then, I assumed that she was just serving as a convenient escort, eye candy that he loved to parade around for others to see, but now it was

clear that he intended to carry it much further and marry her. I immediately called John and, without telling him about Fran's unsent letter (I never did), asked if he planned to marry Hannah. He confirmed that those were exactly his intentions. "But for years you wouldn't even get into a German car," I reminded him, whereupon he informed me that he had taken a trip to Hamburg earlier in the year and met her parents. He returned sufficiently convinced that they were too young to have had anything to do with the Holocaust, and that was enough for him. Before I knew it, he called one day to tell me that he had married her. Needless to say, since I had expressed my emphatic disapproval, I was not invited to the wedding, which I think took place in City Hall without a ceremony. I saw very little of them after that point. I was invited to John's eightieth birthday party, which was held in a boardroom at the Museum of Modern Art. He showed up with Hannah, but did not look well. In the remarks he delivered, he told the assembled guests that arriving at such an advanced age was not really much of an accomplishment, for getting old was not something anyone should look forward to. "I don't recommend it," he told everyone, with all the irony the remark was intended to convey.

In June of 1993, John invited my wife and me to visit him at the Citadelle in Ménerbes. Since we were going to Europe that summer anyway, I decided to make the effort; he was suffering from congestive heart failure, and I did not know how many more opportunities I would have to spend time with him. When we arrived, Hannah was there with another young German woman, the daughter of Marianne Feilchenfeldt, a Swiss art dealer whom John had known for years. They seemed to enjoy one another's company, so they left the Citadelle during the day, returning for dinner in the evening. My wife and I spent the time with John, but he was in rapid decline, both physically and mentally. He asked

me to shave him one morning with an electric razor, so I asked him to lie down on a couch in his sitting room, only to have him fall asleep as I carefully manipulated the contours of his face in an effort to remove every trace of facial hair. It was as close to him physically as I would ever get, and I can recall realizing it at the time, being grateful that I was given the opportunity. On one of our first nights there, Terry and I awoke in the middle of the night to hear John wailing downstairs. We rushed to him and discovered that he had fallen between his toilet and the wall of the bathroom, having urinated all over himself and the floor. I picked him up, but he kept calling for Hannah. When she appeared, the scene disgusted her, so she quickly disappeared. I cleaned him up and got him back into bed, vowing that I would not let the situation stand, that I would write a letter to Hannah when I got back home and tell her exactly what I thought of her.

Shortly after my return to New York, I sat down and typed a carefully thought-out, four-page letter to Hannah, wherein I chastised her for having taken advantage of a situation for her own personal gain, ignoring, for all intents and purposes, the well-being and feelings of my old friend. I began by explaining that I had taken the liberty of writing the letter because, in having introduced them, I felt some responsibility for having created the circumstances that allowed this regrettable situation to exist in the first place. I explained that John had a long history of procuring women, but those he hired were mostly professionals, and he knew exactly what he was getting in exchange for what he paid. Basically, I was accusing her of being a prostitute, but in this case, one who was cheating this particular John (pun intended) by refusing to give him the minimal care and respect to which he was entitled in accordance with their agreement. "All I can think of is how much happier he would be if someone kept him company," I wrote. "No one—not

even Sabine [Paul's widow, John's daughter-in-law]—would begrudge you the money you stand to inherit, if you cared for this man on a daily basis." I accused her of flying back and forth between Germany and the United States (trips that John paid for) not because she wanted to see him but because she wanted to continuously oversee the provisions of his will. "As John's condition progressively deteriorates," I wrote, "your flights are beginning to resemble the encircling pattern of a hungry vulture."

I was clearly angry, and intended to convey my feelings in the most forceful way possible. I told her that I was especially upset over having created a situation that allowed John to eliminate his daughter-in-law from his will, leaving her only with his literary estate, a mere pittance when compared to the millions Hannah stood to inherit. In this context, I warned her that should anyone wish to contest his will, I would be willing to testify that at the time she married John, he was already beginning to lose his mental faculties, a situation that could potentially invalidate the legal status of their marriage. A week before they got married, I attended a dinner with John and five other people at a restaurant near his home, and when it came time to pay the bill, he was unable to properly calculate the tip; on a meal that came to approximately $250, he accidentally left a $750 gratuity (luckily, this mistake was caught by an honest waiter, and there was time to correct it). John had even told me that he was no longer able to read mystery novels (an indulgence in which he took a great deal of pleasure) from start to finish, for he was no longer capable of recalling the plot as the book progressed. Moreover, I reminded her that whenever we discussed their relationship, she made it very clear to me that she was under no obligation to accept his sexual advances, making it, in effect, a marriage in name only. "A believer would seek an annulment," I wrote, "a lawyer would file for divorce, and any morally conscious

person would scream 'deceit' and 'fraud.'" In concluding, I told her that nothing would be gained in responding to me. "Since I am constantly nagged by feelings of duplicity when speaking to you," I told her, "I would appreciate it if you would please refrain from contacting me again. Do not call, and I cannot see anything that would be accomplished in writing. You have my word that I shall not interfere in the events of your life, and I shall make no effort to contact you again, now or in the future."

Needless to say, I never heard back from her. John died less than six months later, on February 2, 1994. As the end was nearing, I received a call from Jane Warman, the art historian John had hired a few years earlier to work on the Cézanne catalogue raisonné. He realized that he would not live long enough to see the project completed, so he had entrusted it to Jane and Walter Feilchenfeldt (the son of his Swiss friend Marianne). Jane told me that John was in Lenox Hill, the same hospital on the Upper East Side where he had his heart operation and where Fran Weitzenhoffer died three years earlier. He was in intensive care and, for all intents and purposes, catatonic. I was very upset to see him in this condition, breathing heavily and gasping for every breath. When the nurse who was attending him came in, I asked if she knew who he was. She didn't, so I told her he was one of the most famous art historians to ever live, that he had written hundreds of books and articles on Impressionism; if he should pass away, I said, she would read about him in the papers the next day. As I was leaving, I told John that I had loved him like a father, and left with tears in my eyes. Hannah was nowhere to be found. Other than a hospital employee, I believe I was the last person to see him alive.

The day following his death, a four-column obituary appeared in the *New York Times*, the sort of recognition that would have made John proud. It was written by Michael

Kimmelman, then the leading art critic for the paper. It was a glowing tribute, one in which John was identified as the premier scholar of Impressionism, an art historian whose writings were indispensible because they were based on primary sources, such as interviews and letters, as well as a detailed study of the places where paintings were made (as in his famous photographs of the landscapes painted by Cézanne). A comment was solicited from Bill Rubin, who said: "I grew up in a generation that considered his works on Impressionism and Post-Impressionism to be the major authoritative statements," whereupon he concluded: "They still are." Kimmelman also quoted a comment made a few years earlier by the art historian Theodore Reff: "What he set out to do, he did more thoroughly and scrupulously than anybody else, and he did it first." Mention was made of the fact that John helped to save Cézanne's studio, and that he wrote regularly to magazines and newspapers "expressing his disapproval of one or another decision by a museum director or fellow scholar or critic" (as in his opposition to Thomas Hoving's sale of works from the collection of the Metropolitan Museum of Art). The detail that John would have been proudest to read, however, is a mention at the end: "He is survived by his third wife, Hannah."

About a month after John died, I received a call from Geraldine, his longtime housekeeper, who asked if I would like to come over to the apartment and take anything that was left. Hannah, she said, had arranged for everything to be sold, but there were still some things there that I might want to have. When I got there, all the furniture was gone, but there were a few framed works lying against the wall of his study. She told me that Christie's had been there and had already taken all of the things they thought could be sold at auction. To my surprise and delight, they left behind a number of items that they did not consider commercially viable, but which

were quite valuable, at least to me: the 19th-century painting of a skull that John had purchased in Florence and set into an elaborate carved wood frame, a large and magnificent ink drawing of the Citadelle from a distance by the English artist Raymond Mason, which had hung opposite John's bed, and the white wooden antique dog that stood near his couch in the living room where he opened the mail during the classes he taught in his apartment. I took all of these things home with me. When Mino next visited New York, I gave him the drawing of the Citadelle, but I still cherish the painting of a skull—which now takes a place of honor in my study—and the wood dog, who now stands sentry in my living room.

"Property from the Estate of John Rewald" was sold at Christie's New York on Wednesday, May 11, 1994. The cover of the catalogue featured an ink drawing made by David Hockney of John's book *The History of Impressionism*, which a note explained was "acquired by Mr. and Mrs. Max Weitzenhoffer and Marianne Feilchenfeldt as a gift to John Rewald." It sold for $21,850, an impressive amount in those days. Included in the sale were most of the African masks and objects John had assembled in his late years, as well as antiques and pieces of furniture from his study. The highlight was unquestionably the many drawings in his collection that ranged from the Impressionists (Cézanne, Signac, Pissarro, Valadon, Vuillard, Bonnard and Redon), to the modern (Maillol, Giacometti, Balthus, Brauner, Bellmer, Masson and Manzu, the majority of which were acquired directly from the artists). Of all the drawings, I was most interested in *Etude d'après le* David *de Mercié*, a small pencil study by Cézanne that had hung in a back room of John's apartment. When I once asked why he did not display it more prominently, he said that in his opinion, it was not a very good drawing. When I disagreed, he admitted that it was given to him by Adrien Chappuis, with whom John had co-authored the catalogue

raisonné of Cézanne drawings. When their collaboration was completed, Chappuis gave him this drawing as a gesture of his gratitude, which, John thought, was not very generous, since he knew that Chappuis had owned many far more important drawings. I told him that I would love to own this drawing one day, so I attended the sale in hopes of acquiring it. It was estimated at $12,000 to $18,000, but it was a period in which I was not in a very healthy financial state, although I thought that I could at least bid somewhere within the estimate. I stopped at $14,000, but, unfortunately, that did not make me the successful bidder (it went for two more increments and, with premium, sold for $17,250). The sale did quite well, with a small Maillol bronze selling for $90,500, and a Giacometti drawing for $74,000. In the end, all 168 lots sold for a total of $1,598,882. It all went to Hannah, of course, as did the sale of the apartment (which I was told sold for $2 million) and whatever cash John had in various bank accounts. In all, it was a staggering amount of money for a twenty-four-year-old widow to take back home with her to Germany.

A day after the sale—on May 12, 1994, what would have been John's eighty-second birthday—a memorial service was held in his honor at the Museum of Modern Art, and Bill Rubin invited me to speak. In my remarks, I recalled only the great things we had experienced together, especially on my many visits to his home in Ménerbes and on our various trips through Italy. I called it "A Whiskey Sour on the Sweet Side," and explained to the assembled guests why I gave it that title (including John's warning about how it was used). I tried to be as entertaining as possible, thinking he would have wanted it that way. I must have succeeded, for as I was leaving the podium, David Rockefeller, who was scheduled to speak after me, grabbed my arm and said, "I hope you're available to speak at my service." Hannah attended the event

with her mother and father, whom, of course, I had never met. We all went to a lunch afterward at a nearby restaurant, and I did my best to avoid eye contact with any of them.

I never saw Hannah again, but approximately a year later, I received a note from her containing photographs of John's grave. She had his ashes interred in the Cimetière Saint-Pierre in Aix-en-Provence, not far from the tomb of Paul Cézanne. John's grave is marked by a rectangular slab of black granite, minimal but elegant, a fitting and appropriate memorial. Her note read: "It's more than one year ago that our friend, my late husband, John Rewald deceased [*sic*]. I know that we all keep him in warm memory." I wish I could say the same of Hannah. Later I would learn that in John's original will, he left me $20,000, exactly the amount I would have needed to purchase the Cézanne drawing from his sale. The money was removed by Hannah, of course, after she had received my letter, condemning her treatment of John.

ARRIVALS and DEPARTURES

As coincidence would have it, I married Terry at around the same time that John married Hannah. It was not intentional, for neither one of us knew about the other's plans. In fact, I can remember to this day when John called to tell me he had gotten married. He was proud and sounded very happy. I could not bear to tell him what I really thought about their union, for it was obvious to me that his main motive was to eliminate Sabine from his will, while, at the same time, foolishly imagining that the whole world envied his ability to ensnare the affection of a woman some fifty years his junior. Leo expressed some caution on the subject of marriage, for he was married only a brief period and, for him, it was an emotional prison. "Every day I woke up," he said, "wishing I hadn't." I, too, had some reservations about the institution, for in accordance with my anarchist bent, I have always contended that marriage should be an essentially private affair, a union undertaken between two individuals who love one another, but who do not necessarily need the approbation of the public to legalize the bond. Besides, we were getting married for a very specific reason: to enable us to adopt children. Although single-parent adoptions were possible, couples could not adopt unless they were married (for obvious reasons of custody). It was the first marriage for me, but the third for Terry. We were informed that a witness was required, so I asked my brother, but told him not to tell anyone else. It was a mistake, for he did exactly what I requested and did not even tell his wife Heidi (an act for

which she has never completely forgiven me, since I was best man at their wedding).

Our decision to adopt children was not greeted well by John, who thought I was making a big mistake. He had experienced some trouble with his own son, which, I suppose, is why he did not encourage me. For some time, I had planned on naming my son after him, but because of his attitude, I decided against it. Instead, we named him Roland (not after anyone in particular, but because we both loved the sound of the name) and our daughter Béa, after Beatrice Wood. Shortly after they arrived, we brought them both to Ojai to meet Beatrice, and she could not have been more pleased. She made a tea set for them, a pot, creamer, two cups and saucers. Surprisingly, Leo also enthusiastically supported our decision to adopt, even though he had never had any children of his own. He was especially excited to learn that our children were coming from Russia, since he was born there some three-quarters of a century earlier. When he met them for the first time, he gave us a delicately brocaded nightshirt, something his sister had when she was an infant in Russia (but which was, of course, too small for our daughter to wear, since she was already almost three years old). I remember that Leo often asked me to try explaining why having children was such a great experience, because, I suppose, he had heard many people say that it was. Nancy Grove, the fellow student who read to me from Rewald's writings some twenty years earlier, once told me that when you approach the end of your life and are given fifteen minutes to recall the most important things you've done, fourteen will be devoted to your children. I did not believe her at first, but she was right, something I became aware of shortly after our kids arrived. Despite having come to this realization, I was still unable to provide Leo with a satisfactory answer to his question about why it was so great

to have children. I once explained that they were like your own chronological development run in reverse, that what you witnessed them learning, you yourself learned at around the same age, but could no longer remember. Although he accepted that explanation, he kept pressing, as though there must be something deeper and more convincing. When he asked the next time, I was ready. "When those kids came into my life," I told him, "the single greatest burden that I had been carrying around with me my entire life was lifted from my shoulders." I paused for a moment before saying: "My ego." He never asked again.

During the remaining years of Beatrice's life, we went out several times to see her. Since Terry's brother lives in Los Angeles and we stayed with him, I was often able to get away for a few days and visit Beatrice in Ojai. The routine was almost always the same. We would spend a lovely day together in her exhibition room talking about various world events, but the discussion would inevitably turn to R.P., Ram Pravesh Singh, the Indian gentleman she met on her second trip to India in 1965 and who, a few years later, moved to Ojai, where, for the next forty years, she employed him as her studio manager. There is no question that she was in love with him, but it is doubtful that he ever felt quite the same about her. There are a number of reasons for this. To begin with, he was some thirty years younger than she, and although he had been married and had a son, he probably took very little interest in the sexual appetites of women. Indeed, Beatrice was obsessed over the question of his possible homosexuality, but felt that it was not a subject that should be spoken about openly. When he was in India, she wrote to him almost daily. When he moved to America, he brought with him all of her letters, which he had saved and returned to her. She combined them with those that she received from him, and decided to transcribe the entire correspondence with the

idea of publishing it as a book with her running commentary. She eventually abandoned the whole project, but always felt that it would have some value in the future, so she marked two boxes containing the original letters and manuscripts and bequeathed them to me upon her death. Fearing that something might happen to the materials, at one point she shipped them to me for safekeeping, inviting me to use them one day as the basis for a play or movie. I kept the boxes for years, but eventually donated them with a group of drawings that were based on her relationship with R.P. to the Beinecke Library at Yale University, where they are safely preserved to this day awaiting the first researcher to take an interest in the story.

As Beatrice's hundredth birthday approached, people seem to descend upon her, not the sort of attention she embraced, for she realized that they were more interested in her longevity than in her artistic production (which, to an extent, was true). She always told me that there were two types of fame: one that you deserved because of your accomplishments, and another that you got from people who just wanted to know someone famous. When I found out that an article was going to be written about her for *Smithsonian* magazine, for example, I was anxious and excited to tell her about it, for with its enormous circulation, I felt that she and her work would become better known to a much larger audience. But when I told her, she did not sound very excited, saying that this was not the sort of fame she welcomed. As coincidence would have it, an event occurred the very next day that would prove her point. We were crossing Beverly Boulevard in Los Angeles—where we had gone to see a massage chair that she was interested in purchasing—when, as we were crossing the street with traffic whizzing by in both directions, a woman grabbed the hem of her sari and demanded to speak with her. She ended up pulling us both to

the side of the road and, before I was able to protest, produced a notepad and pen and asked for Beatrice's autograph. The woman said she had seen Beatrice interviewed on the *Today* show, recognized her, but could not remember her name. I was furious, but Beatrice quietly complied with the woman's request. She then turned to me and said: "Now you know what I meant when I said there were two types of fame."

About a year before Beatrice's hundredth birthday, a film production company decided to do a documentary on her life, and they hired me as a researcher and consultant. The company was called Wild Wolf Productions; its artistic director was Tom Neff, and it was co-owned and operated by two women, Amie Knox, who had made a documentary film on Frederic Remington, and Diandra Douglas, wife of the actor Michael Douglas. An impressive amount of money was raised for the film. Olavee Martin, a friend of Beatrice's and widow of the TV actor Ross Martin, coerced a wealthy friend of hers, Belle Deitch, a philanthropist who lived in Boca Raton, Florida, to put up $500,000 (she is identified in the film credits as executive producer). I took my role as consultant quite seriously, gathering photographs and documents that I thought could be used to guide the narrative, but Neff insisted that I also appear in the film. I was reluctant, fully realizing that I was anything but an actor. I agreed only if they could keep my face out of the picture, so my voice appears throughout the film, but the camera shots are all taken over my shoulder or behind my back. The finished product was entertaining, featuring headshots of many individuals who had known Beatrice over the years, but the unquestionable star was Beatrice herself, who came across as the humorous and wise person she was. They subtitled the film *Mama of Dada*, an inaccurate representation, for it implied that Beatrice came before the Dada movement, which was, of course, a chronological impossibility. More accurate would have been

something like *Daughter of Dada*, which I suggested, but it did not carry the same ring, so they went instead with the historical inaccuracy. As the final credits roll by, Beatrice can be heard telling viewers about her epitaph, which she wants to consist of only three lines: "NOW," because, she says, "the now is all important." "SHIT," because "nothing matters," and finally, "I DO NOT KNOW," because, as she explains, "we do not know anything." The film was a great success, premiering in Los Angeles in 1993 and later at the Whitney Museum of American Art in New York. It was after its screening at the Whitney that I met the actor Michael Douglas in the museum elevator. "You don't know me," I began, whereupon he interjected, "I know who you are. You had some great lines in the film." Of course, I didn't really have any lines at all, at least not prepared lines like actors are given, but I was pleased to receive the compliment. To this day the film is shown on public television, and I occasionally receive calls from people who say they've seen me on TV.

Even though Beatrice had passed her hundredth year, nothing seemed to slow her down. She kept a regular routine of working in her studio daily and, after dinner, retiring to the exhibition room to make more drawings. She would only stop at 11:00 p.m., because she liked watching *Nightline*, and admitted to having developed a deep crush on Ted Koppel, the show's anchorman. In 1994, my book *New York Dada* appeared, which contained a chapter on Beatrice, and in 1996, I organized a show called *Making Mischief: Dada Invades New York* for the Whitney Museum, which included eight drawings by Beatrice dating from 1917–18. In preparation for the latter, I was authorized by the Whitney to conduct a formal interview with Beatrice to be projected in one of the galleries during the show, but it was at an exceptionally weak moment in her life, so on film she appeared tired and stressed. Unfortunately, as a result, it was never used. A few

years later, when Beatrice was 102 years old, she suffered a severe medical condition—a bowel obstruction—that nearly killed her. Actually, the obstruction didn't, but the operation to find it almost did. Doctors at Cedars-Sinai Medical Center in Los Angeles had performed exploratory surgery, cutting her open from the top of her stomach cavity to the depth of her groin, but found nothing. I flew out immediately, for R.P. was quite distraught, fearing that she probably was not going to make it.

When I arrived, Beatrice was in a coma, with a breathing tube down her throat and fluid lines running into both arms. I was appalled, and announced to any doctor who was willing to listen that Beatrice had told me she did not want to be kept alive by machines, that these instruments should be detached. Radha Sloss, the daughter of Rosalind Rajagopal (one of Beatrice's closest friends who had died a few years earlier), was named Beatrice's legal medical proxy, and when she arrived at the hospital, she told the doctors much the same thing. At that point, a young respiratory therapist came into the room and told us that he would remove everything, since that was our legal right, but as soon as he removed the breathing tube, our friend would begin gasping for air and choke to death in about a minute. It would be a violent death. The other option would be to gradually remove the tube, but he asked for forty-eight hours. If it worked, we could decide what to do after that point. We both thought it was a good idea, and told him to go ahead and try. The next day I returned to the hospital (Radha had to go back up to her home in Santa Barbara), and everything was just as it was the day before. The therapist told me that he tried, but she was not ready. The next day when I got there, Beatrice was sitting up in her bed and talking to everyone, as if nothing had happened. She lived another three years, and they were fairly healthy and productive years.

After such a close call, I decided that I would make every effort to fulfill my promise to Beatrice that I would write a book about her. We discussed the possible publication of her diaries, which, by then, she had kept daily for over eighty years! She had already selected a title: "Beatrice Wood: Diary of a Red Hot Mama," which, again, I thought was a bit misleading. She wanted to appropriate the word "mama" from the film that had been done on her, and felt that such a title would spice everything up, for it suggested that the author was a woman of ill repute. Besides, she feared that the information her diary entries contained—much of which simply recorded the names of people she met and brief notations of the activities in which she engaged—would not be of sufficient interest unless they were carefully selected and annotated, accompanied by pictures and additional text whenever possible. I agreed to do this with Terry's help, but I warned her that it was an oceanic job that I might not get to until my retirement. Beatrice didn't care, just so long as she knew it would be done. She began the process by having the entries transcribed by a professional typist, but her handwriting was so illegible that she would often have to go back over the text and make many corrections. The process continued throughout the remaining years of her life, but remained unfinished at the time of her death. Terry and I eventually tackled the project, but only some ten years later and in a somewhat curtailed form (although it is still hoped that a publisher will one day find the project sufficiently intriguing to publish them in their entirety).

In order to assure their eventual publication, Beatrice insisted that we enter into a formal agreement. She wanted us to be paid immediately, just in case she was not around to see the final project through. Instead of financial payment, I asked her to give me a single work of art. For years I had my eye on her *Thank God for Television*, an early ceramic wall piece that

she had hidden in her "secret closet" (actually a place used for storage located to the side of her exhibition room where she kept pieces for safekeeping against possible earthquakes). It depicted a woman with bulging eyes and recessed breasts. When I asked Beatrice about these details, she said, "Maybe that's the way you get when you watch too much television." Actually, I admired the title for a completely different reason. Years earlier I had invited Beatrice to go with me on a safari through Africa, for I knew that she loved everything about wild animals and always wanted to see them in their natural habitat. She refused, saying that she was too old to travel, and that she would only slow me down. She explained that her mother loved these animals, too, but only saw them in a zoo, whereas she saw how they lived and gathered food from documentaries on television. She ended her explanation by saying, "Thank god for television."

Even though Terry and I had promised to publish her diaries one day, I still wanted to write a major book on Beatrice while she was living, something that presented her artistic production in a series of lavish color plates, what is generally referred to as a coffee-table book. As luck would have it, Holly Hotchner, an old friend of Terry's, who many years earlier had worked with her in the registrar's office at the Museum of Modern Art in New York, was named director of the American Craft Museum, a somewhat beleaguered institution then located across the street from MoMA (eventually, it would be renamed the Museum of Art & Design [known by the acronym MAD] and, with Holly's steadfast leadership, moved to Columbus Circle). She invited me to organize a retrospective exhibition of Beatrice's work for the museum, which I agreed to do, but only if she gave me carte blanche to design and produce a sumptuous catalogue, one fitting for an artist of such great accomplishment. She agreed, and over the course of the next

year we had photographs taken of all works that would be included in the exhibition, and I gathered copies of articles about Beatrice that we planned to reprint in the catalogue. I even asked for the lusterware works to be spot-glazed in the final publication, so as to convey a sense of their radiance. Indeed, in my introduction to the catalogue, it was this very aspect of Beatrice's production that I seized upon, telling readers that her personality was a virtual extension of her work, for the sparkle that her vessels possess is reflected in her beautiful eyes, and their radiant surfaces mirror the jewelry and iridescent saris that she wears. Moreover, in her drawings and figurative work the true depth of her character is revealed, for the humor they contain is at the very core of her persona. When the book was in galley stages, I brought out a copy for Beatrice, and we went over every page carefully. She was thrilled, and said, "Now I will have something to show St. Peter when I arrive at the gates of Heaven."

Because of her advanced age, Beatrice was unable to attend the opening in New York, but when the show traveled to the Santa Barbara Museum of Art, she was anxious to see it. During the ride from Ojai to Santa Barbara, however, she got carsick, and as soon as she arrived at the museum, she vomited on the front steps. When she recovered, we toured the exhibition together with R.P. and Nanci Martinez (Nanci was Beatrice's studio assistant and, at the end, a loyal friend and caregiver). It was magnificently installed there, and walking into a gallery surrounded by her lusterware was like walking into a treasure chest. I do not think she could have been happier. When I returned home, we resumed our regular phone conversations. Once I asked her if she believed in an afterlife. She told me that if she believed in reincarnation, she would probably come back as some sort of animal. She loved cats, and thought that was what she would become. Coincidentally, I had heard a joke around that time

that combined her interest in human sexual activity with the subject of reincarnation, so I could not resist relaying it to her. To make it more personal, I inserted our names into the joke, typed it up and sent it to her in the form of a fax, asking her to comment on it.

> One day, Beatrice and Francis sat around discussing the concept of an afterlife. Francis doubted that there could be a heaven or hell, and Beatrice preferred to believe in reincarnation. They agreed that whoever died first would try to find some way to come back and tell the other what it's like.

> Beatrice was the first to go, and although Francis was very sad, he couldn't help but wonder if Beatrice would ever let him know where she was. One day, he was looking into a mirror, and there she suddenly appeared. "Beatrice, I miss you," he cried, but couldn't resist asking: "What's it like on the other side?"

> "Well, you get up in the morning and start screwing right away," said Beatrice. "Then you eat a little lettuce, and screw again. You eat more lettuce, and screw two or three more times, then back to lettuce. This routine continues throughout the day."

> "Is that what heaven is like?" asked Francis.

> "Hell no," said Beatrice. "I'm a rabbit in Wisconsin."

Upon receipt of the fax, she called and began laughing so uproariously that at first I didn't realize who it was. She thought the joke was hilarious, and said that she would like to turn it into a drawing but wasn't sure if she could draw a

rabbit. She had a remarkable sense of humor, one that clearly did not fade with age.

Three months after Beatrice's retrospective closed at the Santa Barbara Museum of Art, she celebrated her 105th birthday, so this time our entire family flew out to attend the festivities. Unfortunately, Beatrice was not feeling well on that day, and although many people showed up at her home, she only greeted them for a brief period in her exhibition room. Our family was allowed into her bedroom for a brief period, where she was delighted to see our kids again. Later that evening, she wrote the following in her diary, something that I would only read years later: "my birthday 105!!! / Born San Francisco Calif. 1893 / my birthday March 3 / mistake / There is great party for the Festivals. / Again I feel alone ???? / There are many darling friends / but not many close, who / care." I was devastated to discover that she felt that way, for obviously a great many people loved and cared for her, especially me. Of course, the person she likely had in mind was R.P., who actually also cared for her more deeply than she ever realized.

Two days later, on March 5, 1998, I was invited up to Beatrice's home to attend a luncheon honoring James Cameron, director of the film *Titanic*, which had come out the previous year and had won every award imaginable (Best Picture, Best Director, etc., also breaking the all-time box-office gross for a movie). It was a great day, for Beatrice was feeling wonderful and was in top form. Cameron was indebted to her, for when he was writing the screenplay for his movie, he wanted to meet people who were around a hundred years old, the age the main character in his film, Rose, would have had to be in order to make the scenario plausible. He went to various nursing homes in the Los Angeles area, only to discover that most of the people who had reached this advanced age were nearly catatonic. When

he expressed these concerns to his friend, the actor Malcolm McDowell, who lived in Ojai, he told him about Beatrice Wood, who by then had passed her hundredth birthday but was as vibrant and as energetic as someone that age ever could be. Cameron went up to visit her and, from what he told me, could not believe what he saw. He rented a camera and spent the day filming her. He even invited Beatrice to play the part of Rose in his film, but she told him that she was too hard of hearing, and would not be able to follow direction. Cameron purchased a copy of her autobiography and read it. To his surprise, he discovered that the theme of his film—where, to the consternation of her wealthy parents, a girl in first class falls in love with an impoverished young man from the lower cabins—was remarkably similar to Beatrice's inexorable desire to break from her own restrictive and conservative upbringing. When I asked Cameron about this, he said that because of Beatrice's artistic past, he wished he could have made the girl in his movie the artist, but in order to present his audience with a beautiful and sensuous drawing of a woman, it had to be a man who made the drawing. When I told him that his lead actress, Kate Winslet, looked remarkably similar to Beatrice in her youth, especially the photograph of her that appeared on the cover of her autobiography, he admitted that he had selected her to play the role, in part, because she resembled that early picture of Beatrice.

As the luncheon party drew to a close, Beatrice asked us all to assemble at the couch in her exhibition room. As usual, she had a question for all of us; it was her custom to gather her guests after a meal and have them all answer the same question. Like any good lawyer, she had an answer, one that she felt would be more correct and compelling than any submitted by her guests. This time the question was "What is the greatest single quality a human being can possess?" Responses were solicited from everyone, and people came up

with all kinds of answers, from "responsibility" to "generosity."
R.P. submitted "compassion," which is what I was going to
say, so when it came to me, I could only second his opinion.
Beatrice carefully listened to all of us, then provided hers:
"Honesty," she said, "is the single most important character
trait a human being can possess." I was somewhat perplexed
by this response, but would eventually figure out why she
said it, for even though she was the most honest person I
had ever known, she struggled with the truth, especially
when it came to her perception of herself. As the guests were
leaving, James Cameron gave Beatrice a two-volume video
cassette of his movie, asking her to be very careful with it,
for the film had not yet been released in that format. After
he left, Beatrice asked me if the film was sad, whereupon I
had no choice but to tell her it was absolutely heartbreaking,
especially the end, "where," I warned, "nearly everyone dies."
I recommended that she view only the first half, which she
did and presumably enjoyed.

We spent the rest of the evening talking, and probably
because I now had a family of my own, I asked her detailed
questions about her childhood. I wanted to know why she
never retained a lasting friendship with her brother. She
explained that he had betrayed her in their youth. She decided
there and then that he was not to be trusted. I also wanted
to know why she rarely discussed her father, since he had
dedicated one of his books on business to her and seemed
to harbor a great deal of affection for his only daughter.
She explained that she loved her father; their relationship
was perfectly normal, and there was nothing antagonistic
between them, as there was with her mother, so there was
not much to say. As I prepared to leave, we hugged, and, as
usual, Beatrice asked, "When will you be back?" On prior
occasions, when she asked this question, I would always
answer, "In a few months," whereupon she would always say:

"Look, at my age, I'm a walking time bomb, so I can't really promise that I'll be here." On this occasion, however, I told her that I would return in about a month, for I had other business in Southern California that would bring me back. "Oh," she said, "I think I'll still be here then." That was an outright gift, for in twenty-one years, it was the first time that I left her presence without feeling bad, for I genuinely believed we would see one another again soon.

That never came to pass. The next day, Beatrice would be taken ill, suffering from an infection in her eye that had progressively gotten worse. The doctors prescribed a round of antibiotics, which apparently wreaked havoc on her delicate digestive system, made all the more fragile by the exploratory surgery her body had endured three years earlier. When they offered to take her to the hospital, Beatrice said: "Are you crazy? I'm 105 years old. Just turn up the heating blanket and leave me alone." That's what they did. She spent the next week lapsing in and out of consciousness. I called every day to find out how she was doing, and when R.P. started crying on the phone, I realized the end was near. I did not fly out to see her, because by then she had completely lost consciousness and would not have known I was there. Besides, I wanted to cherish the memories of her as the living, vibrant being I knew and loved. On the morning of March 12, 1998, nine days after her 105th birthday and only a week since I had last seen her, Beatrice died. I learned of her death from a fax transmission sent to me by Nanci Martinez, who drew the picture of a cherub at the top of a sheet of paper and wrote, "Beatrice is now with the angels." I cried for a week.

Obituaries filled West Coast papers, but, to my surprise, one also appeared in the *New York Times*, written by the distinguished art critic Roberta Smith. After going over the highlights of her long life, she concluded by mentioning that the Smithsonian had named Beatrice an "Esteemed

American Artist," and that Governor Pete Wilson of California had designated her a "Living Treasure." Equally unexpected was that later in the year, in the *New York Times*, Michael Kimmelman selected Beatrice as the most notable artist to die in the previous year. "She spent more than a century escaping convention," he wrote, "and inventing a life on the cutting edge of American art." He concluded the account of her life by quoting her: "I still would be willing to sell my soul to the devil for a nice Argentine to do the tango with." A few months after her death, a memorial tribute was held on the grounds of the Happy Valley School, and I was asked to make a few remarks. I prepared some index cards outlining the things I wanted to say, but all I can remember is breaking down at the end, when I tried to tell the audience about my last meeting with her. The event was covered by the *Ventura Country News*, a local paper that had followed Beatrice's career for decades. It was an article that I enjoyed reading, because there Beatrice is quoted as having said: "The last years of my life were the happiest." I took some solace in knowing that I had contributed to that happiness.

* * *

In the last decade of Leo Steinberg's life, we met infrequently, but spoke regularly on the phone. He was in his eighties now but continued to lecture occasionally. The last I attended was one on Leonardo that he delivered at the Institute of Fine Arts, where he had done graduate work over a half century earlier. As usual, the lecture was overcrowded, and Leo was his typically brilliant self. At the end of the talk, he rushed out of the room and, because smoking was not permitted in the building, they set up a table and chair outside at the top of the front steps for him to greet guests. It was raining, so one student stood next to him holding an umbrella over

his head as he puffed away. I waited my place in line, but he was overwhelmed with well-wishers, so I tapped him on the shoulder and said only, "Thanks for the great lecture, Leo." He smiled and, with cigarette in hand, went back to his adulating fans.

In 2001, his book on Leonardo's *Last Supper* appeared, a complete reworking of the article that was published twenty-seven years earlier in the *Art Quarterly*. Called now *Leonardo's Incessant Last Supper*, it featured on its cover an alluring photograph of the painting mounted onto a billboard on Route 3 in New Jersey in 1967. I was surprised to find that one chapter devoted to the painting's perspective, called "Marginalia" (since much of it dealt with the corner piers I had surmised were depicted at the flanking right and left edges of the picture), discussed my discovery and gave me more credit than I ever expected. He had read my article very carefully and gracefully folded my discoveries into his, reproducing many of my diagrams and presenting them as important contributions to the literature. The book was immediately heralded as an absolute triumph of research and penetrating analysis and, in my opinion, the best single book of Steinberg's career as an art historian. A reviewer for the *Times Literary Supplement* even mentioned my contribution, but, to my mind, the best review was one written for *Artforum* by the distinguished art historian Richard Shiff, a longtime friend and colleague of Steinberg's. Basically Shiff applauds Steinberg's method of looking carefully at a work of art over a sustained period and asking questions about what he is seeing, relentlessly probing until he arrives at a satisfactory explanation of its ultimate meaning, especially as it was understood in the artist's time. He seizes upon Steinberg's use of the phrase "the ineluctable modality of the visible," an unacknowledged quote from *Ulysses*, and goes on to point out how Steinberg is such a masterful manipulator of the

language that he is capable of inserting subtle but ingenious puns into his writing that will go largely unnoticed by most of his readers. After reading the Shiff review, I called Leo to congratulate him, but he sounded unhappy with it. Realizing this, I asked if I could read it again and call him back, because I thought I must have missed something negative that Shiff wrote. After finding nothing, I called him back and asked what he had objected to. "He could have stated that my ultimate goal was to uncover the truth." This, I argued, was the presumed goal of any non-fiction writer, and it hardly deserved mentioning. It was not enough to convince Leo, for when it came to his writings, he was clearly not an easy person to please.

I found an occasion to interact with Leo again when helping an artist whom I represent in my gallery, Kathleen Gilje, to arrange for portraits that she wanted to paint for a series called *Curators, Critics and Connoisseurs of Modern and Contemporary Art*. We had solicited the cooperation of many noted individuals within the New York art world—Robert Rosenblum, Linda Nochlin, Arthur Danto, Michael Kimmelman, Rosalind Krauss, Bill Rubin, Lowery Sims, Robert Storr—and each subject was free to determine in which Old Master painting he or she wanted to be portrayed. Leo said that he would like to be Rubens in the early *Self-Portrait* that was in the Hermitage, but when I looked up that image, Rubens was only in his twenties when that picture was painted. Instead, Kathleen took the liberty of selecting the *Self-Portrait* in the Kunsthistorisches Museum in Vienna, where Rubens is a more respectable sixty-two years old (a bit closer to Leo's age at the time, which was eighty-five). When the portrait was completed, I sent a photograph of the painting to Leo, and he really did not like it. He said that like the Rubens from which it derived, he looked "too corpulent." In the end, he wanted to appear younger, and produced a

photograph by Mark Feldstein taken some twenty years earlier, saying, "If you had asked me, this is the photograph I would have preferred you to use." I submitted the image to Kathleen Gilje, who made a very nice drawing from it (see page 20), and even though I sent a photograph of it to Leo, it did little to appease him. He visited the exhibition, saying that he liked the idea for the show, but disliked how she handled the ear in his portrait, which he said was not painted correctly. He agreed to visit the gallery under the condition that I allow him to smoke. On his various visits, I kept an empty tin of Altoids always ready for him to use as an ashtray, which, appropriately, I labeled "Leo's Ashes."

The last time I saw Leo was about a year before he died. I was attending an opening at Lincoln Center and, since his apartment was nearby, called and asked if I could visit. He welcomed me enthusiastically, but as luck would have it, it was the day when Sheila was there to work with him. Nevertheless, he offered me a glass of apple juice (his staple) and asked me to sit down on the couch and talk with him for a while. After Sheila left, I asked him if he had any significant girlfriends. He told me about Prudence Crowther, whom he had met through the cartoonist Saul Steinberg (no relation to Leo). They went to museums together, and apparently enjoyed one another's company. He then asked me about my family. He reminded me that he had left $1,000 in his will for each of my three children (we adopted a third child from Russia in 2001), which I said he didn't have to do, of course, but thanked him for the thought. A few weeks later, I called and tried to arrange a dinner. We could now go to a restaurant, if he wished, since to my surprise and disbelief, he had quit smoking; after a nearly fatal case of the flu, a doctor convinced him that he could not afford to continue. Of course he had been advised to quit for years, but this time he really did it. He still did not want to go to a restaurant, because he

felt that he lacked the strength to endure an excursion from his apartment, but he welcomed me to come over one evening and bring dinner with me. I asked if our mutual friend Jack Flam could join us, but to my dismay, he said that he would prefer to see me alone. Apparently, when he last saw Jack, he got into a philosophical argument with him, and must have arrived at a point in his life where he would not tolerate the opinions of others who openly disagreed with him. His voice was weak, and he could no longer endure long phone conversations, so we agreed to speak again when I found the time to come over. That never happened, for on March 14, 2011, I received a telephone call from Sheila, saying, "I suppose you know the reason why I am calling." I really did not know, because, despite the warning signs that I had been given, I was unprepared to receive such devastating news. "Leo died yesterday evening," Sheila told me, "surrounded by a relative (his grandnephew) and a few close friends." Although I said nothing, my immediate reaction was to wonder why I was not told he was dying, for I certainly would have wanted to be among the friends who were there at his bedside. Instead, I asked: "What happened?" She explained: "Leo lacked the will to live, so he simply stopped eating and slowly slipped away." He had passed his ninetieth birthday and, apparently, felt he had lived long enough.

Despite the fact that Leo harbored a steadfast resentment that his writings were not accorded the degree of respect he thought they deserved, the obituaries—and there were many—touted him as one of the great writers and thinkers in the field of art history. Writing for the *New York Times*, Ken Johnson pointed out that Steinberg became the first art historian to receive an award for literature from the American Academy and Institute of Arts and Letters. The obituary was headlined "Vivid Writer and a Bold Thinker," a summation that we can only imagine he would have

been pleased to read. "Mr. Steinberg gave academic writing a personal voice: didactic, often urgently polemical, yet generously ruminative, enriched by vivid metaphors, strewn with unfamiliar vocabulary and sometimes idiosyncratic coinages but blessedly free of jargon." Helen Vendler, an English professor at Harvard who met Leo when he went there to deliver a series of lectures in the mid-1990s, put it succinctly when she was asked about his literary prowess. "He knew Dickens and Joyce inside out," she said, "and he had a better knowledge of Shakespeare and the English novel than many professionals in the field." The only detail he might not have been pleased with is the editor's choice to illustrate the article with Kathleen Gilje's painting of him in the style of a Rubens self-portrait, because even though he lived to ninety, he always thought of himself as a much younger man.

For months, tributes flowed in. Virtually every art magazine identified Leo as the greatest art historian of our time. A list of the journals in which the obituaries appeared (and their authors) provides a rough indication of how important and influential his colleagues felt he was: the *Wall Street Journal* (Eric Gibson), *Art in America* (Linda Nochlin); *Artforum* (Achim Hochdörfer); *Source* (a special issue in his honor); *The Guardian Book* (Joseph Rykwert); the *London Telegraph* (anonymous); *The Brooklyn Rail* (David Levi Strauss, Robert Storr, Nancy Goldring). He was also memorialized online in, among others, *Hyperallergic* (Kyle Chyka) *About.com* (anonymous) and internet blogs such as *Schwartzlist documents* (Gary Schwartz), which, of course, Leo would not have consulted. He did not use a computer, neither for writing nor research, although he had one in his apartment that Sheila used, primarily to type his writings, all of which were handwritten on yellow legal pads. *The Brooklyn Rail* printed the complete text of remarks that Leo had delivered to the College Art Association Conference in

Philadelphia in 2002, in a session devoted to him and his work. He told his audience about various events in his life, beginning with several drawn from his childhood in Russia, all in an intentionally amusing style, lending a degree of levity to an occasion meant to honor such an otherwise serious and prestigious scholar. He covered various topics in art history to which he had devoted so much of his time during the course of the previous half century, including Picasso, the *Sexuality of Christ* and the *Last Supper*, seizing the opportunity to ridicule some of his critics. He ended by saying that they might be amused to learn that he was still planning more writing, a piece called "Flotsam & Then Some," and another whose title was taken from a stage direction in an obscure Elizabethan play: "Exit Clown, Speaking Anything."

A few days after Leo's death, a service was held at the Riverside Memorial Chapel on the Upper West Side, not far from where he and his family settled when they moved from London to New York after the war. I arrived and immediately greeted Sheila, who had helped to orchestrate the gathering. Placed prominently on a stand in the middle of the dais was Leo's copy of Joyce's *Ulysses*, a paperback edition clearly worn and read countless times, as well as an urn, which we all presumed contained Leo's ashes. I sat with Jack Flam and Milton Esterow, editor-in-chief of *ARTnews*, the magazine that had published some of Leo's articles, as well as a memorable essay on *The Sexuality of Christ* with a perceptive profile of its author by Margaret Moorman in 1985. The service began as a somber affair, as events like this tend to be, but when the speakers began the mood changed, for they each spoke admiringly and amusingly of their dearly departed friend—or relative, in the case of his nephew (the son of one of his two sisters, who had died long before) and grandnephew. The nephew was a rabbi, and I was quite pleased to hear him speak about the many conversations he

had with Leo about the rich literature of Christianity, which the rabbi had originally dismissed. He was taught as a child that Christianity was "the enemy," so it was difficult for him to open up to its possible merits. Through examples from the world of art that Leo drew to his attention, however, he eventually realized that that it actually had a lot to say, though much of it was conveyed through complex but intriguing visual imagery that could be "read"—at least through Leo's guidance—like a book. Sheila made a few comments about how she got her job with Leo. On the phone, he asked her: "How's your German?" She responded: "Fine, how's yours?" In the end, he probably hired her because she was as sharp and precise as he was, not only about facts but especially about the English language. Besides, she not only typed perfectly but was a formidable researcher and reliable projectionist, exactly what he needed. It didn't hurt that she also smoked, almost as much as he did.

The best speaker was Prudence Crowther, a professional editor who was Leo's closest female friend and companion in his final years. She is the only person known to me who played Scrabble with Leo and stood a chance of winning, for as she said, with that game he took no prisoners. Best was her revelation of his profound knowledge and understanding of many subjects, several of which fell far beyond the field of art history, and his irrepressible erudition, though he himself felt it was not worthy of respect. She also mentioned that he worried about his work, about "the prospect that no one will read it." When questioned about the importance of his writings, Leo told an interviewer, "Nothing I write *needs* writing." When asked if anything did, he curiously cited Orwell's *1984* and, of course, *Ulysses*. Whether or not the world needed Steinberg's writings is something that only time can tell, but for his own personal sense of self-worth, he doubtlessly *needed* to write everything that he did. He

should not have worried about his readers, neither in his lifetime nor in the future, for there can be no question that his writings—like those of all great writers—will be read long after his death, not only by art historians but by poets, artists and probably even theologians, not to mention students in any field who want to witness how a scholar of profound intellect engaged a given question.

A little over a year after Leo died, Sheila contacted a number of his friends and colleagues and invited them over to his apartment to pick out whatever mementos they might want to have (as one of his executors, she was entrusted to clean out his apartment and dispose of everything). She divided the items we could select from into three separate categories: books (although she warned that a bookseller had already taken most of the hardcovers); drawings (mostly from his years as an art student at the Slade School in London); and *tchotchkes* (souvenirs that we might want to have as a memory of our friendship with him). Unfortunately, by the time I arrived much had been picked over, but I managed to take a covered metal canister made from a spent Howitzer shell casing that he kept on the coffee table in front of his couch, as well as the copy of his Touring Club Italiano guide for Rome, filled with marginal notes on the things that he had seen during his many visits to the city. When it came to selecting drawings, Sheila had laid them out on tables around the apartment, and guests were invited to take whatever they wanted. I was shocked by the quality, for although I knew Leo could draw, I had no idea how truly proficient he was. I had seen some evidence of his abilities, but nothing that prepared me for the depth of verisimilitude that was evident in these sketches. Whenever he wanted to make a precise point about a given work of art, Leo would instinctively pick up a pencil and any scrap of paper that was available and try to render the problem visually. Once, he

asked if I ever noticed that there is not a single straight line on the human body, that everything was composed entirely of curves, even in places where you might not expect it. All I could come up with to refute that observation was the fold that was created on the underside of a woman's breast as it touched the surface of her chest, but he objected, and picked up a pencil to illustrate his point. Drawing with his left hand, he skillfully produced three or four examples. I could only imagine how he used this very technique to seduce a woman. Among the drawings that were available, I selected a half dozen done on different-colored papers, one in pencil depicting the head of an old man lying in a bed with his mouth gaping open inscribed "Dr. Sadomsky [?] dead" and dated 1942, several portraits in ink and three academic nudes, one of a male model and two of a woman. The nudes were made in a life-drawing class that Leo took while a student at the Slade; having taken several classes myself as an undergraduate, I can attest that they exhibit a talent and sensitivity beyond the work of an average art student.

In all the years that I knew Leo, he never talked about his desire to become an artist, possibly because he felt that his talents were not sufficient to propel him to a level of serious recognition or, more likely, because he lacked the sort of creativity that was evident in the work of more established artists whose work he admired. In a related situation, he once told me that he did not want his writing to be compared to that of other art historians (who are notoriously deficient in this practice), but rather to authors of the caliber of Joyce and Beckett. I asked him, then, if he had ever tried his hand at fiction. "Never," he said. "I would not know where to begin." When he was asked about his drawings in a formal interview, he dismissed them. "They're sensitive," he said, "but totally academic." Just about two years after Leo died, a show of his drawings was held at the New York Studio School that was

called *The Eye is Part of the Mind*, borrowing the title from an important and influential article that he had published in the *Partisan Review* in 1953 (arguing that, contrary to that which was commonly assumed, even abstract art is the product of thought made visible, and therefore echoes the same approach used by artists since art began). In a catalogue that accompanied the exhibition, Jack Flam wrote admiringly of the drawings. "The hand is sure," he wrote, "the observation astute, the technical command of the medium firm across a range of different modes of vision." Although he found the drawings impressive, he praised Leo for his ability to realize that they were not great, and that his real talent lay in the written word, "words moreover that were intricately bound to images." Included in the exhibition were several magnificent pencil sketches dating from 1940 and 1941 of a young woman identified only as Deirdre. In the catalogue, we learn that this was Deirdre Knewstub, who was the subject of a sculptured bust that Leo made in 1941, the same year that she married the 3rd Baron Aberconway. Despite her impending marriage, it is hard not to imagine that Leo harbored a special affection for this young woman, for her features are rendered with a pencil that not only records what the eyes see, but seems to gently caress the forms it describes (in 1941 Deirdre was nineteen years old, and Leo was twenty-one).

~ IX. ~

SIGNIFICANT OTHERS

When I first began writing about art history, I naturally sought inspiration from the various books I had read and admired. There were two art books that were such engaging reads that I only dreamed of one day possessing the talent to write anything that even remotely approached their quality: Roger Shattuck's *The Banquet Years*, and Calvin Tomkins's *The Bride and the Bachelors*. Indeed, in the preface to my first major book, *New York Dada, 1915–25*, I proudly acknowledged these sources, for not only was my topic chronologically sandwiched between theirs but, as I admitted, the biographical divisions of my book consciously mirrored theirs. Of course, when you are actually writing, it is difficult if not impossible to force your choice of words to emulate those of another writer, but because I was so close to Leo Steinberg, John Rewald and Beatrice Wood, I intentionally drew from them what I felt were their greatest qualities as writers. From Leo, I learned that all writing began as an inquiry, a thought process that always began with the detailed examination of a work of art. From John, I came to know that whatever I had to say would need to be written in the form of a narrative that flowed from one topic to the next, so that I could engage my readers and never lose their interest. From Beatrice, who wrote in a style that resembled speech, I realized that the interjection of dialogue is what keeps a story alive, so I quoted from the artist I was writing about as frequently as possible, usually letting him or her have the first and last word on whatever I was writing about.

Whenever possible, one of the pitfalls I attempt to avoid is the use of clichés. It was one of Steinberg's pet peeves. According to his friend Prudence Crowther, he routinely wrote down clichés encountered in *New York Times* political transcripts and overheard on NPR, eventually weaving all of them together in a satire of political rhetoric called "Speech upon Being Elected to High Office." In my own writings, I cannot help but resort to a myriad of colloquialisms and various crutches of language, especially if I believe the words contribute to the sense of flow that I tirelessly attempt to achieve, phrases and adverbs such as "of course," "indeed," "however," "therefore," etc. (you will find many in the present text).

When I first began writing in the 1970s, I also admired the articles and books by Robert Rosenblum, a renowned art historian who taught at the Institute of Fine Arts, whom I did not know well at the time but would get to know quite well some fifteen years later. Rewald detested Rosenblum because he resuscitated an interest in the forgotten artists of the 19th century, not only minor Impressionists but, to Rewald's consternation, a host of academics whose work his sought to challenge, what commonly became known as revisionist art history. The quality of Rosenblum's writings was actually drawn to my attention by an assignment all students were given in a course on Cubism taught by Leo Steinberg at the Graduate Center. In concluding his first day of class, he asked all of his students to go out and find the very best definition of Cubism we could in the extant literature on the subject. Steinberg knew that few art historians—even those who wrote books on the subject—actually looked at the pictures, so most any definition we found would probably be flawed, and therefore easily challenged. I searched through all of the writings on the subject that were available to me, and I determined that the best definition was to be found

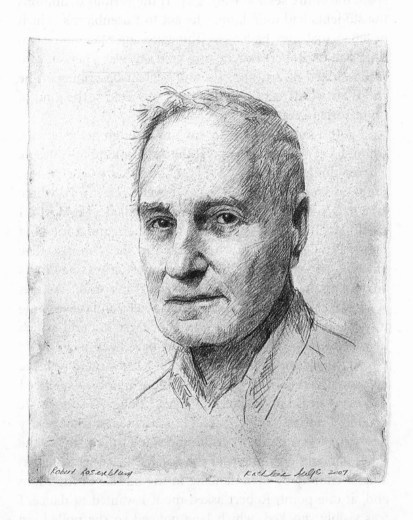

Kathleen Gilje
Robert Rosenblum, 2007
Colored pencil on stained paper, 12 x 9 ¾ inches

in Rosenblum's book on Cubism, so I photocopied that page and brought it back with me to class the next week. Steinberg spent the entire session tearing apart the various definitions the students had found, until he got to Rosenblum's, which he left virtually unchallenged. This experience taught me two things about Robert Rosenblum: firstly, he was a person who really looked at art, and, secondly, when describing it, he chose his words very carefully. That was exactly the kind of art historian I wanted to be.

I got to know Robert Rosenblum through his wife Jane, whom I knew from my years at the Art Institute of Chicago, where, along with Terry, we were students in the M.F.A. program. Upon graduation, we all moved to New York, where Jane met Robert. Shortly thereafter, she called and asked if I would go on a double-date with her, Robert, and a friend of theirs, Rosalie Onorato, who worked in the administrative office at *Artforum*. I jumped at the opportunity, since I was anxious to meet such a distinguished art historian. We met at a restaurant in the Village called Mothers, and the evening turned out to be exceedingly enjoyable since Robert—which he asked me to call him—could not have been nicer. After dinner, they decided to have drinks at a bar located near the Hudson River named Peter Rabbit. Quite innocently (since I had never heard of the place), I tagged along. As soon as we entered, I understood what sort of a bar it was, since a very heavy man was prancing from one side of the place to the other dancing on the top of the bar itself. It was occupied almost entirely by men dancing in the middle of the room and, at one point, Robert asked me if I wanted to dance. I was visibly shocked, which Jane noticed so she pulled me aside and said, "I hope you don't mind. I told Robert you were gay. I'm not sure he would have come if I didn't tell him that." Appalled, I turned around and walked out of the place, but on my way home, it occurred to me how cowardly my

actions were. I should have stayed, explained that I was not gay and, besides, never danced with anyone, man or woman, unless I got so drunk that I did not know what I was doing.

A few years passed before I saw Jane and Robert again. They were living in a loft on Broadway and 11th Street. I came with my girlfriend at the time, and we sat down for dinner at a long table with Robert seated directly opposite me. Behind him hanging on the wall was the painting of an American flag on an orange field that I immediately recognized to be by Jasper Johns. When I asked him about how he got it, Robert said that he purchased it directly out of Johns's first show at Leo Castelli in 1958 for $500, and it took him about a year to pay it off in installments. I was very impressed, not only by the painting, but by the fact that an art historian was possessed with the wherewithal to purchase such an important work of art so early on. At one point in the evening, the conversation turned to snuff films, a subject that was then much in the news, movies in which someone was actually killed and the whole process recorded for pure entertainment. I insisted that the whole concept could only have been a rumor, that such a distasteful thing could not really exist. Everyone argued against me, one person claiming to have actually seen movies of this type. I felt compelled to declare that if such a thing existed, the people who made the films and people who watched them should all be killed. It was a hard line, but it stopped the conversation cold, and it was clear that I did not fit into this company. I left rather sheepishly, and knew that I would never be invited back.

Some fifteen years passed before I saw Jane and Robert again. By then they were married, had two children, and were living in a brownstone on West 10th Street in the Village, not far from the apartment in the Silk Building where Terry and I lived. I would soon learn that they were able to purchase and renovate the building with money from the sale of their

Jasper Johns *Flag* painting, which they sold through the
dealer Jeffrey Deitch for millions (I never asked how many).
We were often invited for dinner to their house, which was
filled with valuable works of art that covered the walls, like a
giant Andy Warhol *Fright Wig* painting, a numbers drawing
by Jasper Johns, a colorful painted aluminum construction
by Frank Stella and, in their dining room, *Eat Dem Taters* by
the African American artist Robert Colescott. As luck would
have it, years earlier I had actually met Robert [Rosenblum]
on the street in SoHo when he was frantically looking for the
gallery that first displayed the highly controversial paintings
of Colescott, who was known for his provocative mockery
of black stereotypes (*Eat Dem Taters* is a parody of van
Gogh's *The Potato Eaters*, where a group of indigent peasants
huddled around a table are replaced by grinning black faces).
It was not until my visit to his home in the early 1990s that
I learned Rosenblum had purchased the picture. It was this
painting guests saw when assembled in their dining room
for dinner, where I would shamelessly insinuate myself into
Robert's presence, sitting right next to him whenever possible.
He permitted this, I think, because there was one thing he
absolutely loved, and that was gossip—gossip of any kind, but
especially within the field of art and art history. Of course, his
engagement in this activity occasionally got him into trouble,
for he enjoyed it so much that he could not stop himself from
speaking freely, even when journalists called. But with me it
was mostly harmless talk about our colleagues, for whom—
depending on the person we happened to be talking about—
he expressed either admiration or disdain. I contributed to
these conversations more to keep them going than for any
other reason. I was there, really, to hear whatever he had to
say; for any gossip to be successful, you need someone who
is willing to listen, which is the minor service that I was all
too anxious to provide, because listening to Robert was—for

me—pure entertainment.

The dinner parties at his home were the closest I have come to experiencing a true artistic salon. Since I was then in the process of writing about the Arensbergs, the experience was deeply rewarding, as it allowed me to imagine how exciting those parties might have been. One visitor to the Arensbergs' apartment said that they "collected not only art, but the artists as well." The same could be said of the Rosenblums. You never knew who you would meet when you went there, but of one thing you could be fairly certain: they would be people you wanted to know—artists, writers and critics—the crème de la crème of the New York art world. Also, unlike many who exploit their friends like living currency, the Rosenblums invited you—indeed, encouraged you—to get to know these people independently, outside the orbit of their immediate friendship with them. Like Henri-Pierre Roché, the French diplomat who was a regular visitor to the Arensberg apartment and who later in Paris established a reputation as "the great introducer," the Rosenblums introduced people to one another on a continuous basis, and thereby expanded the lives of their many friends for years, if not decades, to come.

We were once invited to join them for a weekend at their summer rental in the Hamptons, where I had the great pleasure to spend an afternoon alone with Robert, while Terry and Jane went shopping and took the kids to the beach. Among other things, we talked about the general topic of writing, since he was in the throes of writing a general survey text on the history of 20th-century art (a book, by the way, that never materialized, although the first chapter, on the year 1900, was used as the basis for a great show he organized with a number of other art historians for the Guggenheim some eight to ten years later). I mentioned to Robert that I was in the process of reading—or rather, trying to read—

Ulysses, a text that, like many others, I found exceptionally difficult. I told him that Leo Steinberg got me interested in the book, and that he said he learned English by reading it. I shall never forget how Robert reacted. "I read *Ulysses* on the subway, commuting back and forth to Queens College," to which he added with characteristic humor: "Thank god I already knew English."

At any rate, I was quite anxious to witness Robert in action, since the rumor had spread among art historians that he wrote in a single uninterrupted flow, from the start of an essay or chapter to its very end without making any changes. When I told him that he was known for that ability, he told me it was pure hogwash, a story invented by other art historians just to make him look bad, because if everyone knew he wrote without effort—and they, by contrast, labored through every sentence—then their writings would be, by implication, better. However he might have felt about these allegations, I actually watched him write, and I can attest to the fact that part of the rumor was true. He did begin every sentence without going back over what he had written; instead, he plodded from start to end in a straightforward linear manner, often painting himself into a pretty tight literary corner. In order to get out, he would have to find the exact word or phrase that best completed his thought, so that, in effect, every sentence that was begun automatically offered a challenge to complete, a sort of game with the language that Robert loved. I have no idea how he managed to accomplish this feat, for if you read his writings, you get no sense that they involved any labor whatsoever, but rather, they read as though composed without effort, as natural as speech.

It was Robert's example that also taught me that writing did not have to be such a serious and strenuous activity. For years, I needed exactly the right conditions to compose: my desk had to be perfectly clean (except for the papers and

books I needed to consult), I could not have anyone else in the room, and I could not be interrupted. Robert wrote wherever and whenever he found the time. I have been told that he even wrote in the slide room at NYU, with a whirl of activities taking place around him. At whatever point he was in an article or book, he could pick it up exactly where he left off without missing a beat. He might have been happy to know that when I was asked to speak at his memorial service at the Guggenheim, because I was traveling at the time, I wrote my remarks in several aircraft terminals, on the high-speed Eurostar from England to France and during a sleepless night in a hotel room in Paris, and I finished a rough draft 30,000 feet above the Atlantic (unlike Robert, I edit and revise my texts continuously). For Robert's shining example as an on-the-fly writer, I shall remain forever in his debt.

When I opened my gallery in 2001, Robert followed its program closely and saw most of my exhibitions. He even wrote two catalogue essays for me: one on Mike Bidlo's *Erased de Kooning Drawings* in 2005, and another in 2006, some six months before he died, for Kathleen Gilje's *Curators, Critics and Connoisseurs of Modern and Contemporary Art*. Gilje, who had once worked as a professional restorer of Old Master pictures, became an artist when she began making parodies of these pictures, in the case of her exhibition at my gallery, envisioning contemporary curators and critics in the position of historical figures portrayed in well-known paintings of the past. When Robert was told that she was going to paint him in the guise of Ingres's Count de Pastoret, he could not resist, for he was known to have resembled the handsome count, and had written a wonderful book on Ingres some years earlier. When Robert saw the finished portrait for the first time, he turned around to me and Kathleen and said: "Now I am immortalized." Knowing that he might say something

like this, I was prepared, so I immediately rejoined: "For most of us, Robert, you already were."

I learned about Robert's death from Jane. She called me while I was attending the Basel Art Fair in Miami Beach (I was not yet an exhibitor there). I was shocked speechless by the news, and for about an hour walked up and down the aisles aimlessly, in a fog and not seeing anything. I decided to leave the fair and go back to my hotel room, but right outside of the building, I saw the artist John Baldessari, whom I had never met but recognized (he is known for his white beard and for his 6' 7" stature). I asked him if he knew Robert. When he responded in the affirmative, I gave him the sad news about his death, and he asked: "Can I tell you an amusing anecdote about him?" When I nodded my head he launched into a story of having met Robert at an art conference a few years earlier. He noticed that Baldasarri had in his hand a copy of the magazine *October*, which is known for publishing the writings of art historians who identify themselves as linguists, semiologists and theorists, exactly the sort of art history Robert loathed. "What are you doing with that?" Robert asked. "I was reading it last night," Baldassari responded, whereupon Robert quipped "I didn't know you could read that sort of magazine with one hand."

I know that Robert read the obituaries, and I can only imagine that he would have liked reading the nice things said about him in the *New York Times*. His favorite part of the notice might have been being remembered by one of his colleagues for having been aesthetically perverse, for anyone who knew Robert well knows that perversity was a realm in which he flourished. What he really would have loved about the obituary is that it appeared opposite a photograph of Divine, the flamboyant overweight transvestite who starred in many memorable films by John Waters (Divine appeared because his clothing designer, Van Smith, had died a few days

earlier). You don't get much more perverse than that. He would also have enjoyed reading the recollections of friends, but the part of the article that he would have loved most is mention of Archie, "the beloved family bulldog," who, as we are informed, "predeceased him." That—I believe—would have positively brought him to tears. Robert absolutely loved that dog, just as he loved his noble and devoted successor, Winnie. There was not a single conversation that I had with Robert over the years, nor a card or letter, nor a single email message, in which he did not find one way or another to mention his beloved companion of the moment, curled up at his feet, snoring and slobbering all over his bed. I remember once when he told me about how Archie had a habit of leaving an unmentionable discharge in the shoes and slippers in his closet. When I reacted in disgust, he quipped, "Absolutely nothing that comes out of that animal is objectionable to me." If that's not true love, I don't know what is.

I once asked Robert what type of art historian he would prefer to be remembered as: like Leo Steinberg or John Rewald? We were at a party when I asked the question, so he said, "I'll tell you later." Just before leaving, he walked over to me and said, "Rewald." When I asked why, he said, "It's more important to get your facts straight than presenting ideas, which will probably be forgotten over time." In the end, I only now realize that it was an unfair question, for the two choices I provided were far too limiting, especially for an art historian like Rosenblum. His encyclopedic knowledge and familiarity with countless minor artists allowed him to appreciate the quality inherent in a far greater number of painters and sculptors than were probably even known to the other two art historians combined. As a result, his career differed significantly from that of the others, so much so that any form of comparison would be inappropriate. It was then that I realized that my own conscious choice of

mentors was probably too confining, that you should never restrict yourself to emulating the work of any two or three individuals, when, of course, nothing can stop you from using the entire world of writers—not only in art history, but in all fields of literature—as a potential source of inspiration.

* * *

One art historian contributed more to the field of study that I eventually chose than any other. Robert Pincus-Witten taught the first class that I took at the Graduate Center in the fall of 1973, but by then I was already familiar with his writings, having read most of the articles he published in *Artforum* while still a student at the Art Institute of Chicago. He wrote not only about contemporary artists whose work I admired, but also about historical figures in whom I had taken a great deal of interest, particularly Marcel Duchamp, Francis Picabia and Man Ray. I must confess to having objected to some of his interpretations of these artists— specifically on how he traced the influence of Duchamp on the work of select contemporary artists—and it even led me to make a work of art based on refuting his line of reasoning. Because of my familiarity with his writings, I was anxious to meet him, but whatever preconceived notions I had about him and his way of thinking beforehand all changed when I met him. I found him to be one of the most engaging and entertaining instructors I have ever known, for he did not present information to his students in a straightforward, linear fashion, but rather as a continuous stream of thought, connections and interrelationships between artists and works of art that he imparted with an enthusiasm that was infectious. He didn't stand in the front of the classroom and simply lecture, but bounced around like a Broadway entertainer, his eyes sparkling in the darkened room as they

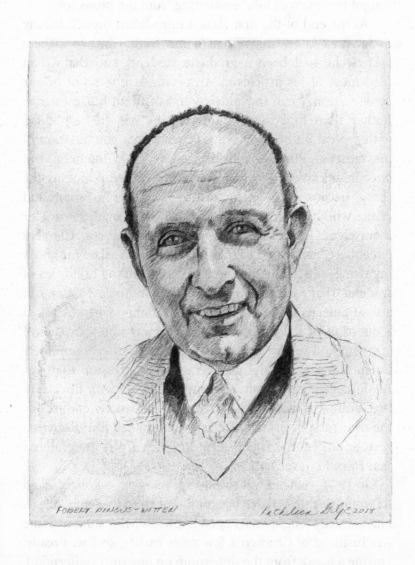

Kathleen Gilje
Robert Pincus-Witten, 2018
Colored pencil on stained paper, 13 1/8 x 10 3/16 inches

caught the beam of light emanating from the projector.

At the end of the first class, I introduced myself, mostly to let him know that I had come from Chicago (where I knew he had been a graduate student) and that I had read most of his articles in *Artforum*. At one point in our conversation, I had the audacity to ask about his last name. Rather than find the question off-putting, he responded with typical humor by saying that it was a combination of his father's—Pincus—and his mother's—Wittenberg. But once he became an art historian, he regretted removing the "berg" because of the many distinguished art historians and critics who had preceded him and who had made names for themselves: Pierre Rosenberg, Sidney Friedberg, Clement Greenberg, and even Leo Steinberg. He then asked me about my name, which surprised me, just one among hundreds of students that he had not only at the Graduate Center, but also at Queens College. It was at that point—when he asked a question of me—that I realized he was not your typical arrogant and self-absorbed professor, but rather a genuinely warm and gracious human being, an impression that was reinforced in every conversation that I had with him from that point onward—a camaraderie that would endure for the next forty-five years. He asked me to call him Robert, a gesture of genuine friendship for which I was grateful and that I would never forget.

In 1974—when I was twenty-six years old—Robert asked if I would be interested in teaching a course at Queens College. I had already taught a survey course as an MFA student at the Art Institute of Chicago a few years earlier, so I was ready. During a break from the slide room on one sunny afternoon, Robert asked me if I wanted to go outside and have lunch. While we were talking about a variety of things, he stopped and said "Can I ask you a question?" I said "Sure." He then asked "Are you gay?" I responded, somewhat apologetically,

"No, I'm afraid not," whereupon he jumped up from the bench and said "Shit, I always get it wrong." I'm happy to say that the question and its answer did nothing to curtail our friendship, for Robert continued to go out of his way to help me and to promote my career in any way he could.

The class in which I was enrolled at the Graduate Center was on the subject of French, Belgian and English symbolism at the end of the 19th Century. Robert had written his doctoral dissertation on *Occult Symbolism in France: Joséphin Peladan and the Salons de la Rose-Croix*, an esoteric subject, but one that he pointed out went directly against the canon of art history as it had been established at the time, which was basically a study of those artists identified as the leading Impressionists of the day. Rewald, who had served as one of Robert's thesis advisors in Chicago, must have resented this incursion into his field of study, for in his voluminous writings he attempted to establish the Impressionists as the only artists worthy of study in this period. Robert was only too happy to point out that the first Salon del la Rose-Croix drew more attendants than all of the Impressionist exhibitions put together, a fact that challenged our assumption that Impressionism was as popular in its day as it became subsequently. I took a clue from Robert's approach to history when I came up with the topic of my seminar report, which was on the use of the guillotine in public beheadings and its influence on the subjects chosen by artists in 19th-century French art, particularly the symbolists, from Gericault's paintings of decapitated heads to various depictions of Salome displaying the head of John the Baptist. In my presentation, I was able to show photographs of freshly decapitated heads alongside paintings, which made one or two students get up from their seats and leave the classroom, an action that I took as a compliment and in which Robert delighted.

It was around that same period when he asked if I would

be interested in writing reviews for *Artforum*. It was the first exciting writing offer of my career, and I again jumped at the chance. In an editorial meeting in the offices of the magazine, where I met, among others, the then editor-in-chief John Coplans, I was given no restrictions, and told to go out and find the art I wanted to write about. I surveyed the various galleries in SoHo and selected five shows, but when it came to writing about them, the task was very difficult. I tried to emulate Robert's writing style, but as those of you who are familiar with it can attest, his articles were exceptionally sophisticated and erudite. Unfortunately, I lack the rich vocabulary he unquestionably possessed. I can recall having prefaced my review with a long introductory text, and when I presented my manuscript to Robert, he simply removed the preliminary remarks and left what I had to say about the five artists. He said "Don't worry about what I took out. Nothing is wasted. You'll find an occasion to use it elsewhere." I cannot tell you how true that advice was. My stint as a reviewer for *Artforum* lasted only three issues, because he—and likely John Coplans—had noticed that I had little positive to say about the art I was reviewing. They called me into the office one day and Robert said that the negativity would probably catch up with me, as well as with the magazine, and in the long run, it would probably do neither one of us any good for me to continue as a reviewer. He recommended that I write articles instead, a suggestion that changed my life for the better.

At just about the time when I stopped writing reviews for *Artforum*, Robert called me into his office and asked if I would be interested in working for Ileana Sonnabend, the owner of a prestigious gallery in SoHo (directly above the gallery of Leo Castelli, to whom she was once married). Robert had worked for Ileana in the 1960s in Paris, and they were looking for someone who could serve as a liaison between the gallery in

New York and museum curators, so he thought that might be an ideal position for me. I was hired, but a few weeks after I began, the gallery held a show of the Greek-Italian artist Jannis Kounellis, and because I spoke Italian, I was given the job of interviewing him and overseeing all aspects of his show. It was a very exciting moment for me, but as soon as the exhibition was over, it became clear that I was otherwise not needed at the gallery (except to make order out of their archives, which were in total disarray). As a result, I stopped coming to work, but Ileana refused to accept my resignation and insisted upon paying me for three to four months after I left the job. It was years before I realized how invaluable this experience had been for me. Firstly, the director of the gallery at the time was Ealan Wingate, a flamboyant and quick-witted man with a dark beard and sparkling eyes, who, some fifteen years later, introduced me and my wife to a couple who, in turn, introduced us to a person who served as the adoption facilitator for our children (for which I shall remain forever grateful). And some twenty-five years later, I would go on to open a gallery of my own, so my short stint as an employee at the Sonnabend Gallery served as my first significant foray into the world of art dealing.

The next course Robert offered at the Graduate Center in the spring of 1976 was entitled "New York Dada and its Affinities." This was a subject true to my own personal sensibilities. Duchamp was the guiding force of this movement and the artist whom I had admired above all others (save Leonard da Vinci, with whom, curiously enough, there are many intellectual parallels). I had first learned about Duchamp while still in high school and had made works of art inspired by his example in college. I was anxious to study the artist in a more systematic fashion, and this course provided the ideal opportunity. For my seminar report I selected "Cryptography and the Arensberg Circle,"

as I had discovered that the writings of Walter Arensberg
seem to have had a great deal of influence on Duchamp and
many other artists in their circle of friends, a subject that
had not been suggested in the prior literature on any of these
individuals. Robert liked the paper, and encouraged me to
pursue this subject as a dissertation topic.

With that goal in mind, I took a research trip to California
and met Beatrice Wood. I also visited the Francis Bacon
Library in Claremont, where the Arensberg papers were
then preserved. Upon my return, I wrote a very enthusiastic
letter to Robert, telling him about all that I had found in
California, and asked if it might be possible to publish a text
in *Arts*, a magazine to which he had been contributing on a
regular basis. The editor, Richard Martin, decided to devote a
special issue of the journal to the subject of New York Dada,
and I was fortunate to not only publish my first major article
in that issue, but to introduce excerpts from the then-as-yet
unpublished autobiography of Beatrice Wood.

In 1977, I applied for a teaching position at the Fashion
Institute of Technology and at Parsons School of Design in
New York, and Robert kindly wrote letters of recommenda-
tion for me. As I read the letter he wrote today, I am somewhat
embarrassed by his words of praise, for he claims that I am
"tinged with a kind of genius." He knew that whenever anyone
said something like that about me, I refuted the notion,
which is probably what prompted him to write, "He wears
his laurels lightly." Frankly, such qualities are more Robert's
than mine, for his intelligence and erudition revealed itself in
every conversation—whether in his years as an academic or
later in working for galleries—he was always modest about
his accomplishments. At any rate, I got both jobs. But when
he wrote another letter for me a few years later when I was
applying for a position at Princeton University, he was a little
more cautious in his appraisal. He informed the evaluator

that I may not complete my dissertation by the anticipated date because I was the type of scholar who attempted "to locate each needle in the haystack." He was right. It would take me another ten years to complete the dissertation. Needless to say, I didn't get that job.

At some point in the late 1970s, I asked Robert if he would like to have the work of art I made in Chicago that was based on his writings. It is a fairly large object—roughly 40 x 40 inches—made of 216 individual words stamped onto metal plates and inserted in six vertical columns. The words were presented in a random order, so the original text could no longer be deciphered. I explained to Robert that the piece was called *Footnote 6*, since it consisted of the text of a footnote I had written for a paper that refuted what he had written on Duchamp's influence on a work by Bruce Nauman. In a typically generous spirit, Robert said that it seemed especially relevant, since challenging the ideas of your professors is what graduate study is all about. I made an appointment to deliver the piece to his office, which he shared in the basement of the building with Professor William Gerdts. He asked me to hang it behind his desk, which was not easy, since it weighs almost 40 lbs. Despite what Robert said about students dissenting with their teachers, I had grown so friendly with him that it pained me to know that what hung behind him secretly contained words of disagreement. So when I went home that evening, I carefully excised that footnote from my paper with a razor blade and destroyed it, so that no one—not even me—would be able to reconstruct what it said. *Footnote 6* remained on display in Robert's office for years, until he left his teaching position to begin working at the gallery of Larry Gagosian in 1990. When cleaning out his office, he called to ask if I would like to have the piece back, since he had no space in his home to hang it (indeed, he lived with his partner Leon in an apartment next to the United

Nations Building that contained many expanses of windows and, removed from context, it would have little meaning).

Throughout the years, Robert continued to help me whenever he could. While working at the Gagosian Gallery, he asked if I would write an essay on a single work of art by Jasper Johns, a large mural-sized painting called *According to What* that they were planning to feature in an exhibition. He suggested this particular painting because he saw that it bore a formal rapport with Duchamp's *Tu m'*, both paintings being long horizontals. I agreed that there could be some connection, so I arranged to meet Robert and view the painting in the apartment of Victoria and S.I. Newhouse. Robert and I spent about a half-hour looking at the painting and discussing its various details, always an enriching experience with him. I went home and spent about a month writing the essay, hoping that it would meet with his approval. I worked with exceptional diligence on the opening sentence, wherein I attempted to encapsulate what the Johns' painting was all about. When I handed him the manuscript, he read that first sentence and said only "Brilliant." He then asked me to leave for two hours to give him enough time to read the rest. When I got back, he noted that I had forgotten to compare the Johns painting to Duchamp's *Tu m'*, the reason he had invited me to write this essay in the first place. He was right, so I went home and added another page, which he accepted and integrated into the final catalogue text. At the opening of the show, I was delighted to see that Jasper Johns attended, as did Leo Castelli, his longtime dealer. As the evening drew to a close, I noticed that Gagosian had invited them and S.I. Newhouse all to dinner, so I walked over to Robert and asked "As author of the catalogue, should I have not been invited?" Robert said, "You would not want to go. It's not the right place for you. They are just going to talk business." At the time, I was quite upset over it, thinking that

I had simply been used to help them sell a painting. Upon reflection, however, he was probably right, for I was merely an academic, and I would have been completely out of my element attempting to converse with those heavy-hitting powerhouses of art-world commerce.

In the many years that passed, if I published anything that related to Robert's area of interest, I was sure to send him a copy. In the acknowledgments to my first major book, *New York Dada: 1915–1925*, I thanked him profusely for what I learned in his course, but my editor thought it was too personal and of little interest to the general reader, so that passage hit the cutting room floor. I wrote to Robert explaining what had happened, but asked, nonetheless, if he would still consider writing a blurb for the book. His response came in the form of an ingenious acrostic, the literary devise used by Walter Arensberg in trying to find secret messages imbedded into original Shakespeare folios. "Like Marcel Duchamp's famous Valise," he wrote, "Francis M. Naumann's *New York Dada* is top of the line, all in there and ready to go...," a statement followed by the following column of words:

Fresh
Readable
Audacious
Necessary
Comprehensive
Indispensable
Substantial

Madcap

Needed
Ambitious
Useful
Meticulous
Authoritative
Nosy
New

In virtually every book that I published subsequently, I was honored to acknowledge the influential role Robert had played in my life. The topic of my dissertation had switched from New York Dada to Man Ray's early work in New York and Ridgefield, and Robert served steadfastly over many years as my dissertation advisor. I was always pleased to mention how important his class in New York Dada had been for me. In the introduction to a book of collected essays on Duchamp that I published in 2012, I devoted an entire paragraph to explaining why I felt his teachings had been of such importance to me, referring to him as "among the most inspirational teachers of my student life." As soon as the book came out, I sent Robert a copy and his response was characteristically effusive, saying "your kind words are always affecting."

In the same email message, he told me about an operation that he was about to undergo for prostate cancer. I worried continuously about his condition, but he kept sending me missives of reassurance, saying that he was in good spirits and that everything that could be done was being done. In January 2015, he was hospitalized again. So many of his friends tried contacting him that he sent almost everyone on his mailing list a group message, apologizing for not writing to each of us individually, but thanking us for our outpouring of concern. I responded by saying that I was hoping for "a total and miraculous cure," adding "I'm shooting high, I know, but in my profession"—by then I had opened a gallery—"I've learned that's the best position from which to negotiate." I kept writing for updates, and he finally responded a month later to tell me that my inquiry arrived at a propitious moment, for he had good news. An MRI scan taken that morning indicated that "the bad cancer cells have been temporarily vanquished with no damage to surrounding tissue." The most unusual thing about that message was that

he followed it with a detailed account of having watched the Academy Awards the night before. "Did you fulfill your role as a god-fearing tax-paying member of the American middle class," he asked, "and watch the Academy Awards?"

> I thought the performances of the big singing stars— Barbara, Adele, Shirley Bassey, Jennifer Hudson, Catherine Zeta-Jones—really stole the show. Charlize Theron is astoundingly beautiful and the best dressed in rational white. Her close-cropped head was so much more intelligent than those stringy mops of long straight hair that dangled into the over-detailed evening gowns. Anyway, who won, won. We've not seen *The Life of Pi*—but special effects is not acting— though the Bengal Tiger was certainly good looking. Leon, inimitably called it 'The House of Pie,' making it sound like a restaurant chain that serves pancakes "ye high."

Since we were corresponding regularly by email, I always remembered to send Robert a greeting every year on April 5th, his birthday. For his 80th, I sent him the words "HAPPY BIRTHDAY ROBERT" in big red letters, to which he responded "I would say you are angelic, were it not for the phrase's sissy overtones," adding "Though you are." He said that a few months earlier, Leon had turned 79. "We are both trying to ignore the pile-up of years, though admittedly 80 is a number on which one stubs one's toes," to which he added "By the way, even if 60 is the new 40, and 70 the new 50, 80 is still the same old 80!"

A few months later, I told Robert that I wanted to send him a manuscript I had just completed called "Mentors" (the present book), wherein, I discuss the influential role played in my life and career by Leo Steinberg, John Rewald and

Beatrice Wood. I forewarned him that he was mentioned only in passing, because I wanted to concentrate on those individuals whom I had known on a more intimate level, each of whom—in very different ways—had a profound effect on me both personally and professionally. He said he would read it, but only in hardcopy, and not from the standpoint of providing advice for publication. I gladly accepted those terms and sent him a copy. Two days later I received an email from him with the subject line: "Could not put it down." He read the whole thing in one sitting, telling me that "the read was gripping." I wrote back to say that a greater compliment could not be paid a writer. He also expressed a lament. "Naturally, I wish now that I could have been so close to you as to have merited the praise and affection you lavished on Leo, John, Beatrice, Robert [Rosenblum] and Jack [Flam], even the overbearing Bill [Rubin]."

Much of my remaining correspondence with Robert pertained to arranging for me to interview him for the oral history program of the Archives of American Art, which had requested the receipt of his papers upon his death. The interview took place in two sessions on March 26th and 27th, 2016, in the elegant, modern apartment he shared with Leon next to the United Nations. Robert was his usual cheery self and although I had prepared for several weeks—compiling a chronology of his professional life, his writings and various jobs both in academia and after—in the beginning I was quite nervous, whereas he was totally at ease and spontaneous, answering each question with humor and nonchalance. We talked about everything that led to his life in the world of art, from his childhood, education, teaching, and work for galleries. Towards the end of the interview, he mentioned that Leon had taught Andy Warhol to make silkscreens, and that he—Robert—had been one of Andy's *Thirteen Beautiful Boys* (for which Warhol prepared screen tests).

When the interview was over, Robert said, "Would you like me to tell you something else about Andy that I left out of the interview?" Of course I was intrigued, and when I said "yes," he whispered: "Andy had a micro-penis." I wanted to turn the recording back on, but he refused, saying that it was not the place to reveal something like that. I asked if he wanted the information to remain private, and he responded "No, it's just not the right time or place."

Robert never fully enjoyed the world of academia. He once told me that he conducted most of his research standing in the aisles of Barnes & Noble, and he referred to each student's dissertation as "the big book report." He never stopped writing and, even in the last years of his life, continued to publish reviews of various shows that interested him in *Artforum*, the magazine for which he had been a contributing editor forty years earlier. In 2007, He generously wrote a catalogue essay for my gallery on the drawings of Carlo Maria Mariani (whose work he had introduced to me years earlier), and he wrote a review of a show that I organized in 2015 devoted to the watercolors of Walter Pach. Less than a year before he died, I wrote to ask if he had seen the show at the Guggenheim "Mystical Symbolism: The Salon de la Rose+Croix, 1892–1897," the subject, for all intents and purposes, of his doctoral dissertation. He wrote back to tell me that he had seen it and was in the process of writing about it, but was struggling because he had too much to say, more than could fit into the normal space of a review. "I went back to the yellowing diss," he told me, "and find the first 109 pages tedious beyond description. All that ultramontane Catholicism of provincial fanatics—Péladan's dad, I mean, and Joséphin's loony brother. How did I ever read that stuff let alone transcribe notes by hand onto 5 x 7 index cards? Imagine, Rewald was a thesis advisor—not that he ever advised anything. But the chore must have been chewing pure gravel for him." In Robert's

published review of the show—the last of his writings to appear in *Artforum*—he was grateful that the organizer of the exhibition acknowledged his early work on the subject, but seized the opportunity to get one final dig in at his old professor, saying that we received only a "stunted view" of this period due to the powerful influence of John Rewald's two books on Impressionism and Post-Impressionism. "Now we recognize that Gauguin was all but unknown at century's end," he wrote, "while the myriad figures of the Rose+Croix of the Temple and the Grail were all the rage."

During the course of the last two years, Terry and I visited Robert and Leon several times at their country home in Washington, Connecticut. It was a 5000-square-foot modern clapboard residence with an Olympic-sized pool and a great view of the surrounding countryside. It had two floors, but they lived only on the entry level, occupying the master suite at one end of the house. It was flooded with light but sparsely, though elegantly decorated, with antiques and paintings they had purchased from stores in the area or that Leon found online. They kept only one bedroom upstairs furnished, for their good friend from New York, Gerry, who was infirm and for whom they cared when he visited. We would always go to brunch with them at the GW Tavern in town, where they kept the same booth and the waitresses knew them well. They were a gregarious and charming couple, and it was always a pleasure for us to watch them interact. After lunch, we went to a local antique mall, where Robert spotted most of his finds, but on the occasion when we went, there was nothing to discover. Back at their home, they saw us off, always waiting at the door until our car disappeared down their long driveway.

In November of 2017, I received a call on my gallery's answering machine from Robert, where he sounded very weak and told me he was in the hospital. I called immediately

to find out what had happened, and he told me the doctors had discovered he had a fissure in his spine that was very painful, and that he was in a rehabilitation center on East 79th Street, which, he noted, was very conveniently located for most of the people who wanted to visit. I wrote an email to him immediately saying that his call had frightened me— that it made me realize how much he meant to me. I called Leon who gave me the address of the hospital and who told me that I could visit anytime. Terry and I went the next day, unannounced. Robert was not in his room, but in the rehab center on another floor in the facility where we were invited to go. We did and on seeing him seated in a chair, he broke into a broad smile, making us at first imagine that all was well. When we watched him go through exercises with a therapist—where he was asked to lean forward and place colored pegs on incremental layers of a wood board—he visibly writhed in pain. It was excruciating to witness, and when we accompanied him back up to his room, we asked if he was taking any pain medicine. He said that the doctors would not allow it, but that Leon sneaks him an occasional Tylenol. I asked Robert if he knew the word iatrogenic. From a person with such a rich vocabulary, I was pleasantly surprised that he did not. It means having an illness that is the direct result of medical treatment, a word that most doctors would prefer did not exist. He loved it. We left and said we would be back soon. Over a month passed, but with the constraints of my business, that never happened.

Curiously, however, his influence on me and my work was destined to continue, and I was fortunate enough to let him know that. A week before Robert died I called him at the rehabilitation center to tell him about an exciting show that I was planning for my gallery in the fall that he had originally proposed to me two years earlier: drawings by a remarkable artist named Gray Foy (whom he had known, but who died

in 2012). Robert did not answer his cellphone, so I called Leon, who was at his bedside. He relayed the news about my show to Robert, whom I heard comment weakly in the background "great draftsman." Those were the last words I heard Robert speak. I asked Leon when Robert would be going home. He said "Possibly next week." When that next week came, Robert did go home. In the comfort of his own bed and with his faithful partner of over seventy years by his side, Robert quietly and gently departed from this planet.

I found out about Robert's death from a notice online. I refused to believe it, thinking it just another example of "fake news." I immediately called Leon, but he did not pickup. I left a message begging him to please call and tell me that it was not true. During the course of that day, other notices followed, so I eventually realized that Robert was really gone. I was so distraught that I sat down at my computer and began writing about him, hoping that the process might help to alleviate the profound sense of loss that I was experiencing. It was only then that I realized how important his example was to the sort of person I became—not only professionally, but personally—whereupon I decided to include my recollections of him in the present volume. Unfortunately, I was never able to tell him that what he had lamented—his omission from this book—was a regrettable mistake that, thankfully, I had the time left in my own life to rectify.

NATURE VS. NURTURE

I suppose everyone is—to one degree or another—a product
of other people, either in the form of inherited traits or by
conscious selection. Having been adopted, I was naturally
curious to know if anything was handed down to me by my
biological mother or father. For my entire life, others seemed
more interested in knowing about my birth parents than I
was, although I imagined that, because my brother and I
were both able to draw in a fairly accurate representational
manner, they might have been artists, or, because we were both
instinctively drawn to an academic life, university professors.
Just after my fortieth birthday, I decided to enter my name
into the New York State Adoption Information Registry,
where, if our biological parents had entered their names,
arrangements could be made for us to meet. They had not,
so I wrote to Catholic Charities in Albany, the organization
that had facilitated our adoption, asking for whatever
information was available. They told me that because my
biological parents had not entered into the registry, I could
only receive "non-identifying information," which they sent
me. It was only then that I learned that my mother's ethnic
origin was German, that she had completed eleven years of
school, that she was a telephone operator by profession, that
she was "small in stature" and that she was nineteen years
old at the time of our birth. Nothing was given about our
biological father, which a cover letter explained was not
unusual for adoptions that took place at that time. Under a
paragraph devoted to "Facts and Circumstances Relating to

the Adoption," we were informed that our biological mother "wanted adoption placement from the outset because she felt she could not meet their needs" (that is, the needs of the twins). Nevertheless, "somehow she was prevailed upon to take the two infants home and she received Aid to Dependent Children for six months." The report went on to say that while we were adequately cared for, "there was disruption and dissention [sic] in the home and at times the twins were the center of this difficulty." Apparently, this difficulty was caused by financial troubles, for the report explained that the father of our biological mother had died, and it was he who had been supporting the family. At six-and-a-half months, we were placed into the Albany Infant Home (an orphanage), and about a month shy of our first birthday, we were adopted by Rose and Otto Naumann of Little Falls, New York.

I was not entirely satisfied with this information, so I called the person who had compiled the report, to see if she could provide anything more. She explained that she had told me everything that she was allowed to, but agreed to look at my file while we were speaking on the phone to see if there was anything more she could say. I could hear her leafing through papers, whereupon she told me that my biological mother was the second of five children, all girls that ranged in age from twenty-one to nine at the time of our birth. Her father (our biological grandfather) was a trained mechanic who died at the age of forty-two. "I don't know if I should tell you this," she said, "but I don't see what harm it will cause." Reading from a piece of paper, she said, "Paternity proceedings were initiated, but denied because of blood tests." At that point, she said, there was nothing more she could tell me.

Some twenty years passed, and then, unexpectedly, I received a letter from the State Department of Health telling me that a biological relative had joined the Adoption Registry,

and that additional information about our adoption was now available if I was interested in pursuing it. Upon signing a consent form, I received a letter providing the name and phone number of a person identified as our biological mother, Helen Newton, who lived in Sheffield, Massachusetts, a small town in the southwest corner of the state, near the border of New York and Connecticut. I called, and, from what I remember of the conversation, neither one of us wanted to say much of anything, except to establish a time and place where we would meet. I volunteered to drive up to Sheffield with my brother, and we set the date for Friday, May 2, 2008, just a week following our sixtieth birthday.

I wish I could say that our meeting was a wonderful, warm and heartfelt reunion, but that was not, unfortunately, the case. She lived in a modest apartment in a retirement home, and when we knocked on the door, we were greeted by six people: our biological mother (although she did not identify herself as such right away), with whom we shook hands politely; her older sister, who hugged and kissed us both; two of her sister's daughters; and two friends, who were there, apparently, for moral support. Once we realized which one of the people was our biological mother, I was immediately disappointed (I can speak here only for myself, of course, for my brother seems to have had a slightly less severe reaction to the encounter). She did not look anything like what I had imagined. She was short in stature (as the report I received earlier had indicated), and she was anything but attractive. She was smoking a cigarette. Her lower jaw was undefined and lacked a cleft, which both my brother and I thankfully have (for without one, to my mind, she took on the regrettable appearance of a chimpanzee). Moreover, at the age of seventy-nine, a certain degree of dementia seemed to have set in, a fact that was confirmed as we spoke at greater length and she continuously kept reminding us

that she had forgotten many things. It was clear that she was never as sharp as her older sister, who would go on to provide much of the information we were seeking. Indeed, one of the first questions we asked was why she chose this particular moment in time to contact us, and she explained that it was not really her idea; she entered her name into the registry at the insistence of her older sister. As it turns out, in the months before we were handed over to the orphanage, we were cared for by the older sister and her husband, for our biological mother had no interest in settling down and taking care of children. The older sister had grown fond of the twins, and entertained the idea of adopting us, but her husband would not allow it, for as he rightly reasoned, her sister could always come back and claim the kids were hers.

Throughout the meeting, I kept looking at our biological mother and wondering if there was any "family resemblance." Friends of mine who had adopted children said that when they met their biological parents, they were shocked to see that the mannerisms their children possessed were unquestionably inherited traits. My brother sat right next to her, so I kept looking back and forth to see if there were any similarities; there was some resemblance around the eyes, but could discern nothing more. At one point, she said to us, "I'm happy to know that I at least gave you something." She paused for a moment before saying, "Good looks." All I could think of was that if we did indeed inherit her looks, we were in for a sad disappointment as we aged. We asked her to tell us something about her life. She told us that she had spent most of her life working as a bartender, and that she had been married three times, but, apparently, the men in her life meant very little to her. She described herself as "a party girl," and at one point her niece (the daughter of the older sister) quietly leaned over to me and described her aunt as "a floozy." If you look that word up in a dictionary,

it is defined as "an offensive term that deliberately insults a woman as being vulgar and promiscuous." There can be no question that this term accurately described her behavior, making it equally clear that she would not have made a very good mother.

That impression was confirmed as she continued to speak. With one of her husbands she had had a son, who, of course, would be our biological half-brother. She was only married to this man for a few years before they got divorced, and she told us that when custody was awarded she did not want to have the child, for she had no means of support at the time. Predictably, this boy often got into trouble with the law, and ended up spending a great deal of time bouncing in and out of correctional facilities in the Albany area. She thought he might have moved to California, but she lost contact with him over the years. Apparently, she considered close relationships like this—especially with men—a burden, something she sought to avoid at all costs. At one point, her older sister pulled out a group of black-and-white snapshots that she kept of us as infants, taken during the months we spent in her care. Two were labeled "Billy and Bobby," which is when we learned that we were first named William John and Robert Joseph, and that our last name was Bigers. From the photographs, the twins are indistinguishable (we face the same problem with other photographs that survive from our youth; if they are not labeled, who's who is anyone's guess). One of the photographs was especially intriguing, for it showed the two of us lying on the ground supported by pillows, but the background is carefully excised. Wherever something is removed from a photograph, you naturally wonder why, and the intrigue only increased when we brought the photograph home and noticed that on the verso was written: "Helen's twins / 1947 [sic] – Adopted / 9 mos. old / Gorgeous Babies / redheads – brown eyes – father died 76."

We were told that this photograph came from the belongings of my biological aunt's sister, not the one that was at the meeting, but another who had become a nun, a Sister of Saint Joseph, who had died a few years earlier. Most intriguing of all about her inscription was her knowledge that the father had died in 1976. When we asked further about this, no one knew anything more. This, of course, led us to ask questions about the biological father, who, I was beginning to believe, must have been the main reason we were so different from the woman who sat before us.

When we asked questions about him, our biological mother claimed that she had no recollection whatsoever, since she was physically intimate with too many men at the time, and was never able to figure out who the father was. This was hard for us to believe, for it seemed impossible for someone to give birth to identical twins—especially in the late 1940s—without having had even an inkling as to who the father could be. When we pressed her further, she said she thought he was Polish, that he was a twin and that he had played football for a nearby high school. At first, I thought she was just extrapolating the information from what was before her: her sister married someone who was Polish, and we were twins (where she got the football reference was anybody's guess). Her niece, however, said that she worked as a secretary in the Albany educational system and could get access to old yearbooks and see what she could find. A few weeks later, she sent us a scan from a yearbook that showed a pair of twins named George "Dutch" and John "Jack" Matuszek. Unfortunately, they looked nothing like us; they had dark hair and no chin cleft. In a caption that appeared below the pictures, George is listed as liking "gym and art," while John likes "reading and aviation." This was intriguing, for my brother and I both went on to study art and take flying lessons. Unfortunately, all subsequent efforts

to locate the Matuszek twins of Albany, New York, have proven unsuccessful.

I left the meeting feeling somewhat disappointed. Not only was our biological mother nothing like what I had imagined—neither physically nor intellectually—but she was unable to tell us anything about our biological father, which left me pretty much in the same position as when I started the whole line of inquiry, for there was still no explanation for how children raised by factory workers in upstate New York both ended up with a Ph.D. in art history. If nothing else, I could now go back to fantasizing about who our biological father might have been, assigning to him whatever attributes I felt were appropriate to satisfy my curiosity. As we were leaving, the niece told me that when we arrived, my biological mother had planned to give us a big hug and kiss when we walked in the room, but that greeting occurred only with her older sister. She was a taller, thinner, more well spoken and generally more elegant woman (we later both confessed that we would have preferred her to have been our biological mother). Somewhat reluctantly, we hugged and kissed our biological mother for the first and last time in nearly sixty years, but it was an awkward experience, one that felt forced and very uncomfortable (probably for all of us).

When I later told a friend about my disappointment in meeting my biological mother, after having told him what she was like, he protested, and said that I should go right back up there and thank her for having had the wherewithal to put us up for adoption. If we stayed with her, he reasoned, the likelihood of our successes in life would have been dramatically diminished. The way he saw it, we narrowly dodged a bullet, so he thought we should be not disappointed, but grateful. I never did tell her that, for about two years later I received a call from her niece (the one who had scanned the yearbook pictures) telling me that she had

passed away quietly in her sleep. I felt nothing. There is no question that, like any physical structure, love is something you have to build and maintain over time. I am afraid that too much water had passed under that bridge to allow for any genuine affection to flow in either direction.

In the end, what you become in life probably has less to do with your biological origins than with the mature decisions you make as an adult about what kind of person you want to be, although the exact percentage can never be determined in any one given situation, for the nurture-vs.-nature debate is anything but settled. In my case, there is no question that having been brought up in a caring and loving home contributed significantly to my future. After all, my brother and I were the children of immigrants who continuously reminded us that the key to a happy and successful life was education, something they were unable to secure for themselves. (Because they had to work and support their families, neither made it past the eighth grade.) It's the typical American story: they worked hard so that we could have the things in life that time and circumstances denied them. In my periodic quest to figure out how my brother and I became who we are, there is one possibility that I never considered until recently: in knowing that we were adopted, we might have felt detached from the expectations of a biological past and actively sought out individuals on whom we could pattern our lives. Moreover, we were free to select from these people the desirable characteristics they possessed that we would consciously emulate, while rejecting those that we would not. To a certain extent, I suppose everyone does that to one degree or another. In having been adopted, it is possible that we followed this pattern of behavior more deliberately, though as with anything else, we were unconscious of doing it at the time.

It was only in retrospect, years after I had fully absorbed

the lessons taught to me by my mentors, that I discovered they were all Jewish. That was apparent in the case of Leo Steinberg and John Rewald (as well as Bill Rubin, Robert Rosenblum and Robert Pincus-Witten), but for Beatrice Wood, it was not made clear to me until a few months after her death. A student by the name of Helen Hennessey, who was in the process of writing her dissertation on Beatrice for a degree in English literature at a university in Florida, called to ask if Beatrice ever discussed with me her Jewish past. I was flabbergasted, and could only respond in shock. "She was Jewish?" I asked in disbelief. "Yes," she said, "her mother's maiden name was Rosencrantz." Beatrice had told me her mother's last name when we met, but for some reason it never registered that she was Jewish (as is well known, Jewish lineage is officially passed down only through the mother). When I once mentioned this fact to Bill Rubin, he told me that there were members of the Rosencrantz family in San Francisco who were not Jewish, or who had denied their Jewish identity. The latter must have been the case with Beatrice, for it was recently discovered by Adrienn Mendonca-Jones, who is preparing a novel based on the events of Beatrice's life, that her maternal grandfather, John Rosencrantz, who left an estate in the 1880s valued at $3,500, gave $25 to the city of Jerusalem, $10 per month to the Hebrew Orphan Asylum and $10 per month to the Hebrew College of Wallozina, Russia, "for the Rabbi to read prayers for the testator" (who, in this context, was Mr. Rosencrantz). He also stipulated that if any of his seven children married "without the approval of their mother, or if they show her the slightest disrespect," they were to receive only $1. When his widow died, she left a far more sizeable estate valued between $150,000 and $250,000 (reports vary), but the children fought over its distribution. Apparently, one of the provisions of the will stipulated that "if any child should marry outside of the Jewish faith he or she

should be disinherited." Reports in the newspaper disclose that Carrie Rosencrantz (Beatrice's mother) fell in love with a Christian named Wood, but she contested the provision, claiming that she had received consent from her siblings to marry him. She subsequently sued two of her brothers (who were executors of the estate), claiming that Mr. Wood was "a man of the Jewish race and religion." How this lawsuit was resolved is unknown, although one report claimed that a compromise of some sort was reached. This all occurred a few years before Beatrice was born, but an educated guess is that once the estate was settled, her mother had very little to do with her siblings, including the religion they practiced.

In the many hours of conversation I had with Beatrice, even about her childhood, she never once mentioned being Jewish. One could naturally leap to the conclusion that she was anti-Semitic, but for anyone who actually knew her as well as I did, that notion is preposterous. When it came to minorities of any type, she was so completely sympathetic to their ways of life and tolerant of their religious beliefs that I would find it difficult to believe she was capable of being anti-anything. If there was any belief system that she followed, it was theosophy, and even there, she was more interested in their quest to uncover the mysteries of the universe than in any attempt to find evidence of a divinity (although she always considered the possibility that certain people could be clairvoyants; thus her fascination with fortune-tellers). Besides, it was probably her mother who made an effort to eradicate the Jewish identity of their family, especially after moving to New York, where her wealth and her husband's career in real estate would allow her to pursue a quest for upward mobility among the city's social elite.

For years, I lived under the illusion that my brother and I might have been born Jewish. Both John Rewald and Leo Steinberg thought it was a distinct possibility, not because

either one of us looked especially Jewish (whatever those physical characteristics might be), but because they felt that other qualities we possessed were uniquely Jewish. One was, they thought, that our minds functioned in a straightforward, logical and linear fashion, and that we were of above-average intelligence. Of course, I took this as a high compliment, and for some years imagined that it might be possible, if not through our biological mother, perhaps through the father. I shared this fantasy with a few of my close friends, but it was not without peril. In the early 1990s, the former wife of my friend Michael spread the rumor that I was telling people that I was Jewish. Of course, I never did that, but it did not stop some people from believing her. In some sort of twisted vindictive act, she told this to the Italian art historian and Duchamp scholar Arturo Schwarz, with whom I had shared a close friendship for years. Whenever I visited him at his home in Milan, because of my fluency in Italian, I was able to converse with his wife Vera, and with the wives who followed after her death. Terry and I even went on vacation with him to his summer home south of Florence, but he was a difficult man, imperious and at times monstrous, even to the members of his immediate family. He mysteriously stopped speaking to me in 1991, and although he never offered an explanation, I was later informed by the widow of my friend Michael that it was because he had heard I was pretending to be Jewish. It is no coincidence that Michael's ex-wife visited Schwarz at his home in Milan a few days before he decided our friendship was terminated. When the third edition of his catalogue raisonné of works by Duchamp appeared, since we had not been on speaking terms for some seven or eight years, I felt perfectly at liberty to review it, and to express my honest opinion of its contents. Years earlier, I had gently told Schwarz that I disagreed with his Freudian theory that Duchamp harbored an unconsciously incestuous desire for

his sister Suzanne, but he simply ignored my objections. This time I decided to take him on publicly, and I began my review by telling a story about how a novice collector who knew little about Duchamp once asked: "Isn't he the artist who slept with his sister?" Schwarz claimed my comments were more ridicule than review, so he threatened a lawsuit against me and the publishers of *Art in America* (where the review appeared). Eventually, the suit was dropped, but only after the magazine agreed to publish his rebuttal, which came in the form of a twenty-page typewritten letter (to which I was invited to respond). In the end, that was some punishment for only having wanted to be Jewish. I suppose the old adage is true: Be careful what you wish for.

In the end, any attempt to model your life after that of another can only be an approximation, for you take what you want from one person, and freely reject whatever aspects of their personality you found objectionable. Some things are consciously emulated, while others occur without awareness, and you only realize their significance years later. Since I have spent so much of my life studying the art and life of Marcel Duchamp, I have often wondered how much of his thinking and lifestyle influenced me. There is no question that I used his line of reasoning about not wishing to be encumbered with worldly possessions to avoid getting married, and that after having discovered the facts of his love affair with Maria Martins, I allowed myself to fall deeply in love and eventually marry. The parallel nature of these events seems more than purely coincidental, but there are others that have occurred without any awareness whatsoever. In the late 1990s, for example, I devoted an entire book to the subject of Duchamp and replication, which I believe was the core of his work. Just as the book was going to press, I realized that I was born an identical twin, meaning, of course, that I was myself replicated. Moreover, my nearly obsessive interest

in Duchamp's concept of the readymade, which represents his greatest contribution to the art of the 20th century, has a mysterious echo in my life, for even our three adopted children could be thought of as having been already made, or in the context of Duchamp, readymades.

When I ponder the influence of my mentors, I can only hope to have absorbed their most admirable characteristics. Ironically, these ideals are probably best expressed in their attitudes toward death. When Jack Flam asked Leo Steinberg what he thought would happen when he died, Leo responded he would probably become exactly what he was before he was born (technically, before he was conceived), that is to say, he would simply not exist. I find the intelligence and logic of that observation profound, as was his thinking on any question he was asked, or, in the field of art history, any question he asked his students or elected to ask of himself. John Rewald, by contrast, once told me that he didn't care if he lived or died. That attitude came as a shock, for if anyone seemed to enjoy the pleasures of life, he did. I supposed the fact that his son predeceased him and that he was unable to secure a lifelong bond with Fran Weitzenhoffer were factors. When I told him that such a nonchalant attitude really hurt my feelings, since it was clear that he didn't care how his death would affect me, nor, for that matter, anyone else, he still didn't care.

With Beatrice Wood, however, whenever the subject of death came up (and it would often as she advanced in age), she was far more positive and life-affirming. I once asked her what she thought about religion, and she said that in her view all religions are essentially the same, that all known deities made the same pronouncements on the same subjects. Years earlier, she had prepared a vertical chart with the sayings of Christ, Mohammed and Buddha, and she could prove that they said essentially the same things, so she saw no reason

to prefer one religion over another. When I asked her about an afterlife, that's when she told me about her belief in reincarnation, and wanting to come back as a cat. I asked that if she predeceased me (not a foregone conclusion in those days, since the stroke I experienced nearly caused me to depart this earth before she did), would she please give me some sort of sign? She agreed to do this, but over twenty years have now passed since her death and, other than for a super-affectionate cat that sleeps right next to my head every night, I've heard nothing.

Perhaps a better indication of her beliefs occurred one evening in Ojai when we went out and walked her dogs. Looking up, I was overwhelmed by the blanket of stars that covered the night sky, since I lived in New York at the time, where light emitted by the city obliterates a clear view of the heavens, and the sheer vastness of the universe prompted me to ask her a question that had been bothering me for years. Since I knew that the earth revolved on its axis and with all the other planets circled the sun, I wondered if she knew that scientists had recently discovered that the earth and all planetary bodies in the known universe appear to be moving in a straight line at a speed of approximately seventy miles per hour. Apparently, this has occurred since the beginning of time and we haven't hit a wall yet, an illustration of infinite space that I found incomprehensible. Since Beatrice had arrived at such an advanced age, I thought she might have an insight into this phenomenon. After explaining my lifelong quest to understand infinity, I said to Beatrice: "Maybe after we die we get to know the answers to these questions. . . . Maybe that's what heaven is." She looked at me, amused, and said: "No, no, no. If heaven is anything, it must be the great relief one experiences in no longer wanting to know the answers to such questions!"

EPILOGUE

In my early years, I consciously sought inspiration from the example of two great art historians and an artist. In witnessing Leo Steinberg's profound intellect, I came to realize that it was possible to experience a great deal of personal satisfaction entirely within your own mind, whereas John Rewald demonstrated that there was an equal degree of pleasure to be had from living an indulgent and luxuriant life. But neither Steinberg nor Rewald provided the emotional guidance that came naturally to Beatrice Wood, whose example made me see that your heart can give you the single greatest pleasure man is capable of experiencing.

Finally, although Marcel Duchamp presented the persona of a man who shunned emotional attachment, having discovered that he fell deeply in love at least once in his life changed mine. Although it was not done deliberately at the time, I followed suit, indicating that you do not necessarily have to know a person intimately for them to serve as a role model. Even in cases where you never actually met the person (although with Duchamp I came close), their example can continue to inspire and serve as a guiding light in both your personal and professional life.

In my particular case, there is no question that the most important decisions I have made in life were more a product of my upbringing than my biological origins. There is no question that the individuals we know and admire most—whether we knew them personally or only through their example—serve to shape our future, molding us, consciously or unconsciously, into the people we inexorably become.

NOTES

NB. Many of the people discussed in the preceding pages are either still living—or knew those who no longer are—better than I. They will surely have recollections that differ from mine and, for one reason or another, they may very well object to some of the accounts I have provided. What I have presented was relayed with the intent of painting portraits of the individuals with the broadest possible strokes, while focusing in detail only when it helped to clarify my relationship with them, or their relationship with one another. Moreover, it should be emphasized that we are all in possession of memories that are faulty or erode over time, but I have done my best to recall the events as accurately as I could, flawed and imprecise though my memory might at times be.

Page

1 In a speech delivered to workers at a GE plant in Wisconson on January 30, 2014, Obama said "folks can make a lot more [money], potentially, with skilled manufacturing or the trades than they might with an art history degree." He later apologized for this comment (see Aamer Madhani, "Obama Apologizes for Joking about Art History Majors," *USA Today*, February 19, 2014).

15 I have here intentionally diminished the account of my discovery of Duchamp and how he influenced my work, because I have already written about this in the introduction to my *The Recurrent, Haunting Ghost: Essays on the Art, Life and Legacy of Marcel Duchamp* (New York: Readymade Press, 2012).

25 "But he must have done something." Steinberg recalled this exchange with me in his long interview with Richard Cándida Smith, February 21, 1988, transcribed and published as "The Gestural Trace," Art History Oral Documentation Project, Getty Research Institute for the History of Art and the Humanities, 2001, p. 153. My account of this incident closely matches that which Steinberg published in his *Leonardo's Incessant Last Supper* (New York: Zone Books, 2001), pp. 159ff.

25 Steinberg's article was 119 pages long, and his footnote to me reads as follows: "The important insight that such supporting piers are essential to the structural rationality of Leonardo's depicted chamber, is due to my graduate student Mr. Francis Naumann, who has further revelations in store." See Leo Steinberg, "Leonardo's *Last Supper*," *The Art Quarterly* XXXVI, no. 4 (1973), p. 395 n. 10.

26 Francis M. Naumann, "The 'Costruzione Legittima' in the Reconstruction of Leonardo da Vinci's *Last Supper*," *Arte Lombarda* 52 (Spring 1979), pp. 63–89.

27 "The next time you ask . . . ," I would not have remembered this inscription,
 were it not for the fact that after Professor Steinberg's death, Sheila
 Schwartz gave me the file that he kept on me and my writings. Within it
 was the offprint that I had dedicated to him.

29 Leo Steinberg, "Eve's Idle Hand," *Art Journal* XXXV, no. 2 (Winter 1975/76),
 pp. 130–35.

34 "He has produced a book . . . ," E.H. Gombrich, "Talking of Michelangelo,"
 The New York Review of Books XXIII, nos. 21–22 (January 20, 1977),
 pp. 17–20. Review of Leo Steinberg, *Michelangelo's Last Paintings: The
 Conversion of St. Paul and the Crucifixion of St. Peter in the Capella Paolina,
 Vatican Palace* (New York: Oxford University Press, 1975).

35–36 Leo Steinberg, *The Sexuality of Christ in Renaissance Art and in Modern
 Oblivion* (Chicago: University of Chicago Press, 2nd edition, revised and
 expanded, 1996). See especially the review by Charles Hope, "Ostentatio
 Genitalium," *London Review of Books*, November 15, 1984. The text
 originally appeared as a full issue of *October* 25 (Summer 1983), and in
 book form in 1984 (New York: Faber; London: Pantheon).

36–37 "I was impressed . . . ," quoted in "Johns On . . . The Artist Drops His Reserve
 and Talks about Painting, Poetry and Himself," *Vanity Fair* 47, no. 2
 (February 1984), p. 65.

37 "Taught me to Look . . . ," in Francis M. Naumann, *Jasper Johns: "According
 to What"* and *"Watchman,"* Gagosian Gallery, New York, January 21 –
 March 14, 1992, p. 9.

40 "The Philosophical Brothel, Part I," *ARTnews* LXXI, no. 5 (September 1972),
 pp. 20–29; "Part II," *ARTnews* LXXI, no. 6 (October 1972), pp. 38–47.

47 *The History of Impressionism* (New York: Museum of Modern Art, 1946)
 appeared in 2nd (1955), 3rd (1961) and 4th (1973) revised editions. *Post-
 Impressionism: From van Gogh to Gauguin* (New York: Museum of Modern
 Art, 1956) appeared in 2nd (1962) and 3rd (1978) revised editions.

58 Rewald's review appeared in the *Gazette des Beaux-Arts* (May–June 1989),
 pp. 249–56. His letter to Harvard University Press is reprinted at the end
 of this article, as are the names and titles of the twenty people whom he
 copied. Sidney Geist, *Interpreting Cézanne* (Cambridge: Harvard University
 Press, 1988).

67 Leo Steinberg, "Resisting Cézanne: Picasso's 'Three Women,'" *Art in
 America* 66, no. 6 (November–December 1978), pp. 114–33, was followed
 by "The Polemical Part," *Art in America* 67, no. 2 (March–April 1979), pp.
 114–27; Rubin's essay appeared in the same issue, pp. 128–47.

69 "Dynamic Duo," in "Letters," *Art in America* 67, no. 5 (September 1979), p. 5.

73 The photograph described was reproduced in Robert Lebel, *Marcel
 Duchamp* (New York: Grove Press, 1959), p. 21, fig. 15.

73 The drawing described is *Aéroplane*, 1912, now in the Menil Collection,
 Houston, Texas. It was listed as cat. no. 84 in Anne d'Harnoncourt and
 Kynaston McShine, eds., *Marcel Duchamp*, Museum of Modern Art, New
 York, and Philadelphia Museum of Art, 1973, p. 263.

74 I arrived in Ojai on August 11, 1976, as Beatrice noted in her diaries:
 "Frances [*sic*] Norman [*sic*] spends day enthusiastically going over
 Arensberg, Duchamp material. Says he will help with my book, also
 drawings" (Archives of American Art, Smithsonian Institution, Washington,
 D.C.).

78–79 See "I Shock Myself: Excerpts from the Autobiography of Beatrice Wood,"
 introduction and notes by Francis M. Naumann, *Arts* 51, no. 9 (May 1977),
 pp. 134–39.

87 Beatrice Wood, *I Shock Myself: The Autobiography of Beatrice Wood*,
 Lindsay Smith, ed. (Ojai: Dillingham Press, 1985); (San Francisco:
 Chronicle Books, 1992 and 2006).

89 "Vessels by Ms. Wood . . . ," quoted in Fred A. Bernstein, "Sacrificing Space
 for Scenery," *New York Times*, June 1, 2008.

92–93 For an example of how her age was unwittingly falsified, see Michele De
 Angelus, "Beatrice Wood," in William Innes Homer, ed., *Avant-Garde
 Painting and Sculpture in America, 1910–25*, Delaware Art Museum, 1975,
 p. 150. Beatrice was born on March 3, 1893. To put that date into context,
 a day later—on March 4, 1893—Grover Cleveland succeeded Benjamin
 Harrison as president of the United States (and Harrison was a brigadier
 general during the American Civil War). Queen Victoria was in her sixty-
 first year of rule, and she would rule for seven more (until her death in
 1901).

97–98 The proceedings of the Halifax conference were published in Thierry de
 Duve, ed., *The Definitively Unfinished Marcel Duchamp* (Cambridge: MIT
 Press, 1991).

99 For Duchamp's exchange with Pierre Cabanne, see Cabanne, *Dialogues with
 Marcel Duchamp*, trans. Ron Padgett (New York: Viking Press, 1971), p. 15.

109 The name Hannah Niemand is fictional, and was here changed in order to
 protect the identity of the person to whom it refers. In German, *niemand*
 means "nobody," and it was used as a name by John Rewald that he
 strategically placed into the provenance of works of art in the various
 catalogues raisonnés he authored in order to catch those who appropriated
 his work without his permission (a device that worked on more than one
 occasion).

113 The Metropolitan Museum of Art's acknowledgment appeared in Alice
 Cooney Frelinghuysen and Gary Tinterow, eds., *Splendid Legacy: The
 Havemeyer Collection*, Metropolitan Museum, New York, March 27 – June
 20, 1993, p. xiv (my assistance was also acknowledged, but the authors
 managed to misspell both my first and last names). Fran Weitzenhoffer's
 work on the Havemeyers was published five years before her death: *The
 Havemeyers: Impressionism Comes to America* (New York: Harry N. Abrams,
 1986).

118–119 See Michael Kimmelman, "John Rewald, 81, Expert on Art of Post-
 Impressionist Period, Dies," *New York Times*, February 3, 1994.

123 In 1962, Steinberg married Dorothy Siberling, art editor of *Life* magazine.
 They separated in 1969 and divorced a few years later but remained friends.

126 Helen Dundar, "Beatrice Wood in Her Second Century: Still Going Strong,"
 Smithsonian 24, no. 12 (March 1994), pp. 86-94.

130 "Terry and I eventually tackled the project . . . ," see Marie T. Keller and
 Francis M. Naumann, eds., "My Life in Art: Excerpts from the Diaries of
 Beatrice Wood," in *Beatrice Wood: Career Woman—Drawings, Paintings,
 Vessels, and Objects*, Santa Monica Museum of Art, September 10, 2011 –
 March 3, 2012, pp. 73–131. As our title suggests, we selected only the
 entries that dealt with Beatrice's involvement in the world of art, first in
 New York and then in California. Even with those limitations, the text
 covered 60 pages of a 144-page catalogue.

131–132 Francis M. Naumann, *Beatrice Wood: A Centennial Tribute*, American Craft
 Museum, New York, New York, March 3, 1997 – June 8, 1997. The show
 traveled to the Santa Barbara Museum of Art, Santa Barbara, California,
 September 13, 1997 – January 4, 1998.

132–133 The joke was sent to Beatrice via fax on December 6, 1997.

137–138 "Esteemed American Artist," Roberta Smith, "Beatrice Wood, 105, Potter
 and Mama of Dada, Is Dead," *New York Times*, March 14, 1998.

138 "She spent more than a century . . . ," Michael Kimmelman, "Beatrice Wood: A
 'Titanic' Figure of the Avant-Garde," *New York Times Magazine*, January 3, 1999.

138 "The last years of my life were the happiest," quoted in Holly J. Wolcott,
 "Hundreds Celebrate Life, Work of 'Beato,'" *Ventura Country News*, June 1,
 1998, p. B4.

139 Steinberg's book on the *Last Supper* was published by Zone Books and
 distributed by MIT Press. See reviews by Richard Shiff, "Flying Colors,"
 Artforum, May 2001, pp. 23–24, and Michael Podro, "Space, Time and
 Leonardo," *Times Literary Supplement*, January 4, 2002, pp. 16–17.

143 "Mr. Steinberg gave academic writing . . . ," Ken Johnson, "Leo Steinberg,
 Vivid Writer and Bold Thinker in Art History, Is Dead at 90," *New York
 Times*, March 15, 2011, p. B19.

143 Helen Vendler is quoted in the Johnson obituary, *ibid*.

144 "Flotsam & Then Some," from Leo Steinberg, "False Starts, Loose Ends," *The
 Brooklyn Rail*, March 17, 2011.

144 Margaret Moorman, "Leo Steinberg and the Sexuality of Christ," *ARTnews*,
 March 1985, pp. 76–84. *ARTnews* published Steinberg's two-part essay on
 Les Demoiselles d'Avignon in 1972 (for full citation see reference to page 40
 above). Tom Hess (1920–1978) was then managing editor of the magazine.
 Milton Esterow purchased *ARTnews* in 1972 and was its editor when
 Moorman's article was published.

145–146 "He should have not worried about his readers . . ." As the present
 publication was being prepared, I learned from Sheila Schwartz that
 Steinberg's articles are being assembled and will be published in five
 separate volumes by the University of Chicago Press (email to the author,
 March 21, 2018). The first on *Michelangelo's Sculpture* appeared in the fall of
 2018, and a second on *Michelangelo's Painting* in the spring of 2019; these
 will be followed by a third on the old masters, a fourth on Picasso, and a

fifth on modern masters. I am fairly confident that these publications will be greeted to great acclaim, solidifying Steinberg's rightful place as one of the most important and insightful art historians of the twentieth century.

148 "The hand is sure . . . ," from Jack Flam, "Leo Steinberg: Drawing a Lesson," in *The Eye is Part of the Mind: Drawings from Life and Art by Leo Steinberg*, New York Studio School, January 31 – March 9, 2013, pp. 4–5.

155 For the show referred to, see Robert Rosenblum, Maryanne Stevens and Ann Dumas, *1900: Art at the Crossroads* (New York: Harry N. Abrams, 2000). The show was curated by the three authors listed, as well as Norman Rosenthal, Vivien Greene and Cecilia Treves.

157 Robert Rosenblum, "Something Out of Nothing Out of Something: Mike Bidlo's Erased de Kooning Drawings," *Mike Bidlo: Erased de Kooning Drawings*, September 21 – November 11, 2005, and "Kathleen Gilje's Reincarnations," *Kathleen Gilje: Curators, Critics and Connoisseurs of Modern and Contemporary Art*, April 5 – May 24, 2006; both catalogues Francis M. Naumann Fine Art, New York.

158 The obituary was written by Herbert Muschamp, "Iconoclastic Art Historian, Seeing the Old in the New," *New York Times*, February 28, 2007.

163 *Joséphin Péladan and the Salons de la Rose+Croix*, doctoral dissertation, The University of Chicago, August 1968, published as *Occult Symbolism in France: Joséphin Péladan and the Salons de la Rose-Croix* (New York: Garland, 1976).

164 My reviews appeared in the January, February and March 1974 issues.

165–166 "Cryptography and the Arensberg Circle," *Arts magazine* (May 1977), pp. 127–133; and "I Shock Myself: Excerpts from the Autobiography of Beatrice Wood," pp. 135–39.

166–167 The first of these letters was written to Ms. Jean-Ellen Giblin, Fashion Institute of Technology and to Professor Martica Sawin, Parsons School of Design, and both are dated June 8, 1977; the second is addressed to Professor John Shearman, Department of Art History, Princeton University, and is dated January 30, 1984 (Author's Archives).

168 "Jasper Johns: According to What," in *Jasper Johns: According to What and Watchman*, exh. cat. Gagosian Gallery, New York, January 21 – March 14, 1992, pp. 9–75. It was this essay that was dedicated to Leo Steinberg.

169 Back jacket cover of *New York Dada 1915–1925* (New York: Harry N. Abrams, 1994).

170 "Among the most inspirational teachers . . . ," *The Recurrent, Haunting Ghost: Essays on the Art, Life and Legacy of Marcel Duchamp* (New York: Readymade Press, 2012), p. iv.

171–172 All references to my correspondence with Robert is preserved in my personal archives.

173 Robert Pincus-Witten, "Carlo Maria Mariani" in *Carlo Maria Mariani: Works on Paper 1987–2007*, exh. cat., Francis M. Naumann Fine Art, September 26 – November 6, 2007, and "Walter Pach," *Artforum* (January 2016), p. 243.

174 Robert Pincus-Witten, "Salon de la Rose+Croix in Paris," *Artforum*
 (October 2017).

185–186 Copies of the articles cited here and several others appearing in the San
 Francisco papers dealing with this matter were drawn to my attention by
 Andrienn Mendonca-Jones, to whom I am grateful. "Like a Novel: Mrs.
 Wood Risked a Fortune for a Husband," *San Francisco Call* 57, no. 145,
 October 23, 1890; see also "A Curious Will: Some Strange Requests Made
 by John Rosencrantz," *Daily Alta California* 38, no. 12681, January 1, 1885.

186–188 On being Jewish. After this account was written, my DNA was tested by
 23andMe, whereupon I learned that I am 0.5% Ashkenazi Jewish. Even
 though I realize this amounts to comparatively little in my overall genetic
 makeup, I will admit to taking some pride in knowing that it is there.

188 See Francis M. Naumann, "Arturo's Marcel," *Art in America* 86,
 no. 1 (January 1998), pp. 35–39, and "Dueling Duchampians," *Art in
 America* 87, no. 1 (January 1999), pp. 25–31.

189 The book on Duchamp and replication is *Marcel Duchamp: The Art of
 Making Art in the Age of Mechanical Reproduction* (New York: Harry N.
 Abrams, 1999).

190 "Maybe after we die . . ." This account closely follows that of my foreword
 to *I Shock Myself: The Autobiography of Beatrice Wood* (San Francisco:
 Chronicle Books, 1985), p. xv.